D0926816

The Parting Light

Samuel Palmer
by
George Richmond RA

The Parting Light

SELECTED WRITINGS OF
SAMUEL PALMER

Edited by Mark Abley

CARCANET
with MidNAG

First published in Great Britain 1985
by Carcanet Press Ltd
208–212 Corn Exchange Buildings
Manchester M4 3BQ
and Mid Northumberland Arts Group
Town Hall, Ashington, Northumberland NE63 8RX

The Publisher acknowledges financial assistance from the
Arts Council of Great Britain.

British Library Cataloguing in Publication Data

Palmer, Samuel, 1805–1881
 The parting light : selected writings.
 1. Palmer, Samuel, 1805–1881 2. Painters,
 English——Correspondence, reminiscences, etc
 I. Title II. Abley, Mark III. Mid
 Northumberland Arts Group
 759.2 ND497.P3

 ISBN 0-85635-619-0
 ISBN 0-90479-47-9

Typesetting by Paragon Photoset, Aylesbury
Printed in England by Short Run Press, Exeter

Contents

Plates

Introduction

'How much literature do we hide beneath our mere invention and restriction of the term? How much do we fail to see because we look all the time for literature to the professional men of letters?'

—Geoffrey Grigson, *The Harp of Aeolus*

Samuel Palmer saw, for a time, with greater intensity and passion than almost any other British artist. His youthful work, ridiculed by his contemporaries as graceless and deformed, has been valued in the twentieth century as an outpouring of the unfettered Romantic imagination. But admiration has been accompanied by misapprehensions about Palmer's character, his beliefs, and the purpose of his art. Some may still think of him as a child of nature, magically awakened by William Blake, and destined to sink into a torpor of Victorian sentiment. His writings tell another story. Pensive, articulate, garrulous, he discussed his art with great openness. Indeed, some of his drawings and paintings can be fully understood only in the light of his words. Reading them, we can begin to understand how and what he saw.

The value of his writings, however, extends beyond commentary on art. He enjoyed the labour of composition; his son and first biographer A.H. Palmer remarked that his father painted with one hand and wrote with the other.[1] Many of his correspondents treasured his letters; the critic and novelist P.G. Hamerton claimed that he read each of them through nine times.[2] Even though much of Palmer's writing has been lost or destroyed, the collected edition of his letters occupies more than a thousand closely printed pages. Besides his lengthy, eloquent letters, he

[1] Cf. Raymond Lister, *Samuel Palmer* (London, 1974), p. 86.
[2] Letter to Samuel Palmer, Nov. 1872 (Linnell Trust).

wrote poems, essays, translations, and journals of startling intimacy. Unlike many other artists with literary aspirations, Turner and Fuseli among them, Palmer had a gift for vivid language.

The son of a bookseller and fitful preacher, he grew up surrounded by words. By the time that he met John Linnell (1822 at the latest,[3] Palmer being no older than seventeen) his mind was well-furnished with English literature, both familiar and obscure, and he had already acquired his habit of voluble self-analysis. His drawing skills were precocious and assured. Linnell took the boy in hand, making him study classical statues at the British Museum as well as the work of Albrecht Dürer; or as Palmer was soon to observe, 'It pleased God to send Mr Linnell as a good angel from Heaven to pluck me from the pit of modern art.'[4] Eventually it pleased Linnell to introduce him to William Blake, from whom Linnell had been brave and wise enough to commission the great engravings after *The Book of Job*.

Although Palmer knew Blake for only the last three years of the poet's life, their friendship had a lasting effect on him. He admired Blake's work as an artist; even more, he revered Blake the man. Refusing to make compromises for the sake of popular taste, quietly asserting the reality of spiritual forces and the glory of the imagination, Blake became a model for Palmer and his colleagues (a circle of young artists including Edward Calvert and George Richmond, who called themselves the 'Ancients' to symbolize their distaste for much recent art). 'He was a man without a mask,' Palmer wrote many years later; 'his aim single, his path straightforward, and his wants few; so he was free, noble, and happy.'[5] The Ancients spoke of Blake as the Interpreter, a reference to the guide in *The Pilgrim's Progress* who reveals visions that will help Christian in his dangerous journey.

They were less devoted to Blake's poetry. None of them understood it well. Indeed, it can be misleading to describe Palmer as a follower or disciple of Blake, for the ideas of the two men were in some respects fundamentally different. Blake rarely created pure landscapes; among his few ventures in the idiom was

[3] Linnell's Cash Account Book, 1813–1822, shows that he regularly bought books from Palmer's father as early as June 1820 (Linnell Trust).
[4] Cf. p. 96.
[5] Cf. p. 179.

a series of tiny woodcuts to illustrate an adaptation of Virgil's pastorals, and of all his works these were the designs that Palmer most loved. But Blake considered it impossible for holiness to exist distinct from men and women. He took little interest in nature except as a vision of the inner life: 'The English Artist may be assured that he is doing an injury & injustice to his Country while he studies & imitates the Effects of Nature.'[6] By contrast, even when Palmer was most under Blake's influence, he saw the design of nature as the art of a benevolent God. By means of landscape painting he conveyed his sense of the divine. (Later in life he feared and resisted Darwinism.) Yet this essentially medieval vision was couched in such radical terms that one art critic has compared his early work to the pictures of Ernst, Klee, de Chirico, Soutine, and Henri Rousseau — not to mention Hieronymus Bosch.[7]

Literature inspired much of his art, and his writings teem with quotations. He particularly relished poets in the tradition of English pastoral: Spenser, John Fletcher, William Browne, the young Milton. A certain ponderous eloquence in his prose style may be the result of his fond scrutiny of Sir Thomas Browne, while the influence of Bunyan went deeper, informing Palmer's response to life. Whatever words he read, he turned them to productive use: his early perceptions were all the more intense because of the poetry that filled his mind. For many of us, and certainly for Palmer in middle age and later, literature functions as a screen against the raw, wayward extravagance of the world. By the time that his painting had become nostalgic reverie, he could speak of 'a Great Gorge of old poetry to get up the dreaming.'[8] But in his youth, he scoured the woods and fields of Kent for living proof of what he had read.

Many of his finest works of art were created during the seven years spent in the Kentish village of Shoreham, free from the constraints and expectations of life in London. The liberty of those years was made possible by a legacy from his grandfather and by his readiness to live frugally for the sake of art. Inspired by the rolling landscape, balancing its repose against its underlying

[6] *Public Address* (*Complete Writings*, ed. G. Keynes, Oxford, 1974, p. 597).
[7] Robert Melville, *Samuel Palmer* (London, 1956).
[8] Raymond Lister, ed., *The Letters of Samuel Palmer* (Oxford, 1974), p. 866.

energy, he could make a green fragment of England into the image of paradise on earth. As one of his close friends, Edward Calvert, wrote later, 'Only paint what you *love* in what you see.'[9] The creative tension that kindled Palmer at Shoreham was caused in part by John Linnell, who had been a central figure in the naturalistic movement among British painters a decade or two earlier. He visited Shoreham several times and chided Palmer into making detailed examinations of the natural world, so that the young man was studying the minutiae of tree-trunks at much the same time as he was conceiving designs of Satan and of the Holy Family.

Growing old amid the gentility of Surrey, Palmer kept these early works in a 'Curiosity' portfolio which he showed to few visitors. The reaction through most of the Victorian period would probably have been similar in kind, if not in degree, to the first recorded criticism of his art, made by a contributor to *The European Magazine* in August 1825:

> . . . there are two pictures by a Mr Palmer, so amazing that we feel the most intense curiosity to see what manner of man it was who produced such performances. We think if he would show himself with a label round his neck, *'The Painter of a View in Kent'*, he would make something of it at a shilling a head. What the hanging committee meant by hanging these pictures without the Painter to explain, is past our conjecture.[10]

Palmer was in good company; that anonymous reviewer found Haydon's work 'infamous', Martin's 'absurd beyond all conception', and Turner's 'sadly repulsive'. To be considered inexplicable was perhaps to be let off lightly.

But what one age finds incomprehensible, another may venerate. The very qualities that damned Palmer's early work in the eyes of his contemporaries have made him tremendously popular in our own time — more among the general public, perhaps, than with art historians. Rich in texture, free from conventions, his youthful drawings and paintings are characterized by exuberance, intricacy, and a desire to experiment with form. A round moon, far across a valley, looms larger than a shepherd close at hand; at the edge of a straight path, a pink tree shudders

9 Samuel Calvert, *A Memoir of Edward Calvert, Artist* (London, 1893), p. 50.
10 *The European Magazine*, August 1825, p. 85.

with blossom; a flock of sheep huddles by night under a hill that resembles a sheep's head upturned (Plate 1). Something new had entered English painting: the willingness to make pastoral land-scapes a vehicle for intense and turbulent emotion.

His writings share many of the qualities that appeal to us in his Shoreham art. They mix description with invention, metaphor with quotation, an abstract idea with a wealth of physical detail. The style is gnarled and muscular, unpredictable in its imagery and movement. In a single letter, and with equal lyricism, he can veer from despair to exaltation, from 'a fen of scorpions and stripes and agonies' to 'the moon thron'd among constellations, and varieties of lesser glories'.[11] Today he would be classified as manic-depressive, as if that explained anything. He never feared emotion; he never quite mastered decorum. This refusal to dis-guise his feelings so alarmed A.H. Palmer that he burned many of his father's early sketchbooks and journals, and felt apologetic even about the correspondence:

> A somewhat singular feature in his character was the almost feminine want of reticence in matters relating to his feelings, griefs, and disappointments; and things which some men would shrink from discussing with or confessing to their wives, he discussed or confessed in letters to friends.[12]

Homosexuality is not implied in the above remark; A.H. Palmer based his concept of masculinity on power and dominance, and his father was anything but a dominating man. Palmer's candour remains surprising: 'I screamed — fell flat upon the floor and kicked like a lady in hysterics — then seizing a tambourine performed a Bacchic dance with agility which would have astonished you!'[13]

He was attentive to the natural world, and at Shoreham he observed it partly to learn what its fertile scenes might suggest of eternity. In December 1828 he informed Linnell that although 'there must be the study of this creation . . . I cannot think it other than the veil of heaven, through which her divine features are dimly smiling.'[14] His luminous Kentish valley demonstrated 'the

[11] Cf. pp. 28–9.
[12] *Life and Letters of Samuel Palmer, Painter and Etcher* (London, 1892), p. 169.
[13] *The Letters of Samuel Palmer*, p. 302. Palmer was writing to John Linnell.
[14] Cf. p. 41.

radiance of Heaven;'[15] by lavishing attention on this world, he hoped to discern the lineaments of a realm beyond. Palmer had little difficulty in reconciling Christianity with some neo-Platonic beliefs he may have picked up from reading Thomas Taylor, who, in *The Works of Plato,* declared that '. . . the soul, while an inhabitant of earth, is in a fallen condition, an apostate from deity, an exile from the orb of light.'[16] In his Shoreham years, that orb of light shone for Palmer as close as the nearest ridge or hill above the winding River Darent. He painted the valley as if he were its lover, taking literally the provocative question posed by Raphael in his beloved Milton:

> . . . what if earth
> Be but the shadow of heav'n, and things therein
> Each to other like, more than on earth is thought?[17]

But the legacy ran out, the circle of friends dispersed, and Palmer had to begin using his art to earn a living. To put it simply, perhaps too simply, the visionary years ended when the responsibilities of adulthood began. His friend George Richmond soon denounced those years: 'We all wanted thumping when we thought in a dream of sentiment we were learning art.'[18] Palmer neither regretted nor renounced the dream. Throughout his career he tried to justify his work in spiritual terms. But as he grew older and wearier, he lost his faith in the ability of the imagination to bridge earth and heaven. 'If the Sun & Moon should doubt,' Blake wrote in *Auguries of Innocence*, 'They'd immediately Go out.'[19] In the early 1830s Palmer began to doubt. A sad affinity exists, here as in many other ways, between Palmer and John Linnell, who abandoned his intense naturalistic landscapes, which were selling poorly, as his family grew. 'The portraits I painted to live,' he wrote much later; it was 'poetical landscape which I lived to paint.'[20] The pathos of Linnell's career

[15] Cf. p. 41.
[16] Taylor, *Works of Plato* (1804), I, lxiii. Quoted by George Mills Harper in *The Neoplatonism of William Blake* (Chapel Hill, 1961), p. 65.
[17] *Paradise Lost*, V. 574–6.
[18] Letter to Palmer, 28 Sept. 1838; quoted by Raymond Lister, *George Richmond, A Critical Biography* (1981), p. 46.
[19] *Auguries of Innocence*, lines 109–110; *Complete Writings*, p. 433.
[20] Autobiographical notes (Linnell Trust).

is that by the time he felt wealthy and secure enough to re-dedicate himself to landscape painting, freshness of vision had deserted him.

At Shoreham Palmer had seen what he yearned to see; but he had been blind to the deprivation and pain of the picturesque labourers around him. 'In all the really agricultural villages and parts of the kingdom,' William Cobbett observed in 1822, 'there is a *shocking decay*; a great dilapidation and constant pulling down or falling down of houses.'[21] Conditions did not improve. In the summer of 1830 four harvest workers were discovered under a hedge, dead of starvation; a few miles away from Shoreham occurred the initial fires and machine-breaking of what has been called 'the last labourers' revolt'. Kent proved to be a centre of unrest. The most common demand was a daily wage of two shillings, or as much as half a crown — a sum which, if translated into annual terms, amounted to about a twentieth of 1% of the Duke of Wellington's pension — and the conduct of the protesters, according to a special correspondent of *The Times*, was nothing short of admirable. Throughout their rebellion the labourers neither killed nor wounded anyone. Yet Palmer reacted to this rising, the largest agricultural revolt that England has experienced, with fear and disgust. Except for one drawing of harvesters hurrying from a field, which (according to A.H. Palmer[22]) is lit by the reflection of incendiary fires, he allowed no hint of the disturbances to enter his art. Rather than observing lives, he had 'drawn the curtains, and retired to rest!'[23]

By 1832 he was finding the idyll harder and harder to maintain. The passage of the Reform Bill in June convinced him that England was going to the dogs, and in December, on the eve of a general election, he published a florid and anonymous *Address to the Electors of West Kent*. Born of his belief that political reform would necessarily breed atheism, it shows that his judgement was, to say the least, uncertain. Like Constable, Palmer longed for a benign paternalism in which everyone would rest content in his appointed place. Such beliefs were the reverse of Blake's. In

[21] *Rural Rides*, 31 Oct. 1822 (ed. G. Woodcock, London, 1967, p. 67).
[22] In his inscription on the reverse of Palmer's colour drawing, *Ightham Moat: The Harvesters hurrying away*, c. 1830.
[23] Cf. p. 145.

later life Palmer was somewhat embarrassed by the *Address*; and in his distaste for imperialist wars, his distrust of material progress and his scorn for gentility, he was by no means a conventional Victorian. He may have come to realize that the Golden Age can be found only in a past of our own making.

In 1837 he married Hannah Linnell, the eldest child of his friend and teacher, and the two of them left at once on a wedding-trip to Italy that against all expectations lasted more than two years. For Palmer the journey was a kind of pilgrimage; he rejoiced in the discovery of Italian light and landscape, Italian churches and customs, and (most of all) Italian art. It seems also to have been a success as a honeymoon; as Linnell's friend Albin Martin reported from Rome, 'I think if there are two happy people in the world it is Mr and Mrs Palmer.'[24] Some of the Palmers' letters to England are remarkable for their freshness and vivacity. But while Palmer was abroad, his friendship with his father-in-law entered a decline. Linnell and his wife resented the length of the Palmers' stay in Italy; they feared for Hannah's safety and comfort; they began to distrust their son-in-law's motives and evasive explanations. For his part, even the deferential Palmer grew angry at the Linnells' lack of confidence in him, their assault on his beliefs, and their apparent ingratitude for the hard work of copying and colouring which the couple undertook on Linnell's behalf.

Back in England, Palmer eked out a living by teaching; he had small success at selling his art. In the 1840s Linnell repainted several of his works; although this was nothing new (he did the same to paintings by Constable, Crome, Lawrence, Fuseli and many others),[25] it can hardly have boosted Palmer's fragile self-confidence. After the birth of his son Thomas More Palmer in 1842, he threw his hopes into the boy's future, burdening the child with a terrible weight of adult duty. His letters to Thomas More often make dispiriting reading. Forced to consider the taste of the marketplace, Palmer smoothed out his art. It lost in individuality more than it gained in conventional attractiveness. Many of his watercolours are worthy of respect, but little else.

[24] 29 April 1839 (Linnell Trust).
[25] Cf. A.T. Story, *The Life of John Linnell* (London, 1893); Katharine Crouan, *John Linnell: Truth to Nature* (London, 1982); and Linnell's correspondence with David Thomas White (Linnell Trust). Linnell thought of himself as a craftsman as well as an artist, and he was not ashamed to undertake tasks which many painters would have refused.

He was ceasing to charge his landscapes with the full pressure of his feelings; his art, in short, was becoming less 'romantic' and more 'classic'. Living and teaching in London, he had to plan his excursions to the countryside with care. By the mid–1840s he found it necessary to organize his thoughts around the theme, *Designs prudentially considered*;[26] the early praise of excess had given way to prudence. In middle age his devotion to nature was practical, as if he were beginning to see, not feel, the beauty of English landscape: 'How is that wholesome, clean, and unpicture-like appearance to be obtained, which on every side delights one in every country walk?'[27] Behind such a question lies a nagging doubt about the power of the human imagination as well as about the quality of his own work.

Palmer remained on good terms with Calvert, Richmond and other former Ancients, and as late as 1857 Linnell still felt able to call him a friend.[28] Their irreversible break came after Thomas More Palmer suffered an attack of rheumatic fever in 1858-9, and Linnell (who found the boy a difficult character and disliked his staunchly Anglican faith) stubbornly refused to invite him out to Surrey to convalesce. At the same time Linnell's wife was unwell, and the Palmers stubbornly refused to write to her without mentioning their son. Two years later, Thomas More was dead. After this, the hardest moment of his life, Palmer had little direct contact with Linnell. None the less, he moved into a villa at Redhill owned by one of Linnell's sons, and could meet the expenses of a bourgeois life worthy of Hannah thanks only to intermittent subventions from Linnell. He was not, as some of Palmer's admirers have claimed, a monster who ruined his son-in-law's existence; he was simply a headstrong, uncompromising man who could make life difficult for those who crossed him.

Linnell and Palmer were men of such violently different temperaments that their eventual estrangement is less surprising than their long, fruitful friendship. While Linnell was full of energy and assertiveness ('a splendid, courageous and manly

[26] Cf. p. 120.
[27] Cf. p. 122.
[28] Letter from John Linnell to Hannah Palmer (undated, but inscribed '1857' by A.H. Palmer in pencil), saying that Samuel Palmer would be able to see a new Linnell work on display in London, and 'I should like a few of my friends to see it as it may go to the country and not be seen . . . ' (Linnell Trust).

tyrant' was one of A.H. Palmer's phrases for his grandfather[29]), Palmer made a practice of diffidence, retreating from confrontations into a private world. Conservative by mood and conviction, he accepted a hierarchical system of government as natural; but Linnell (a former associate of William Godwin) held political opinions that tended to be irreverent and radical. Most important of all, Palmer loved the traditions, buildings and liturgy of the Church of England, which Linnell despised. 'The monster lie exists at Rome,' one of his poems begins; 'Diluted it is seen at home.'[30] He once addressed a letter to his daughter, 'Cardinal Annie, Papal States, via Mud Street.'[31] Having become a Baptist, then joined the Plymouth Brethren, and chosen at last a total independence in religion, Linnell blamed Palmer for persuading Hannah and her sister Elizabeth to be seduced by Anglican dogma. For his part Palmer never forgot that Linnell, who considered church marriage a 'degrading' and 'blasphemous' ceremony,[32] had forbidden Hannah to be married anywhere other than at a registry office.

Palmer's writings reveal the abiding importance of Christianity in his life. The particular form taken by his religious impulse varied a good deal: his youthful faith can be called 'Romantic', his later beliefs 'Victorian'. The 1824–5 sketchbook contains a list of subjects for a remarkably ambitious sequence of religious paintings, beginning with 'the springing of man from God'[33] and ending with the consummation of life in heaven. His impassioned Christianity was at that time infused with elements from Blake, neo-Platonism and the great mystics; by means of art he hoped to transmit visions of religious truth ('I Beheld Satan fall Like LIGHTNING From Heaven', Plate III). Infinity could be lurking in the humblest domains: a cornfield, a fruit-tree, a sheepfold. His celebrated early landscapes are, in a sense, icons of the land. The imagery of Christian pastoral appealed to Palmer profoundly; his Redeemer was at once the Good Shepherd and the Lamb of God. A life in nature and a state of grace were nearly, though never quite, synonymous.

[29] Cf. Lister, *Samuel Palmer*. This was not A.H. Palmer's final attitude; as he grew old and bitter, his opinion of Linnell (and of many other people) plunged.
[30] Ms. poem dated 12 March 1864 (Linnell Trust).
[31] Linnell Trust.
[32] Story, *Life of John Linnell*, p. 104.
[33] Cf. p. 105.

16

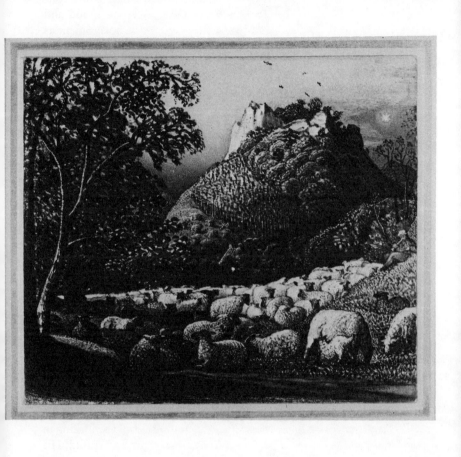

Plate I (*overleaf*) *The Flock and the Star*

This eagerness to create religious art faded only gradually. As late as 1844 a list of subjects derived from Italian and Welsh scenery unexpectedly includes Jacob's dream, 'Noli me tangere', and angels appearing to shepherds.[34] By then his faith had become wholly orthodox, though no less fervent. While he continued to accept that Blake might have been divinely inspired, goodness and charity now seemed far more urgent to him than personal revelation. The Christmas carol he wrote for his four-year-old son begins by describing the vision of angels granted to some shepherds; in the sixth and seventh verses, however, the little boy is enjoined to be just, pure, good, obedient, kind, and true. After Thomas More's death, the few consolations that his grieving father could find included the knowledge 'that he loved theology and chose the Church'.[35] Religion, which had once been Palmer's inspiration, was now his refuge. No longer seeking evidence of God's lively presence in the world, he waited to rejoin his dead in heaven.

Not that he stopped producing sweet, dreamy watercolours for exhibitions and sales. His true state of mind after 1861 is evident less in his art than in his letters, where he uses such signatures as these: A Vapour, The Crushed Worm, The eel in the pan, Less than nothing and Vanity, A. BLANK, Nogo, and The man who turns the mangle. He coped with grief by dramatizing it, taking a dismal pleasure in self-abasement; in a brief letter to Holman Hunt, he called himself a cabbage.[36] The youth who so enjoyed walks through the moonlit countryside had become a man who rarely ventured beyond his own house and garden. 'Mr Palmer has just had an invitation to dinner from Mr Ruskin,' Hannah informed her father, 'but he will not be able to go as he never goes out after dark.'[37] By means of letters, now filled more by reflections than incidents, he maintained a social life: 'Having no time to compose letters, I merely talk with my pen.'[38] Had he found enough time to 'compose', his letters might well have lost their pungent spontaneity and charm. Palmer's formal prose is not distinguished by a lightness of touch.

[34] Cf. p. 119.
[35] Cf. p. 129.
[36] *The Letters of Samuel Palmer*, p. 954.
[37] 20 Feb. 1860 (Linnell Trust); quoted by Crouan, *John Linnell: Truth to Nature*, p. XI.
[38] *The Letters of Samuel Palmer*, p. 755.

He always liked to comment on his aims and achievements in art. His imagination was only partly visual; it often required the stimulus of words. In turn his surviving notes and memoranda provide, it has been said, a 'revelation of an artist's inner mind'.[39] The first of the memoranda in this book was written when Palmer was fourteen years old. Already it betrays a reasoned dissatisfaction with his work. The abundant notes in his 1824–5 sketchbook modify any notion of him as a rapt mystic aloof from everyday life: though his prodigal imagination transformed the impressions of his senses with delicacy and ardour, he also took a hard-headed interest in picture-making. A mass of vegetation 'was very useful among the other foliage'; 'Useful to know by this if . . . one wants to neutralize the keenness of the light'; 'To prevent meagreness of composition from single limbs might it not be useful . . . to cluster together several limbs into one full mass?'[40] Contemplation and analysis went hand in hand. Palmer retained this habit even when the masters of ideal landscape, particularly Claude Lorrain, had become his models in art. He was constantly on the watch for suitable 'effects', recording them by means of designs and words alike. W.B. Yeats was right: each of Palmer's images 'of mysterious wisdom' was 'won by toil'.[41]

As a young man Palmer had written poems of romantic melancholy, redolent of Gray's *Elegy* more than of verse by his great contemporaries, and displaying a reach somewhat beyond his grasp. In middle age he began to translate Virgil's *Eclogues* with his son Thomas More, and after More died the labour of translation proved a comfort to a desolate man. The result was published only after Palmer's death. It has been condemned as stilted and cumbersome, and Palmer has attracted scorn for the alterations he inflicted on Virgil: in the second eclogue, for instance, a beloved boy is transformed into a maiden. Yet criticism has not always done justice to Palmer's skill at versification, the spasmodic richness of his imagery, and his success in establishing a mood of rural peace. The fourth eclogue, published here, was especially close to his heart; he shared St Augustine's view that the

[39] Martin Hardie, *Water-colour Painting in Britain: Vol. II, Romantic Period* (London, 1966), p. 157.
[40] Cf. pp. 103, 101, 104.
[41] W.B. Yeats, 'Phases of the Moon' (*Collected Poems*, London, 1961, p. 184).

poem prophesied the birth of Christ, with whose maturity a reconciliation between man and nature will occur. Behind Palmer's labour over the eclogues, as behind his late devotion to etching, lie his hunger for tranquillity and his perhaps forlorn need to create images of an earthly paradise. Such designs as the famous etching *Opening the Fold* exist only because of his desire to put his translation before the public; with some reluctance he had taken P.G. Hamerton's advice that publication would be unlikely unless he were prepared to illustrate the text.

He prefaced the translation with the essay *Some Observations on the Country and on Rural Poetry*, his final defence of the arts. It begins with a neo-Platonic suggestion that men of the world, who think poetry a waste of time, may be watching shadows. A mocking reference to the 'facts and mutton' which comprise their world recalls a similar remark in his 1824-5 sketchbook about the 'solid facts and still more solid pudding' that nourish a 'waddling alderman'.[42] But this is not visionary prose. Palmer goes on to show the healthy *moral* influence of green surroundings and pastoral verse. Although he condemns the foul air of London, a city which allows its inhabitants little time for 'improvement', he accepts that urban life has become the ordinary condition for most men and women, who find that rural poetry 'presents to fancy what is lost to sight'.[43] Later in the essay his ringing defence of the imagination shows that he still subscribed to Coleridge's distinction between the decorative gift of fancy and the force of creative imagination: the distinction, that is to say, between a day-dream and a vision. But aside from a glance at 'the quiet people by whose healthy labour we subsist',[44] the *Observations* do not extend to the farmers and farm-workers of Palmer's own day. He was introducing the *Eclogues*, not the *Georgics*; and the *Eclogues* were an urban fiction, a sophisticated game. His Shoreham work took its power from a mixture of knowledge and innocence; for all their gentle idealism, his *Observations* and *Eclogues* are songs of experience — even if the central experience is one of escape. The harmony with nature that Virgil's musical shepherds so effortlessly enjoy had become, for Palmer, a dream.

[42] Cf. p. 106.
[43] Cf. p. 155.
[44] Cf. p. 157.

Apart from his expressive skill, Palmer had two traits of character which make his work a pleasure to read. First, his zest for life usually transcends (even after the death of his son) his tendency to self-denigration. His senses gave him delight; the imagery of taste is liable to appear at the most unlikely moments in his prose. He relished odd facts, stray fragments of knowledge; in both senses of the phrase, he was a curious man. Often his lively feeling for the ridiculous rescued him from pomposity. Second, his honesty made him unable to pretend for long. In his letters as well as his journals, his great subject is himself, which he observes without particular joy or satisfaction but with a good deal of interest. In retrospect, his writings comprise a kind of *Apologia* by a man who had an early greatness; lost it; and perhaps, by his perseverance in adversity and his refusal to betray his unfashionable ideals, gained another, subtler greatness which we are recognizing only now.

Textual Note and Acknowledgements

Most of Palmer's writings have been taken from published sources, particularly *The Eclogues of Virgil: an English Version* (London, 1883), *The Life and Letters of Samuel Palmer, Painter and Etcher* by A.H. Palmer (London, 1892), and *The Letters of Samuel Palmer* (edited by Raymond Lister, 2 vols, © Oxford University Press 1974). Where other printed sources have been used, or where I have differed from Raymond Lister's readings, I have indicated as much in the notes.

Many of the *Inscriptions, Journals and Memoranda*, as well as two of the poems, have been newly transcribed from Palmer's 1824 sketchbook, now in the British Museum. Other letters, poems and memoranda are published here for the first time from documents belonging to the Linnell Trust, the Bodleian Library, and the Victoria and Albert Museum. In each case I have endeavoured to print Palmer's exact words. None the less, it has sometimes been necessary to add punctuation, especially in the sketchbook entries; for ease of reading I have also taken the liberty to expand contractions, correct obvious slips of the pen, and print 'and' in place of Palmer's intermittent '&'.

It has not been an easy task to choose the most revealing, lively or poetic letters from the more than 630 that Palmer is known to have written. In principle I have tried to print letters in their entirety, rather than lifting a paragraph here and a paragraph there; but in some cases cuts have been made. These are mentioned in the notes. (It should also be observed that of the letters known only from A.H. Palmer's edition of 1892, many exist in an already truncated form.) The *Inscriptions, Journals and Memoranda* published here are a selection, not a collection, but I have omitted none of the few poems and essays by Palmer that survive.

21

For their kind permission to publish Palmer material, I thank Oxford University Press, the Bodleian Library, the Trustees of the British Museum, the Linnell Trust, the Victoria and Albert Museum, the National Gallery of Canada, and the Art Museum of Princeton University. Like every student of Palmer, I owe a great debt to the work of Raymond Lister and Geoffrey Grigson. I am especially grateful to Mrs Joan Linnell Burton, whose graciousness and generosity have been an inspiration. For assistance in various ways, my thanks go also to Mimi Cazort, Stephen Joseph, John Kelly, Robyn Marsack, Tom Murison, Corinne Richards, Michael Schmidt, Philip Ward, and my loving, long-suffering wife Ann.

Chronology

1805 Born in Newington, on the south-eastern outskirts of London, 27 January

1817 Death of his mother, Martha Palmer. Entered Merchant Taylors' school; removed after a few unhappy months

1818 Instructed by the artist William Wate

1819 Sold his first picture at the British Gallery

1822 Met the painter John Linnell

1824 Introduced by Linnell to William Blake

c.1825 Formation of the 'Ancients', a group of young men who included the artists George Richmond, Francis Finch, Henry Walter, Edward Calvert, and Palmer

1826 Moved to Shoreham, Kent, with his father and his beloved nurse, Mary Ward

1827 Death of Blake

1832 Bought a house in London, but continued to base himself in Shoreham for two or three more years

1832-7 Made several visits to Devon, Somerset and Wales (and possibly the Lake District)

1837 Death of Mary Ward. Married Hannah Linnell, 30 September. Left England for Italy, 3 October, in the company of his wife, George Richmond, and Richmond's family

1838-9 In Italy. Returned to England, 27 November 1839, and settled in London

1842 Birth of his first child, Thomas More Palmer

1843 Elected an associate member of the Society of Painters in Water-colours

1844 Birth of his daughter, Mary Elizabeth Palmer

1845 Spent most of the summer at Margate, Kent, and Princes Risborough, Buckinghamshire

1847 Death of his daughter

1848 Death of his father, Samuel Palmer Sr.

1848–59 Made at least four visits to Devon and Cornwall

1850 Invited to join the Etching Club

1853 Birth of his third child, Alfred Herbert Palmer

1854 Elected a full member of the Society of Painters in Water-
colours

c.1856 Began to translate Virgil's *Eclogues* into English

1859 Severe illness of Thomas More Palmer

1861 Death of Thomas More Palmer. Left London and settled
in Redhill, Surrey

1863 Sold a drawing to L.R. Valpy, a solicitor who com-
missioned a series of watercolours to illustrate Milton's
L'Allegro and *Il Penseroso*

1872 Advised by the critic P.G. Hamerton to prepare illus-
trations to his translation of Virgil

1881 Died, 24 May

I
Early Letters

JOHN LINNELL[1]

Wednesday Septemb^r. 1824 Shoreham, Kent

My dear Sir

I have to thank you for your very ingenious hieroglyphic; I intend to look up a frame for it; but I think you should come immediately to the hopping for fear of rain or accidents. Here are no swollen racks big with tempests and destruction, besides I thought your cloak defied the wind and your hood the whirl-wind. But here are no winds that would hurt a baby — no Eastern blasts atal, nothing but fresh'ning gusts — zephyrs and

'The balmy spirits of the *Western* gale'[2]

I have begun two studies for you on grey paper at Lullingstone[3] — if you make haste you may prevent my spoiling them. I have been doing a head on grey paper life size and tinted, also another sketch of the same person smaller. Have I not been a good boy? I may safely boast that I have not entertain'd a single imaginative thought these six weeks, while I am drawing from Nature vision seems foolishness to me — the arms of an old rotten tree trunk more curious than the arms of Buonaroti's Moses — Venus de Medicis finer than the 'Night' of Lorenzo's tomb[4] and Jacob Ruysdaal[5] a sweeter finisher than William Blake. However I dare say it is good to draw from the visible creation because it is a sort of practice and refreshes the mind tired with better things and prevents spoiling them which I have so often done and so bitterly lament. So I will seal this fools-cap and instantly go forth and make out blades of grass and brick and mortar and new boards and old boards and brown boards and grey boards and rough boards and smooth boards and any boards except *board ministers* with a vengeance: tho I confess I am more fascinated with the

[1] John Linnell (1792-1882), landscape and portrait painter. He lived in London, but visited Palmer at Shoreham several times. This letter was written at the time when Palmer was most under his influence.

[2] Pope, *Odyssey*, VII, line 152.

[3] A park by the River Darent near Shoreham; Palmer's drawings of oak trees there are well-known.

[4] A sculpture by Michaelangelo in the Medici Chapel, Florence.

[5] Jacob van Ruisdael (1628/9-1682), Dutch landscape painter.

brawn of M Angelo's Night or the huge Kemsing Sow[6] than with most exhibitions of clover and beans and parsly and mushrooms and cow dung and the innumerable etceteras of a foreground. I am glad Clary does well for her sake and more for yours for a bad servant is a home nuisance.

Hoping that by tomorrow night you will be cover'd by the skies of the valley — with best respects to Mrs Linnell and love to the little ancients[7] I remain

<div style="text-align:center">

Dear Sir

Your oblig'd obedient Servant

Samuel Palmer

</div>

GEORGE RICHMOND[1]

Novr. 14 1827 Shoreham, Kent

My dear Sir

Winter, shorn of the pleasure and instruction of your society which brighten'd my summer — a Shoreham midsummer, is a very amission of loss; and this gasping hiatus sucks in many dank and acrid crudities of the gloomiest month: I mean in the jaded halts of intellect tugging up the hill of truth with the sun on her head and this excrescent wen of flesh broiling on her back: for tho' the eclipses of thought are to me a living inhumement and equal to the dread throes of suffocation, turning this valley of vision into a fen of scorpions and stripes and agonies, yet I protest, and glory in it for the sake of its evidence, of the strength of spirit that when inspir'd for art I am quite insensible to cold, hunger and bodily fatigue, and have often been surprised, on turning from work to find the fingers aching and nearly motionless with intense cold. Nor can the outward sense govern thus in turn; it is a tyranny of those brothers cruelty and weakness for whom the *rear* of spiritual

[6] Unexplained, but Palmer's 1824 sketchbook includes a portrait of a very large pig. Kemsing is a village not far from Shoreham.
[7] Linnell's children.

[1] George Richmond (1809-1896), an Ancient who became a lifelong friend. The words contained in square brackets near the end of this letter are lost through damage to the manuscript; I have followed Raymond Lister's suggestions as to the original.

thoughts is found too much; the recollections of happy enlighten'd hours, spiriting up to resistance the whole territory of man, till all his energies and desires break chains — march out and rush to prevent half way, with hymns, triumphs, acclamations, the majesty of their returning Freedom.

I want so much to be talking with you that you see I can not wait till next coming to town, but use (would I could as it deserves) that choice device, that wing of lovers' thoughts which 'Wafts a sigh from Indus to the Pole'[2] but not to baulk Montesquieu's too true notion of an Englishman — he says had he been British he had been a merchant — head and shoulders will I shove in mine own secular interest, and beg the favour that if in your ivory researches, you meet with 3 or 4 morsels of very fine ivory, size and proportion not very particular so they be from about 1 inch by 1½ inch up to about 3 inches by 2 inches, you would buy them for me. Some thoughts have concocted and condensed in my mind of what I have seen walking about in midsummer eves and I should not care if I got a few of the subjects on ivory now, to study upon with fresh recollections of similar appearances next midsummer if God spare me; I prefer doing them very small for they are not things by themselves but wings, terraces or outbuildings to the great edifice of the divine human form — otherwise snares. But I have beheld as in the spirit, such nooks, caught such glimpses of the perfumed and enchanted twilight — of natural midsummer, as well as, at some other times of day, other scenes, as passed thro' the intense purifying separating transmuting heat of the soul's infabulous alchymy, would divinely consist with the severe and stately port of the human, as with the moon thron'd among constellations, and varieties of lesser glories, the regal pomp and glistening brilliance and solemn attendance of her starry train. Remembering me kindly to all friends you may see, if you think of it, would you, Sir, do me this kindness in particular to present Mrs Blake with my most affectionate and respectful remembrances;[3] only the having nothing to shew prevented my going to Mr Linnell's when I was last in town. You will perhaps also, giving the same to Mr Frederick Tatham and

[2] Adapting Pope, *Eloisa to Abelard*, line 58.

[3] William Blake had died on 12 August 1827. Frederick Tatham was a friend of Palmer's and a fellow artist; 'Mr and Mrs Tatham' his parents; Mr Waters an early patron of Richmond.

best respects to Mr and Mrs Tatham and Mr Waters if he be there, most adoringly, vehemently and kissingly present my quaint but true knightly devotion to the young ladies One and All, c⌐l-lectively ador'd and individually belov'd — telling them, imp͏ʳ ing them sometimes to think on me (for is it not an honour for fa ladies to think on me, tho it be only to set their pretty mouths a-giggle at the remembrance of my spectacles?) Tell them that herein is my disadvantage — whereas mine eyes are dim save when I look at lady fair — and whereas I can only see their lustre thro' my goggles, those said unlucky goggles so scratch'd and spoil'd that all the fire of the love darting artillery of my eyes is lost upon *them* and redounds not to my advantage, the ladies seeing only two huge misty spheres of light scratch'd and scribbled over like the sun in a fog or dirty dish in a dark pantry, as lustre lacking, as leaden and as lifeless as a lad without a lady. But tell them sometimes to think on me, as I very often think of them, and as in sullen twilight rambles, sweet visions of [their] lovely bright eyes suddenly sparkle round me, [and il]lume my dusky path — double the vigour [of my] pace, rebuild my manhood and renew my y[outh.] You see the perfections of the ladies are unsp[aring] — that is the reason that no sooner do I begin [to] write of *them* than lo! I scribble nonsense — arrant nonsense. Hervey's meditations[4] and the heaths of Fingal and the vapours of the hill of storms.

Ought I to send you such a scribble? but I will send it for the ivories' sake, and to speak my hope that you may have the blessing and presence of the Almighty forever, and that absence has not yet rased from the tables of your memory, dear Sir,

Your affectionate and humble Servant
Samuel Palmer

If you are so kind as to get me the ivories, pray Sir make no hurry but let it be, till you go about materials for yourself and bring the ivorys in your pocket when you do us the favour of a visit, when you will perhaps come in the coat you mention'd. Be pleas'd to present my best respects to Mr and Mrs Richmond. I wish I could add '*and to Mrs Richmond Junr.*'

I must let this note go unpointed uncorrected, with all its

[4] *Meditations and Contemplations* by James Hervey (1714–1758). In *Jerusalem* Blake paid him the compliment of making him a guardian of the gate towards Beulah.

orthographic blunders whether of negligence or ignorance, for if I begin to revise I shall sentence it to the flames very speedily. I am looking for a wife.

GEORGE RICHMOND[1]

Sept. [-Oct.] 1828. Shoreham, Kent.

My dear Sir:

I had not forgotten you, but was silent because I had nothing to say, or send but such good wishes as I hope are always understood. However, as you desired a letter, both on your departure, and again from across the sea, it were churlish to be mute, tho' my head were ever so little in an exporting capacity. But, there *is* one thing I would enjoin, if you cross the Alps, about which, if it had occurred to me sooner, I should have sent you a line, even had you not by your kind soliciting compelled me to a scribble. It is, that from the time you set forward, you punctually devote half an hour every evening to the setting down the prominent circumstances of the day; particularly anything pictorial or intellectual: and that you never miss, thinking to make it up by writing for two or three days at once; for so the task will soon look too formidable and perhaps the journal be discontinued altogether. The characteristic of an ephemeris is slight, vivid sketching from transient occurrences and *first impressions*; not finished periods nor elaborate diction. I should like to know how the Giants of the Sistine Vault strike first upon your soul, in words as near as possible like those you would break forth into on entering the chapel — such words are those you would put down the same evening at your inn; unless indeed, your spirits were rather bound up; and expression itself lock'd in chains of golden rapture; for there are works which wise men admire and fools approve. To be technical, you know that a grand corruscation of sudden light is imitated, either by immediately dashing in the masses on a paper the size of your hand, or by nursing the image in your meditation thro' the slow stages of a picture. Now a traveller's diary is just parallel to the former; — a laboured volume I do not expect you to

[1] This is the longest letter that Palmer is known to have written. The excerpts printed here amount to little more than half of the original.

compose: tho' the daily detail of an artist's pilgrimage to the works of the giants would soon swell into a pretty pamphlet that would amuse his friends at home in the winter evenings, and revive in his own mind as by a magic recall of transpired existence, those precious moments which first brought before his sight the inspirations of the two or three great geniuses of Italy; as Donatello, Da Vinci, Buonaroti: it not being the *number* of pictures that feeds a designer, but he grows most as he eats and drinks with nice, selecting appetite, and draws into a hungry soul of digestive and assimilating function the pure and condensed, insuperfluous aliment of those abstracted, essential, fiery, and eternal conceptions known by few in any age, and embodied, not by the learning of man, but by the wisdom of God. I could wish, also, that you put down a memorandum of any disappointment, whole or partial, from works of which your expectation has been much raised; nor does this imply censure: if you say that you expected more brilliance of colour or force of shade in any man's work than you found; still you assert not whether you expected what was extraneous or inconsistent, or whether *he* omitted or neglected. I suppose, with most young men that go to Rome, you will disagree with me when I suggest that it is not most useful to spend the time in copying one or two pictures elaborately in colours: in a shorter stay how well might you serve the arts in your country by making small drawings for engravings, of a few of the very finest sculptures (not antiques; we have casts enough of them here; good, bad, and indifferent) and of some of the most precious single figures and groups of [them] in the frescoes of the 14th., 15th., and 16., centuries. I fancy myself working intensely hard for a week on grey paper; the quickest way of copying statues; to give my country a true version of the divine St. George of Donatello:[2] the thought of bringing home a true and lively transcript of those intense lineaments, and of only a few other such works, would, if I had extra money, surprise you with a waking vision of me and my round spectacles some evening at Calais, ready, with canvas jacket and trowsers, club and knapsack, to start next morning for the South. By both working hard together for only one month, we might bring home between us a dozen faithful transcripts of true gems of art; which engrav'd with

[2] Now in the Museo Nazionale of Florence.

decent care, would make a drawing book for young students of other kind than the execrable trash with which their first appetite is gorg'd, their taste perverted, their intellectual eyes jaundiced, and their very fingers tortured almost out of the power of drawing a single line or shape of real beauty. But I must not indulge this pleasing dream; rather I must kiss the inoppressive links of lenient penury which tie me to this pleasant valley and to humility, and school and purify the soul; and while they check me in from taking flight over seas and continents yet let me lift up my mind to those altitudes of her own unbounded hemisphere, whence she may serenely muse and contemplate, beyond the waters of the extremest ocean, and last cape and promontory of this transitory world; and far above those noises, of scrambling ambition; wars, tumults, envyings, murders, devastations, gather to the consimilating attraction of her divine regenerative nature such beauty and wisdom, as, fixt by high art, in humility, tribulation, and self-abasement on the canvas or the page may perhaps be heard of even across a continent or an ocean when the hand that work'd is moulder'd, and the eye that saw is blinded in the dust, the spirit then happily beyond the corrupting touch of gold; a base, deject, dirty, and shameful barter for the treasures of the soul; which, only by despising it could attain to do anything truly worthy of their remembrance whose notice is commendation and glory. But how I ramble! believe me, I am in a humble and chasten'd mood; yet will great hopes betray themselves — those trembling hopes which are O how different, how much more self suspicious and apprehensive than the calm assurance of lesser expectations. The high and hoary majesty of the oak wrestles with many a gust and gale that howl innoxious above the training of the wall. Great hopes mount high above the shelter of the probable and the proper; know many a disastrous cross wind and cloud; and are sometimes dazzled and overwhelmed as they approach the sun; sometimes, vext and baffled, they beat about under a swooping pall of confounding darkness; and sometimes struggle in the meshes, or grope under the doleful wings of temptation or despair: but shall escape again and once more sing in the eye of morning thro' Him who is the mightiness of the feeble, and the solace of the broken-hearted. Forgive my spirits; they sometimes haunt the caves of melancholy; ofttimes are bound in the dungeon, ofttimes in the darkness; when the chain is

snapt they rush upward and revel in the temerity of their flight. What I have whisper'd in your ears I should not blaze to vulgar apprehensions: if my aspirations are very high, my depressions are very deep, yet my pinions never loved the middle air; yea I will surrender to be shut up among the dead, or in the prison of the deep, so I may *sometimes* bound upwards; pierce the clouds; and look over the doors of bliss, and behold there 'each blissful deity, How he beneath the thundrous throne doth lie':[3] and I write to one who will know the difference between lofty hope and complacent self-assurance. But hence! this auto-babblery. . . .

There will be some choice as to the way of proceeding Romewards: I should go thro' as many great and ancient cities as I could, and visit as many Cathedrals and convents, for, by continually asking at every church and monastery after pictures, you may light on one or two, shrined up in the recessed twilight of some oratory, or cloister, worth the whole journey. I would ask for pictures everywhere, and see every collection I could get at, however small: sometimes one painting is worth ten galleries. I have seen saloons of noblemen with five or six nominal Raphaels or even Da Vincis, not altogether worth half so much as some single effort of an obscurer name, and in a collection on the whole perhaps much inferior. I would ransack the convents and churches, and get to see some of the Clergy, who, when they know your object will direct you to what you want, and be, much more likely, polite and attentive than most servants or doorkeepers. You may find some exquisite Da Vincis! Then I would wheel back again by a different route; still hunting the pictures with the keen scent of a hound. The great object of an artist in a brief tour is to see pictures, statues, and buildings: — perhaps his second, the beauties of external creation: — afterward, places memorable in history; — universities; — manners, and customs, characteristic of the genius of the nation. — Were two ways indifferent as to the first aim, you would chuse the more beautiful, which, as far as I have tried, is always that running on, or close by a hilly ridge. I find also, that high roads cheat one out of the best scenery though they run thro' the heart of it. You may see glorious things among the Alps and Apennines! If I think on these things I shall catch the fury of wandering, which, however, is useless as I want the

[3] Cf. Milton, 'At a vacation Exercise in the College', lines 35–36.

means: and I will not infringe a penny on the money God has sent me, beyond the interest, but live and study in patience and hope. By God's help I will not sell away His gift of art for money; no, not for fame neither, which is far better. Mr. Linnell tells me that by making studies of the Shoreham scenery I could get a thousand a year directly. Tho' I am making studies for Mr. Linnell, I will, God help me, never be a naturalist by profession.[4] He has been twice to the valley, and is coming again in a day or two. Wherever he is, nothing can be dull or stagnant. He is delighted with the scenery — Rook's Hill — Brasted Chart — Pig and Whistle Valley etc. and says he has seen higher hills but never finer scenes, in Wales or anywhere; and he makes it doubly delightful by his incessant flow of exuberant liveliness ingenuity and wit; interspers'd with hints and reflections of keenest sagacity, and reaching thoughts of the widest span, and highest arc of spiritual wisdom. Our conversation is an entertaining medley not unmix'd with Theology. On art, it is gentle sly hinting, between the *Kemsing Pig Style,*[5] and the *Rustic Shepherd Style* — attacks and defences of cottages; tho' not so fierce and bloody as those of the Belle Alliance or Hougemont.[6] I have not yet opened the campaign against the smooth antiques, but we remain in dreadful silence, not even breathing, ourselves in flying skirmishes. Politics we dabble in: Mr. L. though of no party magnifies the peasants; I, also, as you know, of no party, as I love our fine British peasantry, think best of the old high tories, because I find they gave most liberty to the poor, and were not morose, sullen and bloodthirsty like the whigs, liberty jacks and dissenters; whose cruelty when they reign'd, was as bad as that of the worst times of the worst papists; only more sly and smoothlier varnish'd over with a thin shew of reason. On Theology, and church government, we keep up a perpetual running fight: I am for high church and the less of state expediency and money mix'd up with it the better — my opponents, (for beside Mr. Linnell and my Father, here have been staying some of my anabaptist cousins) parting off severally, to

[4]i.e., an artist content to record exactly what his sight reveals; the opposite, for the young Palmer, of an imaginative painter.
[5]Cf. Palmer's letter to Linnell of September 1824, p. 28.
[6]The battle of Waterloo began in the forest of Hougoumont. Napoleon's centre of operations was a village called Belle Alliance.

the *One Man System:* the Three Man System, viz; one poor sectarian parson wedged between two rich *deacons*: — the *Many Man System,* or the brethren exhorting; and lastly, what I fear is the true end, and inverted climax of free-thinking and dissent, the NO MAN SYSTEM. Also in doctrine we have the Sandemanian or *Believe the Report System:* the modern hypercalvinistic (forgive the jargon) or *Frame and Feeling System*, and *Sweet Hymn System*, an extreme, assimilating in this to its opposite, Wesleyism; and the Quiescent, Converted-contented, Placid or *Cast Iron System*, so christened by Mr. Linnell. One of our party, on being asked his faith, replies — 'Sir, I am a Strict, Calvinistic, Republican Anabaptist'! Another, of a very mild disposition naturally, I ask'd, if he did not think Shoreham Church pretty from where we were looking: — after a pause he replied gloomily — '*Humph — I wish there was not one standing.*' He says 'the Church is Hellish'; he wishes he 'could dig as many holes as there are churches, and bury them in a moment'! Another of the family is more liberal in his notions, and they call him almost a papist. . . .

The wise traveller would endeavour to find the causes, in religion, in government, national habits, popular virtues or vices, education, arts, literature, philosophy and sciences, which brought about the misery or happiness, the glory or degradation of the countries he passes thro': nor would he fail where ever he went, to inquire with lively interest the real condition of the Church of God which He hath purchased with His own blood: its purity or corruption; its increase, or lukewarmness and decay. In the shortest tour, at home or abroad, — in a five minutes' walk, the lover of his brother's soul will know how to say a word of instruction *to him that is weary.* Who, that loveth not his brother will dare pretend to love his God? Who *can* love his brother and refuse to follow the inward motion of the Spirit, which always urges in right season, to allure, or snatch his poor, blind fellow-sinner from the cliff-edge of damnation and despair? But I thank God you know these things and feel them, and, as I believe, are not an unfruitful hearer but a doer of the word; for which God be praised! Who knows but you may say a simple word to some poor fisherman on Calais beach, or to some rich townsman or gentleman (tho' more hopeless) that shall be so sent home by the Convincing Spirit, as to be, under God, the mean of his eternal salvation, and through him, of whole families? — Yea, perhaps

God intends that you are able to do the like *This Moment*, sitting at home, or in your *Next Walk*! I am not for breaking open doors and windows, and howling out *Hell Fire and Damnation* at every innocent dance and merry meeting: the 'Word *in Season*'[7] is often invited by opportunity, and sanction'd by discretion — tho' if it seem otherwise, we must obey the impulse — and, at the moment God is moving your lips to speak, He is opening an ear to hear and converting a heart to understand. Oh! if we lov'd one anothers' souls as we ought to love, methinks our eyes would so run down with rivers of water that we could scarce any more enjoy the shining of the sun: the changing splendour of the seasons would be as an universal blank; the song of the vineyards swell unheard; all the harvests disappear suddenly, as swoop'd into the horrible yawning of the bottomless pit: the whole scope of vision be smear'd with a dreadful confusion of horror; or blacken'd beyond a starless midnight with doleful obsequies of unpardon'd souls. With respect to the objects of travel, tho' you will move too quickly to notice many of them, yet go, Sir, to Italy if you can: perhaps it may be, in a tour; as you know we have found it in a day's excursion; generally more pleasant when done almost at a moment's suggestion. I am sorry, dear Sir, that you labour under such a load of depression. Trust in the Lord, and seek to Him for comfort upon your knees. Let your 'hope surely there be fix'd where true joys are to be found' for 'vain is the help of man'. I have suffer'd O! how bitterly! from a gloomy medium of perception which blacken'd every object and occurrence, and changed the meridian noon to darkness; and I found no help but prayer. Perhaps you may find afterward, that some of your best works were done in entire, humble chasten'd dependence on God, and renunciation of self. 'Heaviness may endure for a night, but joy cometh in the morning.' I have, for several months, been mercifully reliev'd from that overshadowing Horror which was wont to spread its numbing wings over me. It's a long grove indeed which has no light at the end of it. . . .

Farewell! and do for me what I have this moment done for you — intreat God to have mercy on me for Christ's sake; that He

[7] In this passage the phrases within quotation marks are taken or adapted from Proverbs 25:11, the collect for the fourth Sunday after Easter, Psalm 60:11, and Psalm 30:5.

would be pleas'd to sprinkle this vile heart with that infinitely precious blood which is the only hope and last refuge

of Dear Sir

Your guilty but affectionate friend

Samuel Palmer

P.S. Donatello's St. George is in the oratory of St. Michael at Florence.

JOHN LINNELL

December 21st 1828 Shoreham Kent

My dear Sir

I am sorry to tell you that Mr Groombridge's apples of all sorts are gone, and that he does not think any of the kind you had are to be got in Shoreham. I have begun to take off a pretty view of part of the village, and have no doubt but the drawing of choice positions and aspects of external objects is one of the varieties of study requisite to build up an artist, who should be a magnet to all kinds of knowledge: though, at the same time I can't help seeing that the general characteristics of Nature's beauty not only differ from, but are, in some respects, opposed to those of Imaginative Art; and *that*, even in those scenes and appearances where she is loveliest, and most universally pleasing. Nature, with mild, reposing breadths of lawn and hill, shadowy glades and meadows, is sprinkled and showered with a thousand pretty eyes and buds and spires and blossoms, gemm'd with dew, and is clad in living green. Nor must be forgot the mottley clouding, the fine meshes, the aerial tissues that dapple the skies of spring; nor the rolling volumes and piled mountains of light; nor the purple sunset blazon'd with gold; nor the translucent amber. Universal nature wears a lovely gentleness of mild attraction; but the leafy light-ness, the thousand repetitions of little forms, which are part of its own generic perfection; and who would wish them but what they are? — seem hard to be reconciled with the unwinning severity, the awfulness, the ponderous globosity of Art. Milton, by one epithet, draws an oak of the largest girth I ever saw; — 'Pine and *Monumental* Oak':[1] I have just been trying to draw a large one in

[1] Milton, *Il Penseroso*, line 135.

Lullingstone; but the Poet's tree is huger than any in the park: there, the moss, and rifts, and barky furrows, and the mouldering grey, tho' that adds majesty to the lord of forrests; mostly catch the eye before the grasp and grapple of the roots; the muscular belly and shoulders; the twisted sinews. Many of the fine pictures of the 13th, 14th, and two following centuries, which our modern addlepates grin at for Gothick and barbarous, do seem to me, I confess, much deteriorated, by the faces, though exquisitely drawn, looking like portraits, which many of them are; and from the naked form, thwarted with fringes, and belts, and trappings, being generally neglected, or ill expressed, through a habit of disproportioned attention to secondary things, as the stuff and texture of draperies etc. which ended at last in the Dutch school; with this damning difference; that in the fine old works the Heads are always most elaborated; — on the Flemish canvas, the least finished of any part; and yielding to the perfected polish of stewpans and chamber pots: a preference most religiously observ'd by the cleverest disciples of that style at present. An instance of this appear'd in the last exhibition; where was a painting, in which, against the sky and distance, beautiful, intense, and above the Dutch perception, there came a woman's head; hard to tell, whether quite neglected or laboriously muzzed: the least perfect object in the piece; with a careful avoidance of all shape, roundness, and outline. But nature is not like this: I saw a lovely little rustic child this evening, which took my fancy so much, that I long, with tomorrow's light, God sparing me, to make a humble attempt to catch some of its graces: if I can atal succeed, it will be nothing Dutch, or boorish. Temporal Creation, whose beauties are, in their kind, perfect; and made, and adapted by the benevolent Authour to please all eyes, and gladden all hearts — seems to differ from images of the mind, as that beautiful old picture in the last British Gallery (I forget the name; it is that I miscalled Garofalo[2]) differs from the conceptions of the Sistine Chapel or the tombs of the Medici: were both called suddenly into breath, the simple shepherds would, I think, as they ought, modestly withdraw themselves from the stupendous majesty of Buonaroti's 'Night'. So, among our poets, Milton is abstracted and eternal.

[2] Benvenuto Tisi (1481-1559), known as Garofalo. Both his pictures at the British Gallery showed the Holy Family.

That archalchymist, let him but touch a history, yea a dogma of the schools, or a technicality of science, and it becomes poetic gold. Has an old chronicle told, perhaps marred an action? six words from the blind old man revigorate it beyond the living fact; so that we may say the spectators themselves saw only the wrong side of the tapestry. If superior spirits could be fancied to enact a masque of one of the greatest of those events which have transpired upon earth, it would resemble the historical hints, and allusions of our bard. I must be called mad to say it, but I do believe his stanzas will be read in Heaven: and to be yet madder — to foam at the mouth, I will declare my conviction that the St. George of Donatello, the Night of Michelangiolo, and the Supper of Da Vinci are as casts and copies, of which, when their artists had obtained of God to conceive the Idea, an eternal mould was placed above the tenth sphere, beyond changes and decay. Terrestrial Spring showers blossoms and odours in profusion, which at some moments 'Breathe on earth the air of Paradise';[3] indeed sometimes, when the spirits are in Heav'n, earth itself, as in emulation, blooms again into Eden; rivalling those golden fruits which the poet of Eden sheds upon his landscape, having stolen from that country where they grow without peril of frost or drought or blight — 'But not in this soil'.[4] Still the perfection of nature is not the perfection of severest art: they are two things: the former we may liken to an easy charming colloquy of intellectual friends; the latter is 'Imperial Tragedy'. *That*, is graceful humanity; *This*, is Plato's Vision; who, somewhere in untracked regions, primigeneous Unity, above all things holds his head, and bears his forehead among the stars, tremendous to the Gods! If the 'Night' could get up and walk and were to take a swim to the white cliffs; and after the fashion of Shakespear's tragicomic mixtures were amusing herself with a huge bit of broken tobacco-pipe; I think about half a dozen whiffs would blow down the strongest beech and oak at Windsor, and the pipe ashes chance to make a bonfire of the forest!

General nature is wisely and beneficently adapted to refresh the senses and sooth the spirits of general *observers*. We find hundreds in rapture when they get into the fields, who have not the least

[3] Adapting Wordsworth, 'From the Italian of Michael Angelo', line 14.
[4] Milton, *Comus*, line 633.

relish for grand art. General Nature is simple and lovely; but compared with the loftier vision, it is the shrill music of the 'Little herd grooms, Keeping their beasts in the budded-brooms; And crowing in pipes made of green corn',[5] to the sound of the chant and great organ, pealing through dusky aisles, and reverberating in the dome; or the trombone and drums and cymbals of the banner'd march. Every where curious, articulate, perfect, and inimitable of structure, like her own entomology, Nature does yet leave a space for the soul to climb above her steepest summits: as, in her own dominion she swells from the herring to leviathan; from the hodmandod[6] to the elephant, so divine Art piles mountains on her hills, and continents upon those mountains.

However, creation sometimes pours into the spiritual eye the radiance of Heaven: the green mountains that glimmer in a summer gloaming from the dusky yet bloomy East; the moon, opening her golden eye, or walking in brightness among innumerable islands of light, not only thrill the optic nerve, but shed a mild, a grateful an unearthly lustre into the inmost spirits, and seem the interchanging twilight of that peaceful country, where there is no sorrow and no night. After all, I doubt not but there must be the study of this creation, as well as art and vision; tho' I cannot think it other than the veil of heaven, through which her divine features are dimly smiling; the setting of the table before the feast, the tune before the symphony,[7] the prologue of the drama; a dream and antepast[8] and proscenium of eternity. I doubt not, if I had the wisdom to use it rightly (and who can so well instruct me as yourself?) it would prove a helpful handmaid and comate of art, tho' dissimilar; as mercury sympathises with gold, learning with genius, and poetry, with reverence to speak it, with religion. Those glorious round clouds which you paint I do think inimitably, are alone an example how the elements of nature may be transmitted into the pure gold of art: I would give something to get their style of form into the torso of a figure. And I must do my taste, if I have taste, the justice to observe, that I

[5] Spenser, *The Shepherd's Calendar*, 'February', lines 35-6, 40.
[6] A snail.
[7] Palmer actually *wrote* 'the symphony before the tune', and whenever this letter has been quoted the phrase has stood without comment. To me it makes no sense unless it is inverted.
[8] An antepast is a foretaste. I have followed A.H. Palmer's reading, 'dream and antepast', rather than Raymond Lister's 'dream of antepast'.

consider, and have always considered your miniature of Anny, Lisy and Johnny[9] a perfect, pure piece of imaginative art; and I have a pleasing hope that its beautiful living models will some day themselves be poets or intellectual artists. I care not how, or from what a thing is done, but what it is. Parmeggiano's auto-portrait in the Last British Gallery I can't help thinking not only superior to his other works that I have seen, which have been rather composite, but the finest picture of any sort I ever saw; we have only the *copy* of Lionardo's — though I don't know what can go much beyond that. I beg to be understood as not so much positively asserting anything in this half studied scribble on a very difficult subject, which is beyond me, as, for the increase of my knowledge, putting forth a thesis by way of query, that where it is rotten it may be batter'd, thus avoiding to choak the throat of every sentence with *'I humbly conceive I submit with deference'* which had made [these] lines, if possible, more tedious than you will find them. I will not correct them, I overspend that time in talking which should find me doing. To one part of nature I most devoutly subscribe, as perfect beyond compare; I mean the Ladies' eyes 'The vermil tinctured cheek — Love darting eyes and tresses like the morn' O! that I had a pair of such to be my 'Star of Arcady and Tyrian cynosure':[10] a nice tight armful of a spirited young lady, a hearty lover, who would read to me when my eyes were tired, sooth me if vexed, enliven me when sullen; patch my old clothes, and lie on a mattrass, for I understand a feather bed costs 14 guineas, and therefore is not my lot. Also a little thatch'd parsonage and a little quiet, simple evangelical flock in a primitive village where none of the King-choppers had set up business 'The good old Puritans, those Saints' as *Mister Poet Greene*[11] calls them. By the by, how could the King of Arragon in making his exceptions to life's vanity, forget to crown the 'Old wood to burn' the 'Old wine to drink' the 'Old books to read', and the 'Old friends to converse with',[12] with the *Young Wife* to kiss and be kiss'd by: on whose breast to lay a head aching with study, into whose heart to pour our joys, doubled by imparting; in whose love to forget all

[9] Three of Linnell's children. Anny (Hannah) would become Palmer's wife.
[10] *Comus*, lines 752-3 and 341-2.
[11] The playwright Robert Greene (?1558-1592), author of *The Comical History of Alphonsus, King of Aragon*.
[12] Bacon, *Apothegms*, No. 97.

sorrows and disquietudes? You *have* such a wife — I, only in feeble imagination; but in this instance Give me Natural Fact, say I, and I care not how speedily. Poor Alphonso at last when deposed by his own son had less reason than most men to remember his marriage with satisfaction. From what I have always heard as well as from your excellent remarks I think most excisemen are likely to be demoralised, but the young man has been a good deal straightened and was eager for some settlement; so I promised to ask.[13] Mr. Richmond in a letter from Calais asks me very anxiously about your health, he heard from his Father that you were worse. He says, from inquiry, two might go to Rome and stay 6 months for ninety pounds between them. Is this credible? I should like to hunt out some gems, like the St. George if I could go, and bring them home on gray paper, especially such works as we have no good engravings of. If at any time you feel the cacoethes scribendi[14] come upon you I wish you would favour me with your opinion how, should I go Romewards, my time might be most profitably spent there; I have no prospect of travelling yet, but some time or other, God willing, most certainly shall, and wish to get together all kinds of information on the subject. My Father begs to present best respects. With best respects to Mrs. Linnell, and love to the little ancients

<div align="right">

I remain Dear Sir
Your obliged affectionate Servant
Samuel Palmer

</div>

P.S. I should not have delayed telling you about the apples, had I not known that Mr. Tooth's failure would inform you there were none to be had. I have just finished another attempt at a portrait on grey board, in colours. I took pains, and it is a likeness — but whether tolerably executed or not I cannot tell — I am desperately resolved to try what can be got by drawing from nature. I think the pictures at our exhibitions seem almost as unlike nature as they are unlike fine Art. I am going also to try a little child's head — if anything would please me in the copying it is children's heads.

[13] Palmer had been asked to help an acquaintance find a job as an exciseman, and he had requested Linnell's advice.
[14] 'An itch for writing' — from Juvenal, *Satires*, VII. 52.

JOHN LINNELL

Saturday [17] May 1829 Shoreham Kent

My Dear Sir

Pray accept my thanks for the trouble you have taken in getting me the colours: they arrived quite safely. I have not been to town since you saw me; but in a few days, when I have finish'd a bothering little job of a likeness, shall come and have a look at the Exhibition;[1] and, I hope, have the pleasure of your company back to Shoreham: — nothing but such a pleasure has been wanting to perfect my delight at the glory of the season. Tho' living in the country I really did not think there were those splendours in visible creation which I have lately seen.

The ways of the Royal Academy are to me unaccountable — not that it is unaccountable they should reject six of my drawings; but that they should hang those two which I thought far least likely. I expected they would reject the '*Whole Kit and Bailing*' as they have for these two years, and intended with the patience of an ox to prepare eight colour'd pictures for their rejection next season — and if *they* were refused, a like dose on the year succeeding. As they condescended to receive any, I wonder they did not prefer the nature sketches and perhaps two little moonshines in which I think there was more look of light than I have got before; and less of my wonted outrageousness than in the Ruth or Deluge. I will immediately inquire about horses and asses — there are plenty of *brutes* in Shoreham, but no asses that I know of except myself — and *I* don't answer the description — for I cannot say that I am yet *able* to *Draw*, tho' certainly most Willing. The artists have at last an opportunity of wearing the beard unmolested; I understand from the papers that it is become the height of the fashion! I hope they will avail of this. I wonder whether anybody in London has got a real bit or two of Mike's[2] drawing, in the Leda style — her brawn was the richest treat I ever had — I devour'd as much as I could hold with prodigious gust and tho' I have not yet quite digested it, am on the look out for some more. The chastity of most of the Antique is too mild and

[1] The Royal Academy, which had accepted his drawings *Ruth returned from the gleaning* and *The Deluge*.
[2] i.e., Michelangelo!

44

pure for my gross appetite to relish thoroughly — I dare say people have a very refin'd pleasure in a boild chicken, but give me the *'rich experience'* of a roasted goose, which is to chicken what Mike is to the antique for all gentlemen of fine taste unite in asserting that Buonaroti was but a goose to the Ancients.[3]

With best respects to Mrs. Linnell and love to the children. I remain Dear Sir

Your obliged and affectionate Servant
Samuel Palmer

GEORGE RICHMOND

Friday September 21st. 1832. [Shoreham]
Please to excuse great haste and a wafer instead of a seal

My dear Sir

Pray do not fail if you see Mr Knyvett[1] to tell him how sincerely and exceedingly I am obliged to him for his kind remembrance of me. I will be in town on Monday or Tuesday at farthest and in the mean time if there is a desire to see some things of mine my Father will be so kind as to get my blacks which were in the exhibition conveyed to Miss Sawkins. I have been working very hard at art which I now love more than ever, and recreating myself with good books: Sir T. Browne's Christian Morals and the life of holy Bishop Fisher,[2] of which the first is a little casket of wisdom and the second a most comfortable and blessed cordial in this cold heartless and Godless age. I mean to get a print of the venerable Fisher and one of his friend and fellow martyr S[r]. T. More and hang them cheek by jowl in my little chapel, that they may frown vice levity and infidelity out of my house and out of my heart. I have greatly desired to see your little daughter[3] and

[3]Cf. Palmer's annotations to Richard Payne Knight's *Analytical Inquiry into the Principles of Taste*, p. 129.

[1]William Knyvett (1779-1856), musician. 'The exhibition' is that at the Royal Academy, where Palmer showed seven works in 1832. 'Miss Sawkins' is unidentified.

[2] *The Life and death of John Fisher, Bishop of Rochester* (written c.1559) by Richard Hall.

[3]Harriet Ann (August 1832 – July 1835), the Richmonds' first child.

indeed have already loved her though unseen, and while so many children, innocent and beautiful at first, lose daily as they grow up the similitude of their divine parentage, and become weeds and thistles instead of olive branches in the church, what if by the hearty prayers of her parents and friends your child should be like St. John the Baptist filled with the Holy Ghost even from her mother's womb, and like Samuel the prophet minister while yet very young in the temple of the Lord? Yet such glorious things can earnest prayer accomplish! Nothing is beyond its power.

How is the situation of a Christian changed in becoming a parent! an immortal soul placed under his control and guidance for eternity — and that at his immediate responsibility! all sanctimonious whiting and coating apart, it really is a most awful thing — and so indeed is everything influencing the salvation or damnation of a soul. It has now I know become quite unfashionable and unbearable to talk of Hell even in the pulpit but none will fully enjoy the comforts and peace who do not know also the terrors of the Lord, the plague of their own heart and the deadly evil of sin. If people knew how deeply the whole world lieth in wickedness, and how totally it is estranged and set in opposition against God; they would I cannot help thinking, no longer wonder why all kinds of sects and schisms may not equally be term'd the churches of Christ — and think the robe of true Church too mean and narrow without tacking upon it the abominable vestments of Quakerism, Socinianism[4] — yea the church of Mahomet, to swell it to the dimensions of modern Charity but would gladly press into the sanctuary of the Apostolick Church for refuge from the wrath of God and lay fast hold of the horns of her altars. Once I was full of this lightness and folly — yea even to the present time my old Adam can see no reason why the sleek and sober Quaker or the meek and moral Unitarian should be beholden to the Church, claiming the power of the keys of the kingdom of Heaven — But blessed be God. I am changed even since you saw me — I am a freethinker in art in literature in music in poetry — but as I read of but one way to Heaven and that

[4] A sect similar to modern Unitarianism, which denied the divinity of Jesus. A few months after sending this letter, Palmer wrote *An Address to the Electors of West Kent*, in which his Anglican fervour assumed an extraordinary political tone (cf. pp. 145–7).

a narrow one it is not for me to chuse which way I will be saved and make it a pretty speculation or matter of taste, and run to seek my Saviour in holes and corners, but go at once where He is ever to be found, at the Apostolick altar of the Melchisedekian priesthood.[5] Elsewhere; whatever the *uncovenanted mercies* of God may be, we have no ratified charter, no sealed covenant of salvation — at that glorious altar, that Holy of Holies within the rent veil, may our friend Mr. Arthur Tatham[6] (Whose promotion in the Church I much rejoice to hear of) long live to minister oblations of acceptable praise to God, and good gifts to men, and in the fiery trial which is coming to prove and purify the Church, may he be never daunted or dismayed, but live through it and come forth as gold, or die in it and obtain a glorious and eternal crown of martyrdom.

> I remain in great haste Dear Sir
> Yours most affectionately
> *S. Palmer*

GEORGE RICHMOND

Thursday 16th. Oct[r]. 1834. Shoreham Kent

My dear Sir,
 I received your kind and welcome letter the next morning after I have scribbled the foregoing and though I believe our old friendship can subsist very long without fresh nourishment yet you afforded it a very pleasant and nutritive meal and I took it the kinder as you sent it me from the abodes of the great, among so many alluring and attractive objects where the simple and the poor are very apt to be forgotten or despised, but be assured that were there no other ties — and there are very many that bind me to you — beside the kindness and sympathy of yourself and Mrs. Richmond; when crossed in love I was a nuisance to others and to myself — that alone would be sufficient to fix you both in my heart which would want a very rough jerk to tumble you out of it.

[5] In Genesis 14:18 Melchizedek is both 'king of Salem' and 'priest of the most high God'.
[6] Arthur Tatham (1809-1874) was an Ancient who ascended to Cambridge and the priesthood.

With respect to the studious lamp it is just what I wish and hoping to be much more beforehand than usual with my exhibition subjects shall be able [to] clean up my palette by dark and devote if I live the winter evenings to the figure — I should like to tackle two or three very fine hands and feet and to dissect an arm — first finishing the old bust if ever we can manage to get it quite in the right height and position again. I thirst vehemently for your legend of the Rhine and hope to hear it elaborately wiredrawn over six large bowls of Hyson[1] which I am glad to hear you have not learned to despise as I feared. Mr. Calvert[2] told me something about the skies there, which has set me all agape. If you were only to put down in your memorandum book the names of places at which you arrived each day before you forget them, it might help you to keep in mind some of the minutiae which may perhaps slip the memory and I should like to hear an eight hours' description at least. I would not have been without the Devonshire reminiscences[3] on any account — I hardly ever try to invent landscape without thinking of them. You may go for five shillings now by the steamboat to Plymouth, close to the cluster of little rivers, that fall from Dartmoor and see the wonderful Titian etc. — not as a deck passenger as I heard before — but lie on a sofa in the cabin and vomit quite genteelly! I long to see some firstrate distances — and hope you have brought a line or two of some of the quaint rocky or wooded summits of the Rhine. I believe in my very heart (but the heart's a great liar tho' it's the truest part about us) that all the very finest original pictures and the topping things in nature have a certain quaintness by which they partly affect us — not the quaintness of bungling — the queer doing of a common thought — but a curiousness in their beauty — a salt on their tails by which the imagination catches hold on them while the sublime eagles and big birds of the French academy fly up far beyond the sphere of our affections — One of the very deepest sayings I have met with in Ld. Bacon seems to me to be 'There is no excellent beauty

[1] A kind of green tea. I have omitted the second half of this letter and its postscript, which discuss cider at length.

[2] Edward Calvert (1799-1883), artist and close friend of Palmer.

[3] Palmer may well have visited Devon earlier in the year, though he may also have been retelling descriptions given him by Calvert, who came from the West Country, or by the Richmonds, who visited Devon in 1832. By the 'wonderful Titian' Palmer means *Ariadne*, at Saltram House near Plymouth.

without some strangeness in the proportion'.[4] The sleeping Mercury in the British Museum has this hard-to-be-defined but most delicious quality to perfection so have the best antique jems and bas reliefs and statues — so have *not* the Elgin Marbles graceful as they are but it is continually flashing out in nature and in nothing more than in the beamings of beautiful countenances. But I begin now to be quite humbled and to speak of all things as modestly as an impudent man can speak. Every day convinces me with wise and good Dr. Johnson that this life is a state in which 'much is to be done and little to be known'[5] — and what is known is apprehended by doing — and whatever *is* done is wrung out of idle fallen wretched man by necessity immediate or foreseen — and what is done at leisure is done wrong and whatever is done best, is done when there is hardly time given to do it in — talk of putting thistles under donkey's tails to make them go! why *man* imperial Man unless he sits upon thorns will sit still forever. Dr. Johnson would scarce have written anything if he had not been hard driven by want — and as to Milton he had plenty of other business which he was obliged to attend to and most likely came to poetry etc. as a relaxation — and as to artists who paint to please themselves — perhaps they would get thro' ten times as much work and improve thirtyfold — if they were forced to sit half a day behind a desk in the custom house. Happy the artist who has half his time bespoke in commissions, and half to paint what he loves — I intend if I live to keep the lower Port Royal[6] cell neat all the winter and work upstairs and perhaps knock down the partition — and carefully exclude every inch of prospect from the window as I purpose never again to see London again by daylight when I can help it — though I would gladly visit the great national dust hole once more if it were only to enjoy the grand Rhinish tea festival: and at that celestial assembly Mrs. Richmond our fair Hebe will want every particle of her present health and spirits to bear the task of dealing about bowl after bowl of the Oriental Nectar to the Gothic Mythology which will surround her. I am very glad to hear of poor Bolls's improvement, and of the Chevalier

[4] Adapted from Bacon's essay *Of Beauty*. What Palmer calls 'The sleeping Mercury' is actually a Graeco-Roman statue of Endymion asleep.

[5] *Prayers and meditations against inquisitive and perplexing thoughts.*

[6] A Cistercian convent near Paris, the centre of Jansenism in the seventeenth century.

New-come[7] whose melodies when agitated by the poetic fury are I dare say become by this time remarkably sonorous. You shall see my body as soon as I come to town — but as to my poor mind I have been vegetating so long in solitude that I hardly know whether I've any left. . . .

<div align="right">

I remain My dear Sir
Yours most affectionately
Samuel Palmer

</div>

GEORGE RICHMOND

Tintern[1] very deep Twilight Wednesday August 19th 1835. The address for letter is to us at Mr. William Hiscock's — Black Lion, Tintern Abbey, Monmouthshire

My dear Sir

Our Ossian Sublimities are ended — and with a little more of McPhersons[2] mist and vapour we should have had much more successful sketching — but unfortunately when we were near Snowdon we had white light days on which we could count the stubbs and stones some miles off — we had just a glimpse or two one day thro' the chasms of stormy cloud which was sublime — however we have this evening got into a nook for which I would give all the Welch mountains, grand as they are, and if you and Mrs. Richmond could but spare a *week* you might see Tintern and be back again. The Bristol Stages start daily the fare I believe is low and there is a steam boat daily thence (only three hours' passage) to Chepstow, within 6 miles I think of the Abbey — and such an Abbey! the lightest Gothic — trellised with ivy and rising from a wilderness of orchards — and set like a gem amongst the folding of woody hills — hard by I saw a man this evening

[7] 'Bolls' was the sickly child Harriet Richmond; 'Chevalier New-come', her brother Thomas (1833-1901).

[1] Palmer was on his way back to London from a sketching tour of north Wales, made with his friends and fellow artists Henry Walter (1799-1849) and Edward Calvert.

[2] James Macpherson (1736-1796), 'translator' of the Gaelic poet Ossian.

literally 'sitting under his own fig tree'[3] whose broad leaves mixed with holyoaks and other rustic garden flowers embower'd his porch. Do pray come — we have a lodging with very nice people under the walls and three centuries ago might have been lulled with Gregorian Vespers and waked by the Complin to sleep again more sweetly — but the murderer of More and Fisher has reduced it to the silence of a Friends' meeting house. Mr. Walter was shown the inside and says it is superb. After my pastoral has had a month's stretching into epic I feel here a most grateful relaxation and am become once more a pure quaint crinkle-crankle goth — If you are a Goth come hither, if you're a pure Greek take a cab and make a sketch of St. Paul's Covent Garden before Breakfast. Addison speaks of the Cathedral of Sienna (one of the richest in the world) as the work of barbarians — clever savages almost — what a 'Spectator' — he could not bear too *lofty* and *pointed* a style — pity he died before the aera of Doric ware-houses Ionic turnpike gates and Corinthian ginshops! — his taste outran his age — ours hobbles after —

Thursday Evening. Poetic vapours have subsided and the sad realities of life blot the field of vision — the burthen of the theme is a heavy one I have not cash enough to carry me to London — O miserable poverty! how it wipes off the bloom from everything around me. Had I conceived how much it would cost I would as soon have started for the United States as Wales — but I have worked hard[4] — seen grand novelties and enlarged the materials of imagination — if I could but sell a picture or clean another Opie[5] or two or — but I am all in the dumps 'shut up and cannot come forth'[6] and feel as if I alone of all mankind were fated to get no bread by the sweat of my brow — to 'toil in the fire for very vanity' — If you've a mangy cat to drown christen it 'Palmer' — If you could oblige me by the farther loan of three pounds my Father will repay you I dare say if you can call at Grove St. — but I shall very soon be in town myself only — I want enough both to

[3] Adapted from Micah 4:4. Cf. Palmer's drawing *A House and Garden at Tintern* (Plate IV).
[4] A.H. Palmer and Geoffrey Grigson: 'I have worked hard.' Raymond Lister: 'I have not worked hard.'
[5] John Opie (1761-1807). Presumably Palmer had cleaned canvases to earn some money.
[6] Psalm 88:8.

bring me home and enable me to stay a little longer in case I should find subjects which it would be short-sighted policy not to secure — but I hope not to spend so much — If the Movement Party want a professor of drawing in the Marylebone Charity Schools pray canvas for me.[7] Things are come to a crisis now and I must begin to earn money immediately or get embarrassed — horrid prospect — the anxieties of debt on the back of the perturbations of aspiring studies. The refuge I know is in Faith and Prayer — but is daily bread promised to those who overspend their income — which I am afraid is now my case — however I was deceived by the strange misstatements about cheap living in Wales — otherwise my muse should have donkeyfied upon thistles from Husky Hampstead this summer — with a log at her leg. Well! I must come to London sell my pianoforte and all my nice old books — and paint the sun, moon and seven stars upon a sign board I suppose — would I could get it to do! I find I am writing strange stuff and boring you with my own selfish troubles so I'll have done. If you can favor me with the three pounds would you have the farther kindness to send it as soon as possible and with a very full and legible direction on the letter — what if it should miscarry! I must stay at Tintern and go to plough — could you send by return of post? The candle is going out as did the light of my mind some hours ago, so I must wish you miserably good night.

Mr. Walter desires me to give his love and say that he wishes to return directly but not having the means would be obliged if you would make it up a Five Pound Note — I will pay the postage of this when I see you — With kindest love to Mrs. Richmond and such old friends as you may happen to see I remain

<div style="text-align:right">

My Dear Sir
Your affectionate friend
Samuel Palmer

</div>

[7] Self-mocking; a charity school would be unlikely to teach fine art, let alone want a 'professor'.

GEORGE and JULIA RICHMOND

[June 1836]

At Mrs. John Davies's Coach and Horses
Conway North Wales[1]

My dear Mr. and Mrs. Richmond

It is the 'witching' and the soothing time of night, when the traveller's remembrance turns to those he loves. All is solitude and utter stillness, except the fall of a mountain stream, and the ticking of a clock: and to such an accompaniment the heart may utter its full music. Mine, however, you will call a cracked fiddle, not hav[ing] heard from me yet; but a real cremona it still is, I assure you, in matters of love and friendship — though my artistical part, my poor mind, in the process of excentricity-cleaning Nature should serve as the housemaid did her master's violin one morning — scrub off the tone of a century, and so fetch a pot lid out of the shield of Scriblerus.[2] My sufferings are like those of the 'Friends'[3] — 'considerable'. I am walked and scorched to death, and have then to make living pictures of dead nature. I regale on heating eggs and horny ham; the stove within me rages, having fuel from within and without; consuming all vain partiality for socks and shirts, of which last I convince the good people that I have one to my back by leaving it in my bed room. To get the means however of obtaining some new ones should I take to wearing these out I must be up betimes in the morning, and so wish you both good night.

Evening 2nd. — I have just received a letter which has put me into good spirits.[4] O what gracious people you married ones ought to be! — Youthful passions at rest — mutual good example and most sage counsel — participation of prosperity — sympathy

[1] In 1836 Palmer returned to Wales with Calvert on a sketching-trip. This letter survives in three versions: a rough draft, a fair copy which seems never to have been posted, and the letter (printed here) which the Richmonds eventually received.

[2] Cf. *Memoirs of Martinus Scriblerus*, probably by John Arbuthnot (1741). In Chapter III a maid cleans away all the rust thanks to which a modern shield had been pronounced an ancient treasure.

[3] i.e., the Quakers, for whom Palmer had little regard.

[4] He makes it clear in the draft that the letter came from Hannah Linnell (1818-1893), with whom he had fallen in love.

in adversity, and sugar'd-sweet tempers. And then, the 'dear pledges'[5] — 'Good night dear Papa!' 'Good night dear Mamma!' — just before they cuff and scratch the nursery-maid all the way up stairs, and kick over the basin as she washes them. 'Speak! ye whom the sudden tear surprises oft.'[6] As Mr. Calvert and I walked through a romantic dell we saw a very young Welsh Girl of more than ordinary beauty, and loveliness of expression — her features were softened with that delicate shade of pensiveness etc. etc. — She timidly approached, and offered, I think for sale, a large winged beetle not yet impaled on a pin, but girt with pack thread: it was taken away from her and let fly to her astonishment. O for a safe passage to that World where undivorced beauty shall ever be the form and index of goodness — O for a heart with none of the girl and beetle in it though perhaps she knew no harm — and the best men will only glance at the evil — except of their own hearts — but study and contemplate what is good. Yet we are of a bad stock after all — we went astray from the cradle, speaking lies — killing flies at church, and came home telling where the text was. See therefore the worst of your children as they grow up, be yourselves not the censors but the caterers of their pleasures. While it is their pleasure to romp, romp with them; and whip them for vice and disobedience. I am glad when I think of your children — dear friends of mine I hope some day — to know that you both have the good sense to despise the super Bible, super Solomon, stupid, twaddling sentimentality — the French Revolution philanthropy which would disuse the Rod. I agree with you that continual beating is barbarous and ought to be bestowed on the parents themselves who have managed clumsily enough to find it needful: — but depend upon it, fear, of one kind or other, as well as hope is necessary to move either adults or babes to effective wisdom and goodness. With sunshine before, and a thunder cloud behind, we make way. I believe the dread of ultimate bodily correction is the only real bugbear to children — while on the other hand a thousand are the pleasures and holidays which may be made for them; nay, by great skill, even their learning may be given them in sugar — The right hand may shower indulgence if the left hand hold the rod — but the parents

[5] i.e., children; perhaps adapting a phrase from Robert Herrick's 'Blossoms'.
[6] Adapting *Spring* by James Thomson, lines 1157-8.

who will not correct their children always become their slaves or
their dupes. And now that I am hortatory I hope you Sir take care
to cater for yourself after your professional labours a soothing
evening: something to look forward to through the day — and
you Madam take a basket and go to market and buy a skipping
rope and be jocund and don't think of the 'thirty one'.[7] It is a good
while since I tried my hand at a bit of twilight poetry; — but here
goes —

EVENING. 'Then Evening comes at last, serene and mild' —
Thomson.[8]
　　　　Dedicated to George Richmond Esqre.

When each has been working all day like a horse,
And Master looks crusty, and Mistress looks cross;
He combing his mind, and she knitting her stockings;
The door beat with craftsmen and carpenters' knockings,
And the maids in and out, and the candles want snuffing,
And Babbington's come from his errands all puffing: —
Then vow you'll not stand it; but get out your Handel;
And a kind friend will call in and give you some scandal:
When gone, get your Jebb and your Knoxy so deep,
And quiet at last, — you will fall fast asleep.
Then Mistress will pinch you, and say 'At least when
Mister Palmer's not here, you might chain up at ten:
And *I* know some persons who'd beg him to go
At half after nine, let him like it or no!'
You rise, with a yawn that would swallow an ox;
And leisurely lengthen the latches and locks:
When Hark! — A low tapping at which your heart fails
'You're the first friend I've called on since come
　　from North Wales'
Then some Art, and some gossip, and free will and fate
Will sweetly refresh you for 'sitters at eight'.

Evening 3rd. I hope you have secured the proposed Saturday
for favorite studies: I think it would improve your health and

[7] Perhaps alluding to Palmer's own age.
[8] Thomson, *Spring*, line 1170. *Evening* is Palmer's only surviving poem in
jocular vein. 'Babbington' is unidentified; 'your Jebb and your Knoxy' refers to
Thirty Years' Correspondence between Bishop Jebb and Alexander Knox, one of the
less exciting publications of 1834.

spirits, beside the intellectual solace and profit. How many blessings does the future promise! How do the present and the past belie it. How beautifully and usefully may the hours of the day be parcelled out, even in a moderate and sober plan of life: but an allowance must be made for accidents and ugly etceteras. However, if the leading points of a good scheme be generally secured, it will be more than one in a thousand is able to accomplish; so few have any plan atal, or see the two or three leading advantages which are worth securing at almost any cost. How does all animate and inanimate creation, all the range of high arts and exquisite sciences proclaim the immortality of the soul by exciting — as they were intended to excite — large longings after wisdom and blessedness which three score or three hundred years would be too short to realize. We are the chrysalis dreaming of its wings! The simplest division of our time seems to me to be into a portion first for Religion, and its fruit active benevolence: next for business: thirdly for bodily exercise; and lastly for soothing intellectual recreation. It would be well if Christians in easy circumstances divided the poor of the neighbourhood among them, and had each a little circle of sick and indigent to visit by turns; say one every day. This with other walking might be done in an hour, and would secure the arrangement for bodily exercise. There are visiting societies, I believe, belonging to some of our churches, which enter the lowest haunts of wretchedness: — but there is many a fine modern Christian who would have stopped his nose at poor Lazarus. Combination will do very much at the expense of very little individual labour. I am inclined to think that the happiest hours of many people are those in which they work at their calling: and if recreation itself were something both useful and necessary, and not a mere hulling about, and kicking of one's shins, it would be much more effectual recreation than it usually is. I should think the amusements of Sir Thomas More and his family were, beside bodily exercise, little other than changes from the severe to the elegant studies, or still more lovely charities. O! blessed biography which hast embalmed a few of the graces of so many great and good people! Perhaps to those who are in earnest for improvement no literature is so useful. Principles and precepts are the grammar of morality — example is its eloquence. Though I have often talked of the importance of quiet intellectual evenings to those who are fagged in the day, and though I think them a

delicious and never-cloying luxury, yet I do not mean that we should make pleasure of any sort the aim of life: on the contrary, as things are so constituted that every little self denial and agonizing brings after it 'a sacred and home-felt delight',[9] so, on the large scale, our whole earthly existence ought to be a short agony to secure eternal blessedness. But as in a long sultry walk we choose out shady places now and then, to sit down in, so I think none will agonize so effectually as those who take the mental bath and balsam of a little daily leisure. Blessed thoughts and visions haunt the stillness and twilight of the soul; and one of the great arts of life is the manufacturing of this stillness. The middle station of life, where more is demanded to be done than there are hands enough quietly to do, almost forbids it; and the rooms of our houses are so crowded together that we less enjoy life than listen to the noise of its machinery. It is like living in a great Mill where no one can hear himself speak. So I think the fewer wheels the better — but what matters how I think — who am mad on this subject? — Mad I mean to be till I get more light, and wherever I find it will turn to it like the sunflower. For obstinate though I may have been in trifles — much to my shame — I am not stubborn about greater matters, but like a little babe crying out for food — for which I expect kicks and buffets. However I am prepared; and with a body and mind pretty well adapted, so far as that is concerned, to get through life with — oil outside, and adamant within: but I hope less and less oil of vitriol every day of my life.

I have not seen a paper, but suppose things are going on as they have been for some time: occasional reform of real abuses, accompanied, as good and evil always tangle together in this world, with a gradual demolition of institutions which Englishmen ought to hold sacred. Jews, Turks, Infidels, and Heretics have broken down the walls of bigotry, and I suppose will soon be throwing the stones at each other. In the mean time, as long as the still small voice of friendship can be heard — with kind love to Mr. Walter believe me Dear Mr. and Mrs. Richmond

<div align="right">ever your affectionate Friend,

Samuel Palmer</div>

Though I should delight to hear from you I know your time is so occupied that I ought scarcely to expect it, but if an opportunity

[9] Milton, *Comus*, line 262.

offers a letter put into the post not later than two days after you get this will find me

at Mr John Davies's
Coach and Horses
Conway
North Wales.

I have been hindered altogether about three weeks by rain but I hope the weather is now more settled.

JOHN LINNELL

22nd December 1837 [Rome[1]]

My dear Sir —

Italy — especially Rome, is quite a new world — the magnitude of the buildings; the decorations of the churches — the processions of monks the teams of bas-relief-like oxen — the statues in the open air; the antique ruins — and above all, the glorious sunshine which is worth coming the distance to see — leave only to be wished the English friends and fireside with a register stove, which last we should be much more likely to worship than relics or images — I have often sighed and shivered for it. I have not yet seen a twentieth part of Rome — as I do not go out sight-seeing but examine any church or temple which presents itself — going or returning from some place at which I am working — otherwise no work could be got through with here. With respect to art — two things impress me — one, the exquisite adaptation of objects and climate to a painter — the other — the blessedness of those who paint easel pictures instead of walls — for Raffaelle's frescoes are on dark walls and ceilings — fit only for the employment of a fifth rate painter and in all the churches and the few galleries I have

[1] Palmer married Hannah Linnell on 30 September 1837, and they left England three days later in the company of George and Julia Richmond and their son Thomas. The group travelled through Paris, Milan and Florence (cf. Palmer's letter to the Giles family, pp. 74–82), reaching Rome in mid-November. Initially they planned to return to England within a year. The trip had been made possible by Richmond's loan to Palmer of £300.

In reading the letters from Italy, it should be borne in mind that neither the Linnells nor Palmer had previously left Britain.

seen the very spirit of perverseness seems to have dictated the placing of works of art. The remains of the last supper at Milan[2] are in the most dismal hall I ever saw and half overshadowed — the Louvre has only one picture room well lighted and in the Florence Gallery for want of sloping the pictures two inches forward at the top it is sometimes impossible to get out of the glare of the varnish. I am also inclined (contrary to the usual report) to believe that oil painting is more permanent than frescoes, for all the frescoes I have seen are injured and seem to be fast decaying while oil pictures of the same age are in perfect preservation. At the same time the Vatican frescoes have been injured in other ways than by time. They are wonderful works. We think it best to get — as you advised — tracings of the whole pictures on a small scale rather than copies of bits — so as to obtain something of the effect and color of the whole — and I think nothing of the kind is at present in England.

I am very sorry to hear that my house is not yet let out[3] — as I thought I might reasonably expect it would — it will make a great difference to us — but I am most heartily glad we came as this is a profusion of interesting improving and beautiful matter for the landscape painter and subjects which being full of *historical* interest will I think fully repay our expenses. As our house is not yet let — do you think anything could be done with some of the most finished of my Welsh Drawings. I think the Chudleigh Rocks, Carnarvon Castle, or some of the best waterfalls might be bought by some of the water color collectors if they saw them; but however that may be, or however the house may go, I never was more convinced that we have taken a right step, and from which great benefit will accrue though the house intelligence has put me a little out of spirits. Lady Torrens is not yet in Rome.[4] We have seen Mr Williams who has been very kind and useful to us. My anticipations of happiness in Anny's society have been most

[2] The fresco by Leonardo da Vinci at the refectory of Santa Maria della Grazie.

[3] Linnell was responsible for Palmer's business affairs while Palmer was abroad, including the sale of his art and the rental of his house. The Palmers, meanwhile, would devote months of effort to copying pictures and colouring prints for Linnell.

[4] Lady Torrens was a Scottish friend of Linnell, who had painted a delightful portrait of her family. Penry Williams (?1800–1887) was a Welsh painter who lived in Italy.

fully realized and every day I think brings an increase of affection, without exception or alloy. If I can but fight the battle of Art and the battle of life as I hope to be enabled to do I shall have my hearts content. If we can but bring back improvement and a huge cargo of drawings — how happily shall we sit down by our little fire side in Grove Street and I hope to come over to Bayswater as much as ever — for now that I can bring Anny with me and take her away again, I shall feel so much happier than when obliged to leave her behind me. Anny is exactly the wife I wanted. I am rejoiced that you will write to *me* next time and shall much value any hints or advice that may suggest themselves. I have yet got no commissions but Mr Richmond has mentioned me to Sir Henry Russell who started for Naples just as we [arrived] at Rome.[5] But I think — in such a country whether I get commissions or not it must still be the best thing for my future interests — though they would of course be welcome enough. I am my dear Sir

<div align="right">

Yours affectionately

S. Palmer

</div>

MARY ANN and ELIZABETH LINNELL

21 February 1838 [Rome]

Dear Mrs Linnell[1] —

I am delighted when I think how happy you must be to receive from time to time such good reports of Anny, and no efforts of mine shall be wanting to support her in comfort, if industry and intense study will do it — and to comfort and cherish her as you would do if you were with her. Her affection for all whom she has left has not in the least abated with her daily increasing happiness here and if you could find time to write her a long letter it would be a great treat — she keeps your letters always by her and would cry if one of them were lost. Though I am at present without

[5] A baronet (1783-1852). Richmond proved successful in gaining lucrative commissions from the many wealthy Englishmen in Italy; Palmer did not.

[1] Mary Ann Linnell (1796-1865) had been opposed to the idea of her daughter travelling on the continent.

commissions in Rome yet when I see how very indifferent artists manage to get on and spend three times as much as we do both together — I cannot help thinking that encouragement will ere long shine upon us. I heard with surprise the other day that Mr. Linton[2] gave a grand party and had a line of carriages at his door and therefore I think it is not too much to hope that Divine Providence will give to the united exertions of the two wanderers at least their daily bread. I do not yet see how, but that does not in the least abate the spring and vigour of our exertions — as I find the climate agrees with me, and only increase my appetite, good spirits and clearness of thought so that I fancy I see my way in art plainly before me. I am, as Mr Linnell advises me to be, of good cheer — and am very much encouraged by what he said in the last letter but one — encouraged to work harder than ever. Anny is most industrious, and we work without intermission. We have a halfpenny-worth of chocolate for breakfast and 5 pennyworth of bread and ricotta — a sort of curd, 2d. the pound out of which we make a luncheon at noon, and when it is dark we go to the dining rooms — which we find the cheapest way; our dinners costs for both from 15 to 18 pence — we have no tea or supper for we go to bed soon — and we find this ample nourishment for Anny's face is like a full moon and it would do you good to see how snug and happy she looks when she goes to dinner wrapped in her cloak and boa up to the chin. I am only afraid you would think that the grand tour had shaken her gravity too much for she is so merry a companion that I feel about twenty years younger for her company. I never yet heard of an industrious couple who indulged in no one luxury and had each a profession coming to want it, and I do not think it will be our case even though fortune should scowl upon us till the eleventh hour. Anny is much cheered by her Papa's kind commission in the Loggia — and perks up upon it and feels herself quite an artist.[3] She is at this moment sitting before me on her little camp stool getting the outlines from some prints and looking as eager as possible. She is growing taller I think every day and is in the finest health. I think you may most safely

[2] William Linton (1791-1876), fashionable painter of Italian landscape.
[3] Hannah had considerable talent as an artist. She had been commissioned by her father to colour his mezzotints of the Loggia frescoes by Raphael in the Vatican.

trust James[4] to come over and our being here will be of great advantage to him with respect to lodgings, permissions to copy etc. and I hope contribute to his comfort. We both long to see him. Pray give our best remembrances to Mr. Martin and believe me my dear Mrs. Linnell —

<div align="right">

Yours most truly
Samuel Palmer

</div>

My dear Miss Lizzy[5]

I have only room to say that more than brotherly affection would lead me to write you a very long letter if I had not to earn the bread of my necessity by the sweat (perspiration) of my brow — but if I should sell a drawing for ten or twenty guineas I will devote a very long evening to you, life seems too short to get through anything but I will always find time to say that I am your most affectionate friend and brother

<div align="right">

S. Palmer

</div>

JOHN LINNELL

30 April 1838 [Rome]

My dear Sir

I am very much obliged by your careful and excellent advice which I will attend to, and endeavour to follow: and I hope from time to time you will communicate any suggestions that arise in your mind — as I am out of the way of instruction and left to my own resources. I do not wish to prolong my stay but fear that we can never accomplish what lies before us at Naples etc. before the late autumn and then we may either return in the winter or winter at Rome and begin our homeward march in the very early spring taking Terni and Florence in our way. All the English visitors see the Roman exhibition in which our works are hung on the line of

[4] The Linnells had thought of allowing their son James to visit Rome while the Palmers were there, but nothing came of the idea. (He was five years younger than Hannah, having been born in 1823.) James would have accompanied Albin Martin, a pupil of Linnell's who eventually did join the Palmers in Italy.

[5] Elizabeth Anne Linnell (1820-1903) was, next to Hannah, the eldest of Linnell's nine children.

the eye and perhaps half a dozen of my most highly finished
summer drawings might make an impression on them and do me
good in England. But here is the annoyance — The price I should
be obliged to put on the original studies from nature would render
them very unlikely to sell in the exhibition — and as I shall not be
able, judging from my experience hitherto to make any acquain-
tance with the English gentry resident or travelling — they would
not have the opportunity of asking me to make copies or drawings
of other subjects — which is given them by the free intercourse
they hold with other landscape painters and draughtsmen here
who are selling drawings every day and who, having brought
good introductions, are, like the resident artists, on visiting terms
with the gentry who form with them here, one large family of art
— from all communication with which I am as remote as a
Laplander — not having brought one introduction to an influential
person. I think I could sell, if I could once come in contact with the
buyers; but *that* is the difficulty. All who know us by sight, know
us as nobody, and as creatures whom nobody knows; and the free
terms of intercourse here make such exclusion seem the more
disgraceful. I have not been introduced to a single person but Mr.
Baring.[1] As I hope soon to have something which may be worth
seeing, some acquaintance with the gentry at Naples, Rome or
Florence might be of the greatest use. I should be very glad if you
could think of anything which might bring it to bear. I dress as
well — indeed better than I can afford and try not to be disgusting
in any way but there seems to be a great chasm between me and
gentility — that gentility which I despise, but of which I should
like to suck the sweetness — so far as the wants of a simple life
require.

Here we stand like two little children, snubbing their noses flat,
at the glass of a pastrycook's window — longing not for the
pastry and sweetmeats of life but for that supply of simple wants
which we cheerfully trust that Providence will give us, but for the
attainment of which we must use all means. . . . How is it that all
artists and students both here and everywhere, be they never so
poor or ignorant or green or scrubby dress like Lords. The world

[1]John Baring (1801-1888), a member of the eminent banking family. Thanks to
George Richmond, he had commissioned a drawing from Palmer of *Modern
Rome*. A few lines have been omitted from Palmer's second paragraph here.

seems to have banished poverty and to be too good for me who am like a wart upon the neck of it. However if I can only get a forty guinea commission now and then I shall know how to take care of it and be able I trust to go on with Anny improving ourselves in art and if we get more I hope we shall do good with it and use it for the bodily intellectual and moral benefit of ourselves and others. Anny will do very well for society as she has great presence of mind and carries herself well but 'I — the dogs bark at me as I halt by them'[2] and the time is not yet come for throwing my crutch at them if I were so disposed. I am obliged to leave off and cannot fill up the space I had left as the post is going. I intend never to write without ruling lines as it makes small writing legible — I am dear Sir

Yours affectionately
Samuel Palmer

A little of the pleasant minutiae of domestic news concerning either family would refresh us and perhaps Miss Lizzy could find time to get it up for us. I am almost sorry Mr. Mulready[3] found time to finish his picture for this exhibition as I shall perhaps lose as great a treat as the sight of it would have been. Give us some account of what you have sent and of the kind of thing Turner exhibits this year

ELIZABETH LINNELL

14 July 1838 [Pompeii]

My dear Miss Lizzy
We are living in a farm house at Pompeii, and dining every day in one of the ancient cellars. We got to work immediately, but could not sleep for gnats. We travelled ten miles for gauze to make a moveable bed curtain. We got two donkeys, and Anny rode very well up and down the steep mountain roads, till the girth

[2] Cf. *Richard III*, I. i. 23.
[3] William Mulready, R.A. (1786-1863), an old friend of Linnell's. By 'this exhibition' Palmer refers to the Royal Academy show.

broke and off she came; only bruising her arm a little. In the evening, after a fruitless search for the gauze, we enjoyed, the first time for four nights, a quiet rest; and going out upon the balcony in the morning, looked downwards towards the bay of Naples, and upwards toward the mountain, over a forest of orange, olive and vine. Next morning, after getting the gauze, Anny mounted a mule very courageously, and we retraced our wild and beautiful road. Going a few steps out of our cottage in the twilight, we look down upon the dead city, not remarkable for very grand or spacious buildings, but having some elegant and classic temples, and shewing the detail of ancient domestic architecture. Above the mutilated victim towers the dark Vesuvius; which has been rather uneasy of late, but refuses to give us the longed for spectacle of an eruption. Opposite Vesuvius, across a fertile valley stretches a grand ridge of higher mountains, wooded to the summits — then the beautiful bay with its distant isles and promontories fills the panorama. High as is the gratification of exploring this beautiful country, those who do not feel disposed to cross the channel may comfort themselves by knowing that *specimens* of almost every class of beauty may be found in our island with the exception of rich costumes, cities and villages cresting the hills and precipices; and this heavenly sunshine and atmosphere, of which however we have a tolerable hint in our very clearest summer days. In *apparent* richness I think Kent and Devonshire have the preference of everything I have seen, though you have no pomegranates and oranges. We are anxious to bring, besides some finished drawings, as many lines and sketches as we can, with hints of the effects under which we saw them; so as to have much material, which the matter everywhere to be found in our own country may enable us to work up. For a long time after our return, we hope there will be no occasion to leave our native country, but should enjoy to sojourn some day with you in our beautiful vales, to hide ourselves from an impertinent world in tangled orchards; to go sitting on our thyme hills, and in our magic Northern twilight to hear the village clock ticking in his grey tower — tastes of those delights are given us here in some lucky moments, snatched from bustle and care, to make us seek for their undisturbed enjoyment in the renewed world, and in heaven; where I doubt not there is an abundance of fruit trees and gothic architecture. Much as I love England — I think every

landscape painter should see Italy. It enlarges his IDEA of creation and he sees at least the sun and air fresh as from the hand of their maker. If we are blessed with prosperity on our return and are able to make another continental excursion it will be short for I should like to try the vale of Aosta under Mont Blanc — Turner's favorite place — tackling also the Swiss waterfalls. When I say you can get at home hints of everything here, I must except Rome applying the line ridiculed by Swift in his Bathos 'None but herself can be her parallel'.[1] The poetry of our English villages, and our noble forest timber and kingly oaks we do not find; but we went on board one of our own fine *hearts* of oak[2] when at Naples where our fleet lay and found it among other things, the model of a painter's house — all in order for action — full stores, simplified by the exactest order — the cleanliness equal to any drawing room, among 800 men packed into so narrow a space that one could have expected nothing but filth and confusion and all this host under the blessed ancient discipline, kept in happiness and order by a handful of officers. As we descended to the lower deck — the band struck up Rule Britannia making my heart throb with anxious fondness for our poor old country — while along the end of the quarter deck met our eyes in large characters Nelson's last word of Battle — 'England expects that every man will do his duty.' It is however very difficult to do ones duty — very difficult to do anything well, from the blacking of shoes upwards. This one begins to find at thirty, when as Young says, in some stanzas which every one should learn by heart, 'Man suspects himself a fool.'[3] My own life has been embittered these two months, by a searching of heart which comes on every evening, to find out whether I really am or am not a fool in grain. Where is the golden autumn of life? We are first green, and then gray; and then nothing in this world, and as far removed from the next generation as the busy people of Pompeii. I lost much time formerly — but am really glad I had a dose and glut of reading at Shoreham; some savour of which is yet within me like the relish of wine in an empty cask — otherwise, I am now so engrossed by

[1] Actually it was Pope who, in *Peri Bathous*, ridiculed Massinger's line 'None but itself can be its parallel' (*The Duke of Milan*, IV. iii).

[2] H.M.S. *Pembroke*, on to which the Palmers had been escorted by their new friend Henry Acland. (Cf. his later letters to Acland, pp. 172–9, 213.)

[3] *Night Thoughts*, I. 417.

work that I should be a dolt and a sot. I would *entreat* those who are younger than myself to get plenty of reading while they can and that kind of reading which *forms a Taste* nay which models into its own likeness the heart and understanding and attunes the ear to music, the proper language of Truth — till we come to seek in anything which calls itself a book — not stale notions, gilded over with staler fancies but IDEAS made pictorial by imagery and musical by melody and rhythm. Such is the prose of Milton. As we choose our early classic *poets* — so I think in prose we should do well first to study our early classics also; — Milton Jeremy Taylor Barrow Sir Thomas Browne and the like of which there are not many — and afterwards, with our minds and ears full of these go to Swift Burke Johnson etc. — and to 'what tho' rare of later age' 'Ennobled hath the hotpress'd page.'[4] And if the style of the elder masters seem harsh and some of their majestic pregnant sentences obscure — if they give you now and then a hard bone to pick yet there is plenty of solid fibre and lubricating fat 'gravy gravy gravy'[5] — but the books ladies get hold of now are minced veal and milk and water. I must finish upside down from the beginning of this letter. Blessed also will be the mind that is embued with Plato — would that mine were so! — the very antithesis of the literary impudence dandyism and materialism with which most [of] our modern periodicals tend imperceptibly to imbue the mind. If I am ever to open a book again and not to 'live a fool and die a brute' may I open once more the divine leaves of Plato in some happy Grove St. evening with you and dear Anny by my fire side — but it is too good to be hoped for in this world except with Euripides,[6] in his cave; too deep to hear the rumbling of her rubbish-carts. But blessed be the rattling wheels dear Lizzy that shall bring us face to face again, tho' united by links that traverse the ocean and the mountain: and that you may ever be blessed yourself, and a blessing to every one about you, till you pass into that land where there shall be no more curse is the hearty prayer of my dear Miss Lizzy

<div align="right">

your most affectionate friend
Samuel Palmer

</div>

[4] Adapting Milton, *Il Penseroso*, lines 101-2.
[5] Falstaff's words in *2 Henry IV*, I. ii. 154.
[6] Presumably a mistake for Plato.

JOHN LINNELL

22 August 1838 [Corpo di Cava[1]]

My dear Sir —

As we are still at Corpo di Cava I have nothing new to tell you,
except a little about that interesting animal myself. I have felt, in
the phrase of certain preachers, 'much enlargement' here — not
from the good dinners; though they have somewhat increased my
bulk; but from an awakening of my mind; the dispersion of a
cloud of doubt and anxiety, and a flow of imagination in the
choosing and treatment of my subjects. The ungracefulness of
talking of self forbids me to be much 'led out' in 'giving in my
experience'; but I will just mention that I have put in hand here
eleven new drawings; one large, and some very little. I am trying,
at however humble a distance, to treat fine bits of nature on a
small scale in something like the taste of Titian and Domenichino;
and have made some discoveries which lead me to see, in the
bright key of nature, their depth of tone: — have found out the
point of danger in yellow; which, however, I have been very
careful of through the whole of this expedition: — its true relation
to white, and its proper place on the scale: — have discovered how
to make foregrounds, where it is necessary to invent them, more
of a piece with the whole: and, above all, to see in my mind, when
I sit down to a subject or effect, the completed picture; with
figures, foreground, shadows and arrangements of color. I think
this, in time, will make me very rapid; as it shows at once *where* to
labour the imitation, and what to touch slightly or to omit. I think
I have also found how good deep greens may be ventured on a
more comprehensive scale of harmony than that which has so
often obliged artists to turn them into brown. Turner's cor-
ruscation of tints and blooms in the middle distance of his Apollo
and Daphne is nearly, tho' not quite so much a mystery as ever:
and I am inclined to think that it is like what Paganini's violin
playing is said to have been; something to which no one ever did
or will do the like; though Claude and Titian have done just as
well or better in another way. I would give anything to see some
of Turner's best water-color drawings now; and if I am preserved

[1] The head of a mountain valley near Naples.

68

to come home, shall beg the favor of Mr. Daniel[2] to get me a sight of a most splendid collection which he took Mr. Penry Williams to see: I forget the proprietor's name; but he lives at Stoke Newington; and I should think from what I heard that you would like to see them. I find that if I go on as at present, there will be a plentiful portfolio of my things, besides bushels of Anny's; who works very rapidly; and is now going on, sometimes in joy, and sometimes through those blessed afflictions which alone make the mind of man or woman much different from a dog's, to genuine, and I hope, high excellence in the art. She sometimes says that she fears it is only the mind of man that can grapple with Art; and that women were created with an intellectual grasp too weak for such an enterprize: but I think of a woman what Dr. Johnson thought of a Scotchman, that much may be made of her if 'caught young'; and especially if secluded for a time from the cap-and-bonnet-society of her own sex: and I am happy to say that Anny is studious and most industrious in her habits; and does not hanker after the gewgaws and trumpery which befool most of her kind; though quite as neat, and clean, and orderly as ever. Tivoli, where I hope we shall be in the late autumn, will yield some beautiful waterfalls, a general view of the scene and a superb study of Cypresses: — then I have in hand a third large view of Rome; and Terni will be glorious game, and afford both of us (for Anny is now quite capable of tackling it) some fine energizing: and if we can increase our stock of little effective drawings, to sell off while the large ones lag, I hope we shall do well — but I shall try to struggle on, if possible, without selling our original drawings from nature; which, if dispersed, we may never be able to replace again: and as I found in Mr. Baring's drawing, that by taking great pains at first, I could make the copy decidedly better than the original; have good hope of it. I long to do something which I can show without fear to you or Mr. Mulready; and am trying to make one of my drawings in particular such as would really please him. I hope he will get me a sight of his 'Seven Ages' — for the half which I saw would make me grieve not to see the whole. Pray enter into particulars in your letters; and tell me, from time to

[2] Revd. E.T. Daniell (1804-1842), an amateur artist and friend of Linnell's. The 'most splendid collection' was perhaps that of Samuel Rogers.

time, what you are painting and what is doing in the arts; this will cheer Dear Sir

Yours very affectionately
Samuel Palmer

P:S: If my Father leaves his 'few sheep in the wilderness'[3] for a day or two and comes up to Vanity Fair pray give my kindest love to him. By Vanity Fair I do not mean Bayswater but horrid smoky London with all its begrimed finery and sooty shows.

JOHN and MARY ANN LINNELL

October 9 1838 Tuesday afternoon [Bay of Baiae[1]]

My dear Mr and Mrs. Linnell —

We came this afternoon to Pausillippo (Putioli) where St. Paul landed and I managed with my morsel of Italian to get food and lodging at 3/4 per day for both of us. We are on the shore of Baiae and I ascertained from Sig[r]. Vianelli's[2] sketches that there are two first rate views of Baiae from the hill above us. We are in a wild kind of inn — with a large room about 16 feet high looking rather dreary — but Anny is now a good traveller — pulls out her knitting and makes herself at home in a moment. I have endeavoured in what I have been doing to get all that is essentially Italian on the spot and having those two great desiderata — effect and foreground arranged — look forward with delight to completing my drawings or making others from them in Grove St — and when I am at a loss — (as I now wish to have studies from nature for everything) to running out into the Regent's Park or Kensington Gardens for a study of a group of leaves or a bit of ground whenever I want it, and I hope we shall bring home a stock of subjects which will last us a long time and which the material that lies ever close about London will render thoroughly

[3] 1 Samuel 17:28. Vanity Fair is, of course, a city in *The Pilgrim's Progress*. Palmer's father was trying his luck as minister to a small congregation at Aylesbury.

[1] A bay near Naples, well known for its beauty.

[2] N. Vianelli, a minor Italian artist to whom the Palmers had taken a letter of introduction.

effective. The pain in my right fist which I attributed at Corpo di Cava to clenching my brushes still continues in a small degree and I feel a slight pain and stiffness in it when I wake in the morning — so that I am inclined to think it arises from something the world would think much more dignified than art — namely a touch of the gout!! My fingers have a little redness and swelling in the morning sometimes I think — will you tell me what is good to do if it be incipient gout? You will tell me not to stuff any more ducks — would I had ducks to stuff! and the great king of birds — on which I could not help wasting one tender thought on the twenty ninth of Septr.[3] cackles and struts on no green commons here — and green tea and toast and the hissing urn and the capacious sofa littered with ancient books and the piano and Gregorian chants are absent — but Anny is here and those delights partaken with her in London — with two or three commissions to start with would make me too happy. I do not mean the delights of goose for that should be used only occasionally, to grease the wheels of life a little when they begin to creak with study, but those cheap and blessed intellectuals which a hundred a year will buy though ten thousand often fail to purchase them. I must now go to bed that I may begin the siege of Baiae with daylight.

Thursday — We tried yesterday to climb an almost inaccessible mountain which baffled all our attempts (but having set my teeth at it I hope to try again on a donkey tomorrow morning and if I fail then I will be pulled up by ropes) — however I got a beautiful long subject from Monte Nuovo — with a foreground made up — but not by me but Nature: for a volcanic explosion threw up the whole hill in 36 hours. Anny is pleased beyond measure with anything volcanic and has the heart of a lion the moment she begins to slip about on cinders and ashes. Today I tried to draw in the streets in spite of insolence and annoyance which made it almost impossible even to me who have drawn in the streets of Rome during carnival — finding no other means would answer, I did as our government have probably (for I see no papers) done with O'Connell[4] — I hired the ring leader of the mob for a trifle, to keep off the rest; which he did with all authority and I finished

[3] Michaelmas.
[4] Daniel O'Connell (1775-1847), Irish journalist and politician whom Palmer held in low esteem.

my study in sweet peace. You cannot stir a step here undogged with cicerones boatmen etc. — but our inflexibility has nearly tired them out. The incessant struggle with imposition and the snares everywhere set to catch our cash sometimes really sicken me — but after a night's rest and a breakfast of coffee, milk, butter, four eggs, beef steaks, pears and grapes we turn out again to the combat panoplied in slow and sallow obstinacy. We had a great storm hurled after us yesterday because I civilly declined the offer of a boy to carry my sketching apparatus which was very heavy and nearly rubbed the skin off my hip bone. I wonder what aspect I was born under — other people slide on without all this bother — but I — though far from courting difficulties and trying to follow American Jeffries'[5] advice to his nephew always to 'take hold of things by their smooth handle' — am a sort of little Esau with every one's hand against me — tho' my hand or heart are I am sure not against any one — not even against the Devil — for though I hate his ways and his works I wish him well, most sincerely — and would not carry an additional faggot to burn him on any account unless the same fire would burn up all his mischiefs — and yet I am called Papist and persecutor by one — infidel by another, madman by a third — one calls me extravagant, another miserly — one says I starve myself — another that I love goose — if a tailor makes me a coat in the fashion there is not room for a pocket handkerchief — if I contrive a coat for use I am hooted — I am buffetted cheated pelted, belied, abused, trodden on, tripped up and spitted on — and what do I care? only if possible to get a little money and keep out of debt — and then I could stand as steadfast as one of the pyramids if all the world 'laughed at me in chorus' I try to rank myself as neat and passable as may be — have begun with Falstaff to 'purge and live cleanly like a gentleman'[6] — perk up in a neat stock and a clean collar — and yet when I come alongside any regular dandy look like a coal barge by a royal yacht. Having so many times found your advice to be based upon good reasons I took it and came to these shores of Baiae and though I think people generally overrate scenery very much — and that though many places afford wonderful scraps, yet there are very few perfect *views* — must confess that Baiae is an epitome

[5] i.e., Thomas Jefferson.
[6] Adapting *1 Henry IV*, V. iv. 160-1.

of all that is beautiful. Every point I have seen affords the finest lines of capes — reaches — and islands — and a months stay would furnish distances for life — after having, however, secured the grand scene from the mountain that withstands me, and got one subject of Avernus[7] we must return to Naples or poor Tivoli with all its waterfalls will be lost — and I want to get as many cascades as possible that with my Welsh ones I may have a good stock. If Lord Holland[8] would pension all his poorer kinsmen — or give me a nice little whig sinecure I would go to Rome by the upper road which is now too expensive, and spend next spring in Turner's favorite place Aosta, under the Alps but as at present I am likely to get more kicks than halfpence — I must make my halfpence last and try to turn a penny as soon as possible in London. I long to be there, and have a great curiosity to see what will become of me — *I think*, as has always hitherto been the case, Providence will provide in time of need — but having had such good living in Italy — it will be hard to feed on pulse and I must turn rat-catcher if things are at an ebb — that I may get plenty of animal food. Tho' the rabble of cicerone boat men etc. have sneezed at us yet the clever and good people have done differently. Messrs Gibson[9] Williams and Ackland have treated us with marked attention and respect — and we go back to Rome as to a house of old friends. . . .

This extempore letter writing without revisions and erasures or even a rough copy — tumbles out a strange hotch potch — but as carelessness and slang are the fashion of the day I suppose it may be very gentlemanly and shew more breeding than one of Cicero's epistles. When I consider the distance we have travelled and the things we have seen — I think the amount we have spent was never better laid out or brought more for money — and I hope and believe it will turn out a good bargain in the end. Being in haste I can write no more but that I am Dear Mr and Mrs. Linnell

ever yours affectionately

Sam.*l* Palmer

[7] A lake not far away.

[8] Henry Fox, Baron Holland (1773-1840), whose mansion in Kensington was famous as a centre for wit and intellect. Palmer claimed to be a distant relative.

[9] John Gibson, R.A. (1790-1866), an English painter resident in Rome. I have omitted a long passage following this sentence, which mainly concerns Palmer's financial affairs and expectations of his return to England.

The GILES FAMILY[1]

October 1838 [Pozzuoli[2]]

To my dear Mrs. Giles, and to the rest of my dear cousins in
King William Street assembled, greeting

An account of all the novelties which I have seen, if hung from
the top of the Monument, would trail upon London Bridge;
therefore I will just mention a few things as they occur to me, and
waive all introductories excepting an apology for having seemed
to neglect you so long, occasioned by the continual press of
labour and study, which has prevented my writing a line to any
one, but in our periodical letters to Bayswater. Yet, many a time,
have I sat down in spirit by your cheerful and intellectual fireside,
where have passed some of my very happiest hours.

The inside of a Romish church was the first novelty which
presented itself; not a believer's band-box, in which the greatest
quantity of lace caps and laces are crowded into the smallest
possible space, partitioned out into dress boxes called pews, for
the comfort of consciences too tender for the opera; where fine
ladies cover their heads with *Valenciennes* to play at hide and seek
with the angels (by which, perhaps, were meant, says Dr. Gill,[3]
young ministers), and making what is called a *respectable* con-
gregation — a *thriving interest*. Not this, but a refuge for the abject
and the outcast, the peasant and the pilgrim; with no *free seats*,
where all are free, to publish his poverty — no brandy-faced
beadle to drive Lazarus from the door, and waddle before Dives
to the chief seats. A continental church is no whitewashed pantile
shop for paroquet costume, where a picture or statue could not be
tolerated for fear of worldly pomp! But a temple enriched by the
noblest talents of man for the honour of God, and opening its
gates for him who has no other friend. I expected to find one great
altar, gorgeously decorated, and no more; but found an altar
enriched with carved wood, statuary, pictures, and precious

[1] Palmer was a particularly good friend of John Giles, a stockbroker who had been
an Ancient in his youth. But this letter is addressed equally to his brothers,
Samuel, Albert and Felix Giles, and to Samuel's wife Rebecca. The family were
Roman Catholics living in London.

[2] On the bay of Naples.

[3] John Gill (1697-1771), an eminent Baptist minister. *Valenciennes* is a rich kind of
lace.

74

marbles in every side recess, and between the pilasters all along the side aisles; so that service may proceed, without much interruption, in several places at once: and there are groups of poor market-people, who have laid down their baskets for a few moments (some still poorer), praying in oratories and dim recesses; and others prostrate at the door.

Thus far all is right, tho' the Romanists have not been wanting in other means of money-getting; but there are things more questionable. In the churches of Naples you see life-size figures of the Virgin, dressed out in the height of the fashion of the time when they were made; with stay-tight waists, and Bond Street hips, and rings on their fingers. When an image of the Madonna makes a procession through the streets it is preceded by soldiers with fixed bayonets, and a military band playing merry tunes. An image which I saw carried in Rome, with seven daggers in her breast, was, I think, borne by butchers — at least it was the butchers' costume, which is said to be that of the sacrificing priests of Jupiter. Like the Pagan household gods, little ugly dolls of the Virgin and Saints under glass cases are kept in many of the houses; and votive offerings are hung in profusion in some of the churches, before the shrine of the delivering saint: horribly-painted little pictures too of remarkable deliverances from fire, drowning, or spirited horses, are suspended about them: and at a favourite shrine of Our Lady I saw innumerable knives stuck into leather thongs up the wall, which were the weapons of converted assassins. You see parents lifting up their children to kiss the foot of a Saint. That of St. Peter in the Vatican, though of brass, is much worn.

No one was ever more cruelly or unexpectedly disappointed than myself with almost all the church music I have heard in France and Italy. During the consecration of the Host, they play operatic music; and an organist once, who could not please the congregation by other melodies, played the air of 'Go to the Devil and shake yourself', very much to their satisfaction. An eminent artist at Rome, who is also an organist, told me that after wearying a convent with fine music, he quite delighted them with 'Bumper Squire Jones'. At high mass I have heard the chant of the priest accompanied in the most frivolous taste; and when after loud music there comes an unaccompanied chant, the organ keeps the priest in tune with a loud shrieking note now and then, all the

stops having been left open. The vocal choir of St. Peter's and the Sistine Chapel is very fine, but in the gallery of the former the leader stands in front beating time very energetically, and the cries of '*Piano! Piano!*' are rather *forte*, and much too distinctly audible.

We saw the grand Easter ceremonies, and were several times within a yard of the Pope. We saw him wash the feet of the thirteen priests (whom he afterwards waits on at dinner, girding himself with a napkin), and after singing mass, bless the immense assembled multitudes from the facade of St. Peter's. This is a sublime spectacle — thousands of country people in their picturesque costumes, beating their breasts, holding out strings of beads, and awaiting, in breathless silence, the great benediction. When the Pope appears, all is hushed. He spreads out his arms over the people and blesses them; and then, all in a moment, the great guns of St. Angelo fire, the martial bands distributed over the piazza, strike up, and the bells of the city, which are silenced through Passion Week, ring out a peal. Before this, at the grand mass at St. Peter's, at the moment when the elements are consecrated and all are prostrate, a slow, sublime harmony of wind instruments peals along from over the great western door, softened in this immense vault as in the open air. The dome, though much higher and vaster than St. Paul's, is not, in my judgment, nearly so sublime: and in sublimity and musical effect I think the grandest ceremonials of the Vatican are far short of our cathedral worship.

We found the scenery from Calais to Paris pretty tolerable in places, but the few villages on the high road looking very desolate and deserted. Indeed, throughout our French journey, excepting one single village in the south, all the little country places appeared dismantled and wretched, with not a gleam of cottage comfort. No rustic chimney 'between two aged oaks' (for forest timber we saw none till we came to Switzerland), no 'neat handed Phillis';[4] but houses in the taste of Walworth Common and Rotherhithe, only without, or with broken, glass, and tumbling to decay; and instead of ruddy ploughmen, ragged, sallow, blue-coated monsieurs: the whole looking as if it had been purged, not purified, through twenty, instead of three or four revolutions. This is not caricature,

[4] Milton, *L'Allegro*, lines 82 and 86. Describing Milan Cathedral later in this letter, he also quotes from *Il Penseroso* (line 160).

or an exaggeration of the *general* impression made on my senses. Our modern philosophers say, I believe, that our ideas come only through the medium of the senses, and really the sense of smelling is by no means an inactive agent in forming one's idea of France and Italy; nor the sense of feeling in the flea season, though happily for us, in Rome (to parody the kitten pie-man), *when frosts was in, fleas was out.*[5] In Rome, where the bed-linen is shaken into the streets, we are told that in summer the fleas swarm you so as you walk that people are obliged to change their clothes when they come in; and at Naples, those little creatures which in the language of Dante are called 'pedoccii' so abound that they are sent home in the clean linen. However, a comb and soapsuds would sooner clean one of these, than the most stoic philosophy of the blue devils in lurid London. These vermin, though they certainly do not contribute to ease, are light and limber enough to grace the modern style of epistolary correspondence, which is said to derive most of its grace from facility of movement.

The fury and vociferation, and brutal, butt-end horsewhipping of French *diligence* drivers are a strange contrast to the quiet mastery of the 'Mr. Wellers' of old England. But the movement-note of one of our charioteers was very curious: while he was beating away with all his might, he was exciting his cattle with a tone exactly like the cooing of a dove!

We arrived at midnight in Paris, and put up with a most dismal-looking room in a great hotel whose gates were guarded by sentries. Nothing in travelling is so wretched as a night arrival in a strange city. We were surprised to find no soap on our wash-stands, but soon found it was an unheard-of luxury which we must buy and carry about with us through the whole journey. We found here several pretty nauseous examples of French filthiness.

At the risk of being every moment pushed down or run over, we began to explore Paris — were delighted with the Louvre, tho' the pictures are hung in the dark, but had not time for the Luxembourg. We were detained day after day by the shameful delays of the passport system, [and] our consolation was to creep now and then into the Louvre. We did not then know that by

[5] '. . . fruits is in, cats is out': the pie-man to Sam Weller in Chapter XIX of *Pickwick Papers*.

giving a few francs to the commissionaire of the inn, all would have been done for us. O! the physiognomies that I saw in the public offices! We were told that, some time since, the present *liberal* government took away from travellers on the frontiers the pistols which they carried for their private safety. The new king's soldiers form a guard of honour with a standard, over the graves of the so-called patriots who were killed in the act of dethroning the last monarch!

I shall not easily forget some grand old fortified and cathedral towns near the Swiss frontiers of France. We had just a glimpse of their grey fanes and mouldering battlements before we entered for the night, and left them before daylight in the morning; which, when we looked back, we saw glimmering upon them in the valleys beneath. Sometimes the morning mist filled up the vales and plains like an ocean with its friths and bays; while the rising sun, striking upon the island-like summits and mountains, fired with living gold here and there an ancient village or city on their glowing ridges. Sometimes what seemed to be sky opened and disclosed a patriarchal village nestled among the pastoral downs, and glistening like silver or pearl through the rarer vapour; or the cloud would partially vanish or rise like a curtain, and disclose a champaign country at our feet; while, on either side of the road, the village people were brushing away the dew from the ripe vineyards, and piling up the purple treasure in baskets, or loading them upon teams of cream-coloured oxen.

Then came the wonders of Switzerland; while, winding up and down among vast green or furrowed slopes, or shaded by luxuriant forest timber, we saw the hoary Alps at sixty miles' distance glimmering like sunny clouds across the horizon — above them, greyer or more vaporous colour, and the Alps again! Lausanne sweeps down with its terraces and gardens to the margin of the great lake as it seems, though a mile intervenes, which is lost in the stupendous scale by which the eye measures everything: being filled with the giant forms on the other side.

On the hilly environs of the Lago Maggiore stands the statue of St. Charles Borromeo as large as a tower, with his hand stretched out over the country, as if blessing all beneath him. There is a staircase inside the statue, and several people can dine in his head. Mr. and Mrs. Richmond and Mrs. Palmer saw it, and a room where this blessed saint and servant of God was born, with a cast

of his face, some of his hair etc. I did not, being plagued with heavy boots, and unable to ascend to these precious relics, which I reckon a great loss. I however saw the statue at a distance.

Our first sight of the lake was from a flower-trellised balcony at the inn, with the first crimson flush of dawn glowing behind its mountains.

Milan cathedral is a wonder of holy, Gothic, inspired art, and its dim religious light gilds the very recesses of the soul. It is the antithesis of the new Post-Office, and not very similar to the National Gallery.

But Florence is the 'city of my soul'[6] — quaint, antique, stately, and gorgeous, and full of the gems of those divine and divinely inspired arts which, three centuries ago, lived there in wedded love with the old Platonic philosophy. Not the pot and kettle philosophy of The Useful Knowledge Society, beginning in steam-engines and ending in money and smoke, but visionary and ideal — the solid food of the soul. For money and beef are not, as people imagine, the solid things of the *mind*; but as unreal and unsatisfying to the immortal part, as a lecture on metaphysics would be to a hungry belly.

But what shall I say of Rome, of whose wonders a tenth part I have not seen, yet have seen what would fill a volume? Its churches are cathedrals, and its Vatican larger than the city of Turin within the walls. Rome is a thing by itself which, once seen, leaves the memory no more — a city of Art which one had dreamed of before, and can scarce believe that one has really seen with these ocular jellies — to which London seems a warehouse, and Paris a trinket-shop. What must it have been in its antique glory? You can only look at its dazzling palaces, blazing in Italian sunshine, with your eyes half shut. Indeed, Italian air and Italian light, and the azure of an Italian sky, can scarcely be imagined in England. It spreads its magic over streets and houses, and invests the commonest objects with a peculiar beauty: but the people do not, I fear, plunge into the Tiber after athletic games as heretofore, or wash their carcases as we do every morning in cold water; for they leave a wake of unsavoury odour behind them as they walk the streets, which are strewed with filth.

[6] In Canto IV of *Childe Harold's Pilgrimage* by Byron, Rome is called 'my country! city of the soul!'

We have lately been exploring the wonderful environs of Naples, are now at Pozzuoli (Puteoli, where St. Paul landed), and hope soon to be in Rome for the winter.

I grieve to pass another Christmas without our family meeting. It made me sad last year to think of it, and I do earnestly hope, my dear John, that we shall spend next Christmas but one together, and in company with our feathered friend, whom I have not forgotten, though my last sight of him was in your company. Green tea too, and the bookish evening have charms to draw me to England, where I hope we shall often enjoy them together. Pray write me a *long* letter . . . and tell me what delightful books you may have lighted on since my departure, and how little Willy and Samuel[7] get on with their studies, which I long to know. Give my best love to them, and tell them they are not forgotten. Pray begin to write as soon as you get this, and write five minutes a day in a very small hand till the letter is full.

I saw Dr. Wiseman[8] at the Easter ceremonies, with a purple gown and fur tippet, looking as sleek and fat as ever, and heard him preach once or twice. He has been getting up performances of Shakespeare's plays by his pupils of the English Academy. He sings, and is, I believe, fond of the arts.

I have been received with great respect by the first English artists in Rome, who were much pleased with a drawing I exhibited there. Mr. Richmond kindly introduced me to Mr. Baring, who gave me forty guineas for a view of the city, for his father's, Sir Thomas Baring's, collection. We met with a very pleasant and intellectual friend in a son of Sir Thomas Acland, who passed a good deal of time with us at Naples. I have said nothing about Mr. Richmond as I know he has been in correspondence with you: indeed, I am very anxious to know where he is, as I do not much think he remained at Florence. Pray let me know, if you have heard. Do not forget between you to get me up a long letter. Give my love to all relations and friends, and believe me, my dear cousin,

<div align="right">

Ever yours affectionately,
Samuel Palmer

</div>

[7] Sons of Samuel and Rebecca Giles.
[8] The future Cardinal of Westminster.

When we were leaving Pozzuoli this morning, I saw a monk getting the materials for dinner in a very cheap and ingenious way. He was presenting to all the old men and women in the little fish-market a glazed, coloured print of the Virgin to kiss, and was in turn presented by each with a small fish, which he carefully deposited in his handkerchief. I think in Billingsgate he would find himself as much out of his element as the fish themselves.

We have just heard from Mrs. Tatham (their aunt, at Naples), that the Richmonds are at Rome; that Mr. R. is now quite well; that Mrs. R. has continued all along in perfect health; and that the Roman baby has cut six teeth and is a giant. Our children also are, I trust, pretty well. They are twins; viz. Mrs. Palmer's drawings and my own. Dear little creatures! They will I hope, support *us* instead of our having to keep *them*, which I hope will not be long; for I desire speedily to launch them on the tide with a favourable gale. If they sail into the port of prosperity, people will begin to say, 'What a nice young man Mr. Palmer is. Ah! I always said *he* would get on.' Perhaps now they say, 'Do you know that old fellow Palmer, with grey bristles on his head — he's an odd fish, isn't he?' If I get on, I mean to live most temperately, but to establish a monthly Goose Club, with a few select friends who appreciate that noble bird. The morning to be spent in reading our old poets, the bird to be discussed about two o'clock, and vivid green tea to be brought in at four, and kept on the hob all the evening; during which, over a blazing fire, we can talk over our old times at Greenwich and Shoreham, and have a little bit of Fletcher's *Faithful Shepherdess* now and then, or some of your old sophisticated Catholic books, dear John, which you must bring in your pocket. Tell me where you spent last Christmas Day, and whether you mourned, as I did, that the old family compact was broken up.

My dear Albert, if you go on drawing, continue to study from the divine, eternal, naked form of man, even if you are driven out from the society of men, and obliged to pursue your studies in a hay-loft. Take the greatest pains to secure a beautiful outline, and study from the works of the finest masters. Every inch you gain in this way is a mile. The devout and holy study of the naked form purifies the imagination and affections, and makes us less pervious to evil temptation. Here, beauty is often the whited sepulchre of vice; but in eternity that human form is, as it were, the body and

symbol of goodness and truth. Seas may forsake their channels, mountains be shaken to their base, but the eternal form of man will survive the wreck, and, as it existed from eternity in the Divine Idea, will flourish in immortal youth amid the 'clash of worlds'. I again subscribe myself, my dear cousin,

<div style="text-align:right">

Yours most affectionately

S.P.

</div>

Now! Do you think I'm mad, all of you? If I am, come and be bitten, for the vaccination of artistic madness is a good specific against the small-pox of worldly vanities.

Excuse bad composition, for I write in great haste.

JOHN and ELIZABETH LINNELL

2 December 1838 [Tivoli[1]]

My dear Sir[2]

I am very much obliged by your information about the gout { } after lasting two months or more my pain vanished so gradually that I had utterly forgotten it till reminded by your letter. Many thanks {also} for your advice on art. Whenever I have added anything to a subject {it} has only been what the first impression of that subject suggested and I have been enabled in consequence to complete my drawings consistently: instead of having to change my foregrounds about as I was obliged to do with my subjects. Rome would stock me with figures for life and we are deter{mined} at any cost to get them but they charge highly and have all one price, about 2/2d for four hours which if we had them every day would soon exhaust our finances; however we will try what can be done and I will secure at first studies for all the figures designed in my landscapes. Figures which are made

[1] A town east of Rome, a favourite resort of landscape artists.

[2] Palmer's letter to Linnell was dictated to Hannah. I have followed Raymond Lister's suggestions where the manuscript is damaged, indicated by curled brackets.

very large and principal as in Mr Collins's[3] subjects require more knowledge than I am master of and my feeling leans more to the treatment of Claude and Poussin, where though beautifully executed, they are adjuncts to the landscape. I however abhor the thoughts of slurring them as I have done formerly and make it my first care in studying animals for instance to secure the difficult points; as, the head front and profile, and the legs and hoofs in the front side and back views, by which abridged method of study I find myself able after a days drawing from nature to draw them pretty tolerably from memory; the Roman oxen are superb — I introduced two of them in a street scene and finished them I think pretty highly, from lines which I got in the streets and we shall now hire a team of them for the day and try to learn them by heart: I hope to send several finished drawings to the Roman exhibition in January and think we shall be obliged to hire two rooms, as friends or new connexions will not come to us in a bedroom, and as two rooms are very little dearer than one. Last year Mr Ackland and Mr Lear[4] called early in the morning while I was dressing, that I was obliged to go out in dishabille stand between them and the door and stammer out a very uncouth and unshaven apology. . . . Please to give my kind love to my Father if you see him, I hope Trimmer[5] is alive and well as in this forlorn world one is loth to lose even ones four legged friends. O! wretched that I am, may this be the very last Christmas I shall spend beyond the sound of Bow bells, my bowels yearn for the old family meeting and the bird of the capitol. Ungrateful city that forgettest thy deliverer and embalmeth not his sweet body with herbs and onions. I had a plate of him at the Trattoria but it was like a piece of my shoe. Mr Palmer's asleep and wont tell me any more so I shall conclude in his name.

O! now he's awake again and says in Italy life's a great humbug and says that thousands of bankers clerks [who] would take home a fowle [or] one bit of sweet mutton in their handkerchiefs to their snug little boxes on Kennington common from Leadenhall market

[3] William Collins, R.A. (1788-1847), a former neighbour and friend of Linnell's. Twentieth-century taste has tended to find his figures sentimental.

[4] Edward Lear (1812-1888), landscape artist and nonsense writer. The Palmers met him again the next summer. After this sentence I have omitted several lines of mundane requests to Linnell.

[5] Palmer's terrier.

of an evening, are quite in domestic comfort compared with these Italians who shiver in the shade and catch vermin in the sun. Give me a register stove and a Sea coal fire and a good old book and a couple of dips to read him by, and the poets and painters may take all these wide ho{mely} chimney corners — organ pipes through which every wind of Heaven sings and bellows — I am old enough now to know what are the few simple comforts that the poor old crazy tottering body wants and that a little money will buy them and if you will continue from time to time to remind me of the wants of my poor mind which in spite of Christmas dinner I value much more than this piece of pork my body you will still farther oblige my dear Sir

<div align="right">

ever yours Affectionately
Samuel Palmer

</div>

My dear Miss Linnell

You write as if you were low spirited — I have been recommending to Mr. Richmond, however he combs his mind during the day, always to secure one evening hour of undisturbed comfort — to roll himself up by his fire-side like a cat or dormouse, and to practise purring — a sound most significant of happiness, and by no means peculiar to the brute creation, as one of my Cousin's servants in the City always signified her satisfaction, by that sound, over her meals. Shakespeare tells us that there is a 'frock or livery' to things fair and good which 'aptly is put on'[6] — now nothing is better than happiness except goodness; and purring is its fur livery — which would be quite as becoming to young ladies as the accomplishment of scratching in which they are said to resemble the genus felis. Few people have swallowed blacker doses of suffering than myself, though nobody will believe it, because I am round in the waist and the corners of my mouth turn up naturally: and in labours and difficulties I delight, knowing these to be the price of all real excellence and wisdom — but I have always taken care to find some little hour in the evening in which I could loll and roll about like a cat upon a rug — *this* is the way to grease the wheels and make the old mud cart of existence roll on without creaking. It is better to cry and shriek and howl every morning and get a cosey oily hour out of

[6] *Hamlet*, III. iv. 165-6.

the night, than to mix up joy and *grief* in the mortar of moderation
till they neutralize and to smear the nasty mixture over the day. A
yell or a laugh for me! — no simpering — and then we get on
nicely like well brought up children with rod and plum cake. But
if you rod *yourself* well with mental discipline your hide will be
hardened against the rubs of chance and time — and the very
angels will come down with sweetmeats — which to see you
masticate will varnish with joy My dear Miss Linnell the face of
your afflicted fat Friend

<div align="right">

Samuel Palmer

</div>

I must tell you that Anny has made another step of improve-
ment and has done a drawing of a wonderful fountain today
which we should think beautiful if done by anybody — with such
an example before me I think I must improve, dogs meat as I am.
You must wonder at our staying so long in Tivoli, but you would
not wonder if you saw it — I have got a finished study of pines and
cypresses — the latter 300 years old and wonderfully fine

JOHN LINNELL

(?)9 June 1839 [Subiaco[1]]

My dear Sir.
 I am baked with heat — fatigued and when I am able to think at
all thinking wholly of art just at present — so that I have nothing
to communicate unless I were to disclose inward hopes and fears
— exaltations and horrors — I am endeavouring to pursue with as
little deviation as possible that order of study and abridgement of
study which I have so clearly seen before me in Rome and else-
where — endeavouring to supply deficiencies — and to attain to
some degree of completeness and proportion of knowledge.
Foreground and landscape figures are therefore at present my
object — with a watchfulness after phaenomena of skies and

[1] Having returned to Rome in late December 1838, the Palmers stayed there for
about five months, spending much of their time copying and colouring for
Linnell. When they left Rome, they went back to Tivoli and then continued
eastward to the town of Subiaco. They were travelling in the company of
Linnell's friend Albin Martin.

effects dependent on them by which I have profited of late. As trees are a part of foregrounds I am anxious by degrees to master each class — and by a very abridged process have learned the general characteristics of the cypress from those in the villa D'Este[2] which are reckoned the finest in existence. At Subiaco I have most happily found a fine specimen of the winding and dipping lane of Gaspar Poussin and by a week's very hard work hope to get several studies, and what is of more importance a clear general knowledge of that very important part of landscape. I shall if I live sketch them in oil or on Grey paper. I made a morning's sketch of Subiaco — but as there is a much finer specimen of a city on a hill at Cevara 8 miles distant — did not think it worth more time — indeed — having a plentiful stock of *subjects* I am not anxious to increase *them* but am wholly absorbed in trying to get that knowledge which is necessary to complete them. It is the fashion of the English Landscape Painters and Amateurs to say that fine subjects may be met with everywhere — now I think them extremely rare — having never for instance seen the wild winding romantic lane in any degree of perfection till I found it here. I have great hope from massed and classified study — and as I am willing to undergo any degree of labour and study and application — hope soon to reap a reward — but the shortness of remaining life and the quantity to be accomplished would distract me — if I had not reduced my mind into some degree of order — keeping my wants distinctly embodied before me — and not as a vague apparition to terrify me. I feel nature to be no longer a disorderly heap of beautiful matter perplexing from its intricacy and profusion but — a treasury able to supply every want of which the student is distinctly conscious. I long to leave study making — much as I have endeavoured to make it bear upon the great end and begin picture painting — with a constant reference to nature — ideally studied — but I expect the purer and higher desires of my mind will be much interfered with — by the almost necessary rivalry into which one is thrown in London with the popular art — the best of which however powerful tends to quite another end than the deep toned splendour and remote grandeur of Titian and the finest efforts of N. Poussin. — What a blessing shall I feel the National Gallery to be!

[2] At Tivoli.

As I have no high swelled notions about size I am ready to try my hand at drawings and pictures from two inches square and upwards so that I hope to produce much saleable matter — and to make the 'pot boil' with fuel 'kindled at the muses' flame'[3]. Little cultivated mountains are here in perfection — and in the neighbourhood much exquisite matter I suspect — finer than what we saw near Naples — Baiae always excepted which is a thing by itself. I am obliged to content myself now with little pencil sketches in a book — of beautiful distances — which I have drawn so often that I begin to know them by heart — I hope before writing again to have amassed a stock of the choicest wild foregrounds capable of framing and sustaining the grandest distances. The only *subject* I care to get before moving to Terni is Cevara — which from Sketches — I believe to be very first rate. I think I have at last attained to the art of *coming to the point* and avoiding the temptation to impertinent and superfluous labour — which after all is a much more formidable obstacle — than carrying any difficulty which lies straight in the way. I feel mind and body choked up just at present like a live bird half baked in a pye — so begging you will send any word of advice which may tend to enable me to paint a *consistent energetic-picture straight through* on my arrival in London I remain my dear Sir

<div style="text-align:right">

ever yours affectionately
Sam. Palmer

</div>

JOHN and MARY ANN LINNELL

23 June 1839 [Subiaco]

My dear Sir,

 I have just read your letter dated May 26 in which you say to me — speaking of the Loggias — 'notwithstanding all you assert to the contrary I am persuaded *you* never were favourable to the Commission.' I felt and justly felt so much hurt at this that I was going to say no more than that *notwithstanding* I remained yours affectionately etc. But among much besides which is open to criticism I think it necessary to note another passage especially as

[3] Gray, *Elegy Written in a Country Church-yard*, line 72.

you mention with such particular emphasis the necessity of being *explicit* in the *beginning* of our transactions. You say 'You have many tough bits of fatigue to encounter when you return before you can sit down quietly at work. While that is accomplishing however Anny must be *ours* again for a time.' I think I perceive in this and other passages that you expect us on our return to live under a sort of parental control. I do not like the word '*must*'. You know very well that there is no one to whom I have so often resorted for advice as yourself. But neither Anny nor myself can receive suggestions in any other 'shape'. Her filial affection and veneration will I hope always remain — her *obedience* is transferred to me and in whatever circumstances I may be placed. I hope never to be obliged to barter or sell that kind of manly liberty which is consistent with humility or meekness. As you seem to insinuate that I have been a hard task-master, no wonder that you wish to release Anny for a few weeks or months, on her return, from such iron bondage. But I believe that Anny is so well pleased with her *conservative* government that she would not readily change it for any other, and as I hope immediately on her return to place her in a condition more comfortable (though very very humble) than much that she has experienced on her travels, and as I think it would be for her benefit and comfort to remain with me, I am compelled to differ from you in my views of the future. As to the Sistine and the Loggia I shall say no more of what I have felt or done because you declare your disbelief in all I say. To mention my own leanings at all in the matter would come with an ill grace from me, and there is now a double reason for abstaining if it is to be marked with the stigma of falsehood. I therefore will only subscribe myself

<div align="center">Your injured but yet obliged and affectionate friend</div>

<div align="right">*Samuel Palmer*</div>

You will have heard by this time that the whole of the Loggias are done — the latter ones by colouring the prints. They are with the Sistines beautifully packed and at the bottom of our trunk.

My dear Mrs. Linnell,

Let me *conjure* you to correct that unjustifiable and distrustful anxiety which at once embitters and falsifies your views of the future. *You* WRITE calmly, Mr Linnell excitedly; but I know very

well that Mr Linnell's distress half arises from daily witnessing *your* unhappiness. *Why* should you be unhappy? Your daughter is well and unhurt, and has spent nearly two years in acquiring intellectual and moral power, and experience which will by the blessing of Divine Providence, lead her safely through the mazes of life. If you could have the advantage of a few such months of travel and adventure you would see the unreasonableness of all such hideous surmisings. Anny never thinks of the morrow, but endeavours to provide for it by doing the duties to-day. How odd it is that her cheerfulness — uniform cheerfulness has supported and cheered *me* in all times of depression and yet that this happy being has been unconsciously the cause of such hideous apprehensions. I hope you do not directly or indirectly attack Mr Linnell for letting her go for all your unfavourable prophesyings have been falsified and Mr Linnell has so many things to irritate and exhaust him that a continual annoyance at home will embitter if not shorten his life. You must excuse this plainness for I write as a sincere friend to him and to you, and though you carefully avoid expressing it in your letters out of kindness to Anny, yet I know what goes on at Bayswater as well as if I were there. Your family has been blessed beyond almost any other with health and prosperity — and you are almost beyond anyone else anxious and apprehensive. Excuse this for it is *true* and meant kindly by your most sincere and affectionate friend

<div align="right">*Sam^l Palmer*</div>

JOHN LINNELL

13 August 1839 [Papigno[1]]

My dear Sir

I think the falls will make a couple of shewy drawings — I would not have returned to England on any account without seeing what I have lately seen — since I have turned my attention peculiarly to foregrounds I have been happy enough to light on some very beautiful and *poetic* specimens and have found some

[1] A town in central Italy, north of Rome. Cf. Palmer's watercolour *Papigno on the Nar, below the falls of Terni* (Plate V).

which with the least touch of distance would make most poetic pictures. Our protracted stay in Rome and the dreadful heats have cut up a great part of our sketching season — but now though intensely hot — there are fresh breezes so that we have been able to get out again and are trying to redeem the time. There are some rocky and cavernous foregrounds here of a peculiarly beautiful character. I never till lately saw very *poetic* foregrounds, they have generally been merely simple matter calculated to sustain and accompany distances. I work now with much less *painful* effort than heretofore and get an equivalent result with a fourth of the labour I think — not trying to do it by 'main force' as you say — but dwelling on the essentials — the characteristics — almost every study in this place is a picture. As Florence is so proverbially hot I think it would be bad economy to get into narrow straits till the cool weather, especially as we have such a rich harvest about us. I am aware that our finances have not an encouraging super-abundance and shall continue moving Northwards as quickly as possible without sacrificing things in nature or art which may be very beautiful and calculated to repay us fourfold.[2] As Anny continues well we shall in future write once a fortnight — unless we hear that you wish a letter oftener. I remain in haste my Dear Sir

<div style="text-align: right">

Ever yours affectionately
S. *Palmer*

</div>

P.S. We live in a house all by ourselves and have our food brought up from the valley. The bolt of our outer door was so heated by the sun that at mezzogiorno it was painfully hot to my hand which was itself heated by walking in the sun. We have a bundle of Galignani's newspapers[3] and the diary of a Physician[4] which Mr. Martin bought and which have much amused us — it is the most powerful writing of the day in the novel class as far as I have read and contains some most powerful and m{anly} touches of pathos and passion — it is an old favorite of mine and I think every one should read it especially as it has a most moral and religious

[2] They finally reached England at the end of November. It was to be their only trip abroad.
[3] A sheet of news in English, published daily in Paris.
[4] Samuel Warren, *Passages from the Diary of a Late Physician* (1838).

tendency — though that would not be a very popular recom-
mendation — as it is to be feared that scepticism — covert or open
is becoming rapidly the religion of mankind —

II
Inscriptions,
Journals and Memoranda

FROM A SKETCHBOOK OF 1819[1]

This Study though the sketch is uninteresting was very good in nature —: the left hand hedge was soft at the edges and light and playful — and in the centre extremely dark; off which mass the grey stems and playful foliage relieved well — some nettles and dead sprigs also had effect. The willow behind the cottage was thin and playful.

Friday June 11. 1819 —
Sam. Palmer —

FROM PALMER'S TEENAGE JOURNALS[1]

N.B. in my attempts to copy the Antique statues[2] to try and draw most severely, and to cry out for more and more form; and then I shall find in the Antique more than I can copy, if I look and look and pry into it earnestly for form. I shall not be easy till I have drawn one Antique statue *most severely*. I cannot execute at all. The least bit of natural scenery reflected from one of my spectacle-glasses laughs me to scorn, and hisses at me. I feel, ten minutes a day, the most ardent love for art, and spend the rest of my time in stupid apathy, negligence, ignorance, and restless despondency; without any of those delicious visions which are the only joys of my life — such as Christ at Emmaus; the repenting thief on the cross; the promise to Abraham; and secondary visions of the ages of chivalry, which are toned down with deep gold to distinguish them from the flashy, distracted present.

[1] This inscription describes a watercolour sketch of a country lane. Palmer was fourteen years old at the time. The inscription is printed by courtesy of the Trustees of the British Museum.

[1] These journals do not survive; the words are those quoted by A.H. Palmer in his *Life and Letters* of 1892. The exact chronology is uncertain, and the order in which they have been placed is mine.

[2] John Linnell had advised Palmer to study the classical sculptures at the British Museum. This entry probably dates from 1823.

Look for Van Leydenish[3] qualities in real landscape, and look hard, long and continually. Look for picturesque combinations of buildings, and elegant spires and turrets for backgrounds.

As it seems reasonable to divide the soul's journey into stages and starting-points, and to stop and look back at certain intervals, and at each fresh stage to go back to the primitive and infantine feeling with which we set out; and to lay in such a store of humility, simple anxiety to get on, and diligence in the great, nay stupendous pursuit of grand art as may stand us in stead for a year's journey or so, I divide my life with respect to art into two parts. First, my very early years, in which I distinctly remember that I felt the finest scenery and the country in general with a very strong and pure feeling; so that had I then seen the works of the very ancient Italian and German masters I should have admired and imitated them, and wondered what the moderns could mean by what they call their 'effects'. Then, when I gradually learnt arithmetic and grammar, my feeling and taste left me, but I was not then completely spoilt for art. But when I had learned to paint a little, by the time I had practised for about five years I entirely lost all feeling for art, nor did I see the greatest beauties of even the Dutch Masters, Cuyp, Ruysdael[4] etc.; so that I not only learnt nothing in this space of time that related to high art, but I was nearly disqualified from ever learning to paint. But it pleased God to send Mr. Linnell as a good angel from Heaven to pluck me from the pit of modern art; and after struggling to get out for the space of a year and a half,[5] I have just enough cleared my eyes from the slime of the pit to see what a miserable state I am now in. . . . I have now made my first struggle — alas, with how little success. I shall now begin a new sketch-book, and I hope, try to work with a child's simple feeling and with the industry of humility.

[3] Lucas Van Leyden (?1494–1533), Dutch painter and engraver.
[4] Salomon van Ruysdael and Aelbert Cuyp (like Paulus Potter and Meyndert Hobbema, whom Palmer mentions shortly) were Dutch landscape-painters of the seventeenth century.
[5] Probably this was written in the spring or summer of 1824, by which time Palmer (thanks to Linnell) would have seen the collection of ancient master-paintings, including works by Memling, Petrus Christus and Jan van Eyck, owned by the German businessman Charles Aders.

Memoranda, day after going to Dulwich.[6] Cox is pretty — is sweet, but not grand, not profound.[7] Carefully avoid getting into that style which is elegant and beautiful but too light and super-ficial; not learned enough — like Barret. He has a beautiful sentiment and it is derived from Nature; but Nature has properties which lie still deeper, and when they are brought out the picture must be most elaborate and full of matter even if only one object be represented, yet it will be most simple of style, and be what would have pleased men in the early ages, when poetry was at its acme, and yet men lived in a simple, pastoral way.

Girtin's twilight, beautiful, but did he know the grand old men? Let me remember always, and may I not slumber in the possession of it, Mr. Linnell's injunction (delightful in the per-formance), '*Look at Albert Dürer.*' In what a simple way Landscape impressed the mind of Raffaelle; yet his little bits make me despair.

How superior is Mr. Linnell's style of colouring to that of any other modern landscape painter, and yet not half so captivating to an ignorant eye as others.

Look at Mr. Blake's way of relieving objects, and at his colour.

The copy of Leonardo da Vinci at Dulwich is merely a head and shoulders.[8] How amazingly superior it is in style to any portrait there. The tone of the flat blueish sky is wonderful, though it is nothing of itself. It is the colour of the soul, not vulgar paint. Ruysdael, Hobbema, Paul Potter, and Cuyp — how intense, how pure, how profound, how wonderful!

November, 1822 to June 9, 1824. — Now it is twenty months since you began to draw. Your second trial begins. Make a new experiment. Draw near to Christ,[9] and see what is to be done with Him to back you. Your indolent moments rise up, each as a devil

[6] According to A.H. Palmer, Samuel Palmer paid many visits to the Dulwich Picture Gallery at about this time; these notes record his impressions of a visit made in the company of John Linnell.

[7] David Cox (1783-1859), a water-colour painter whose influence is strong in Palmer's 1819 sketchbook. George Barret the Younger and Thomas Girtin were also painters of landscape.

[8] According to Geoffrey Grigson, this refers to *Portrait of a Young Man*, now attributed to Piero di Cosimo.

[9] Echoing the priest's invitation 'Draw near with faith. . .' at Communion.

and as a thorn at the quick. Keep company with the friends of Publicans and sinners, and see if, in such society, you are not ashamed to be idle. Ask Christ to manifest to you these things; Christ looking upon Peter (called *Repentance*) and Peter's countenance. Christ's promise to the dying thief — the looks of both. Christ leading His blessed to fountains of living waters[10] (which being the union of all vision, should be done as the artist's Prince); Jesus weeping at Lazarus' tomb. The three first are the chief, and are almost unpaintable — quite, without Christ. Lay up, silently and patiently, materials for them in your sketch-book, and copy the prints to learn such nicety in pen sketching, or rather, making careful studies, as may enable you to give the expressions. But smaller studies of separate glories of Heaven might be tried — hymns sung among the hills of Paradise at eventide; . . . a martyr, having painted his murder, laughing, or rather smiling at his torments. A family met in Heaven. . . .

On Saturday, 9th October, 1824, Mr. Linnell called and went with me to Mr. Blake.[11] We found him lame in bed, of a scalded foot (or leg). There, not inactive, though sixty-seven years old, but hard-working on a bed covered with books sat he up like one of the Antique patriarchs, or a dying Michael Angelo. Thus and there was he making in the leaves of a great book (folio) the sublimest designs from his (not superior) Dante. He said he began them with fear and trembling. I said 'O! I have enough of fear and trembling.' 'Then,' said he, 'you'll do.' He designed them (100 I think) during a fortnight's illness in bed! And there, first, with fearfulness (which had been the more, but that his designs from Dante had wound me up to forget myself), did I show him some of my first essays in design; and the sweet encouragement he gave

[10] From Revelation 7:17.
[11] For all their vividness and intensity, Palmer's scattered recollections of Blake betray an occasional confusion of detail. This famous passage has usually been taken as a description of their first meeting, and such is the clear implication in his autobiographical letter to F.G. Stephens (cf. p. 221). But in a fragmentary letter to Alexander Gilchrist, Palmer stated that Blake was working on the *Job* designs, not the later *Dante*, when they met. Palmer also remembered the favourable impression made on Blake by *The Milkmaid's Song*, a painting by T.G. Wainewright, which was exhibited at the Royal Academy in May 1824 — five months before the date given here. (cf. *Letters*, pp. 574, 595.)

me (for Christ blessed little children) did not tend basely to presumption and idleness, but made me work harder and better that afternoon and night. And, after visiting him, the scene recurs to me afterwards in a kind of vision; and in this most false, corrupt, and genteelly stupid town my spirit sees his dwelling (the chariot of the sun), as it were an island in the midst of the sea — such a place is it for primitive grandeur, whether in the persons of Mr. and Mrs. Blake, or in the things hanging on the walls.

January 2nd [1825]. — Now is begun a new year. Here I pause to look back on the time between this and about the 15th of last July. Then I laid by the *Family*[12] in much distress, anxiety and fear; which had plunged me into despair but for God's mercy, through which and which alone it was that despondency not for one moment slackened my sinews; but rather, distress (being blessed) was to me a great arousement; quickly goading me to deep humbleness, eager, restless inquiry, and diligent work. I then sought Christ's help, the giver of all good talents[13] whether acknowledged or not, and had I gone on to seek Him as I might, I had found His name to me as a civet-box and sweeter than all perfume.[14] Notwithstanding, as it was, I think (by Him alone) I improved more since I resolved to depend on Him till now, than in the same time ever before; and have felt much more assistance and consolation. For very soon after my deep humblement and distress, I resumed and finished my *Twilight*, and quickly took up my *Joseph's Dream*, and sketched in my new sketch-book. Mr. L. called, and looking at my *Joseph*, sepias, and sketch-books, did give me indeed sweet encouragement. Soon, by his desire, I went with him to Mr. B., who also, on seeing my things, gave me above my hope, over-much praise; and these praises from equally valued judgements did (God overruling) not in the least tend to presumption and idleness, and but little to pride; for knowing my own stupidness (but not alas, to its full) I gave back the praise to God who kindly sent it, and had granted to me desponding, that at eventide it should be light.

[12] Probably *The Repose of the Holy Family* (Ashmolean Museum, Oxford).
[13] Cf. the Collect for the seventh Sunday after Trinity.
[14] From Mr. Standfast's declaration at the end of *The Pilgrim's Progress*, II.

FROM THE 1824 SKETCHBOOK[1]

15 July 9 o'clock P.M.
Seen in Midsummer. At that time of twilight when the azure behind a high spired turret was very cool but almost blueless. The chastened glow of the light tower against it was very beautiful, the sky being textureless and without a cloud but what I write this for is to remark that though all was low in tone, as preparing to receive the still and solemn night, yet the tower on which the last light glimmered seemed luminous in itself and rather sending out light from itself than reflecting it, and I noticed it on other stone buildings going along — that it was as if they had inherent light somewhat reminding one of mother-of-pearl — it was luminous though pale faint and glimmering. Nothing but the melting of many gradations in the lights opposed to elaborate shadows and architectural members near to it, the sharpness of the cool shadows against the cool sky etc., could I should think give that mild glimmering poetical light of eventide.

It would be false in order to make the warmth of the above buildings greater to exaggerate the blueish tint of sky behind them and make it perfect blue, for then the warm stone colour would not have strength to bear out against the blue — so that perhaps we should oppose a brilliant coloured cool (as ultramarine) and a nearly neutral warmth to a nearly neutral cool — though an elaborate building with strongly marked shadows would through a neutral tint bear out against a *flat* mass of the most vivid colour, but the colour of twilight is another thing.

[1] The basis of A.H. Palmer's *Life and Letters of Samuel Palmer* was the 'kind of skeleton autobiography' provided by 'more than twenty . . . large, clasped pocket-books' in which throughout his life the painter recorded his emotions and analysed his impressions. When he prepared *Life and Letters*, however, A.H. Palmer did not have access to this early sketchbook which had been given to Samuel Palmer's old friend George Richmond. It passed to A.H. Palmer after Richmond's death, and he spared it from the fire which seems to have consumed all the other pocket-books in about 1910.

It should be borne in mind that many of the entries printed here accompany sketches in the original. The facsimile edition of the sketchbook, published in 1962 for the William Blake Trust with an introduction by Martin Butlin, gives an excellent idea of the wealth and range of visual imagery with which the young Palmer was blessed.

The poems 'Twilight Time' and 'The Shepherds' Home', printed on pages 133 and 137, come from this sketchbook. In many of the entries I have found it necessary to add punctuation; I have tried to do so unobtrusively.

Sometimes the rising moon seems to stand tiptoe on a green hill top to see if the day be going and if the time of her vice regency be come

A large field of corn would be very pretty with as it were islands peeping out of it — a clump of cottages completely inclosed and shaded by trees — the corn being high, no part of the little isles in this wavy sea of plenty would be seen till they were perhaps 5 or six feet from the ground — only a clump of elm trees rising distinctly from the midst would be pretty.

A group of different sex and age, reapers, might be shewn in the foreground going down a walk in the field toward the above cottage island, and over the distant line that bounds this golden sea might peep up elysian hills, the little hills of David, or the hills of Dulwich or rather the visions of a better country which the Dulwich fields will shew to all true poets.

N.B. Keep the landscape feeling from encroaching upon the figure feeling.

These leaves were a gothic window but sometimes trees are seen as men. I saw one a princess walking stately and with a majestic train. This wall should be covered with ivy.

Remember the Dulwich sentiment at very late twilight time with the rising dews (perhaps the tops of the hills quite clear) like a delicious dream

Useful to know by this if in a building with many angles against the sky one wants to neutralize the keenness of the light against one or more of them, to do it by this lace work which enriches the building and makes it also more solid. Also on walls grow the most dotty light things — what a contrast! and they may be near large clumps of chesnut trees perhaps with leaves as long as a

man's fore-arm — also *soft* velvet moss on a *hard* brick wall moss *green* wall *red*

The colour of ripe corn gives to the green trees about it increased depth and transparent richness.

These streaks were as when one throws a stone into the water which spreads out circles. They were caused thus: heaps of reaped corn were laid in lines across the fields — I think Titian felt streaked fields

Opposite the cottage was (across a little valley where they were cutting corn) a range of hills — you walk up, the sheep bells going all the time, through several fields (of different sorts, rye, hops, fallow, meadow) of colour, form, and texture various — then you come to the line of thick wood which runs all along the summit very close wild and intricate, yet such as you would wish to explore guided by one that knows its mazes to a shaded cottage and garden of sweet herbs and flowers in the midst where you might forget the wretched moderns and their spider's webs — and their feasts on empty wind thistles and dung — it's a dog refusing plum pudding would lap up a vomit.[2]

Place your memorandums in your book more neatly you dirty blackguard — then you may in coming time refer to them with pleasure and see that you begin over leaf or I shall stand here a witness against you.

A monastic figure with much background of Gothic Cathedral

The time twilight — the pinnacles and enrichments in light painted with silver and toned down to the many gradations of colour and shadow, warmish tones and elaborate feeling of that time in summer evenings when those venerable buildings seem no longer to be brute matter but with a subdued solemn light which

[2] Echoing 2 Peter 2:22, but Palmer may have found the image in Hopeful's discourse in *The Pilgrim's Progress*, I.

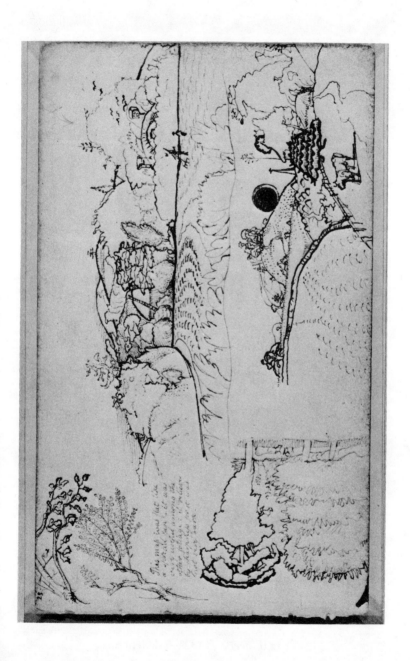

Plate II (*overleaf*) 1824–5 sketchbook

seems their own and not reflected send out a lustre into the heart of him who looks — a mystical and spiritual more than a material light. And with what a richness does it beam out from the neutral coolness of the quite flat sky behind it — it is indeed such a precious, luminous tone that though it is not perhaps really lighter than the sky, and only as light in the very highest lights, yet it shows as a mass light from the sky — the silvery, to paint all the lights in with at first would be invaluable — the light not for instance of the clustered columns, or among the fretwork rising up a broad pinnacle of unadorned face, a mass of silver there would tell indeed.

So exquisite is the glistering of the stars through loop holes in the thick woven canopy of ancient elm trees — of stars differing in glory, and one of prime lustre piercing the gloom — and all dancing with instant change as the leaves play in the wind that I cannot help thinking that Milton intended his 'Shady roof Of branching elm *star proof*'[3] as a double stroke — as he tells of the impervious leafy gloom — glancing at its beautiful opposite — 'Loop holes cut through thickest shade'[4] and in them socketed the gems which sparkle on the Ethiopic forehead of the night.

This mass was flat like a spread fan — it was very useful among the other foliage: it relieved by sharpness for it was not very dark.[5]

Remember that most excellent remark of Mr. B's — how that a tint equivalent to a shadow is made by the outlines of many little forms in one mass, and then how the light shines on an unbroken mass near it, such for instance as flesh etc. This remark alone if generally acted upon would go a good way toward the much hoped for and prayed for revival of art.

[3] *Arcades*, lines 89–90 (italics by Palmer).
[4] *Paradise Lost*, IX, 1110.
[5] Reproduced as Plate II.

The moon also to rule by night for his mercy endureth for ever[6]

To prevent meagreness of composition from single limbs might it not be useful sometimes where there are several figures to cluster together several limbs into one full mass?

A statue[7]

Day of Pentecost	under this — subjects of inspired poets painters and musicians perhaps met in heaven.
Foundation of the Church on S. Peter	Under this — subjects of the sacraments and duties of the minister visiting the sick etc. — all the ceremonies of the church

A statue S. Paul

Crucifixion

The Lamb shall lead them to living fountains of waters[8] etc.	All the little pictures under this to be of the sufferings of saints and martyrs.

Resurrection

A statue S. Peter

Creation of Adam	under this the great works of the old worthies Samson David Jephtha Elijah Moses etc. etc.

[6] Psalm 136:1.
[7] This page offers what might well be called a map of a high altar. As a young man, Palmer had no inhibitions about placing 'inspired poets' in a position as exalted as 'the old worthies'.
[8] From Revelation 7:17.

He made great lights Under this picture — little ones of
labourers going out at sunrise
coming home to their families and
meeting them near the door the
horned moon rising — the harvest
moon — ascending fields ripening of
all kinds of grain, Fruit and forest
trees, cottages and churches with
proper sentences on each
Also a starlight.

A statue

A grand subject for a series of pictures would be perhaps — The
springing of man from God and the fellowship of God and man in
the patriarchal ages — then the Kingdom of Satan in murders
battles lusts and God's judgments on them — Lastly the more
abounding blessing in Christ till all is consummated in heaven —
from 'The Lamb shall lead them' etc.

 In this last part should perhaps be introduced those two most
wonderful but I am afraid unpaintable subjects, the look of his
denyed saviour which pierced S. Peter's heart and that more
thrilling look from Jesus in agonies of the cross, on the converted
thief —

I Beheld Satan fall Like LIGHTNING From heaven[9]

Note. that when you go to Dulwich it is not enough on coming
home to make recollections in which shall be united the scattered
parts about those sweet fields into a sentimental and Dulwich
looking whole. No. But considering Dulwich as the gate into the
world of vision one must try behind the hills to bring up a mystic
glimmer like that which lights our dreams. And those same hills,
(hard task) should give us promise that the country beyond them
is Paradise — for to the wise and prudent of this world what are
Raffaelle's backgrounds but visionary nonsense, what the back-

[9] Reproduced as Plate III.

ground of the Last Supper but empty wind — and its figures but a party of old fashioned Guys at supper? What to a waddling alderman is Raffaelle's heavenly colour? The body and mind both in sweet union nourished, with solid facts and still more solid pudding, forming their notions of loveliness from their ladies, straddling, scrofulous and oily, with faces richly imbrowned with youthful servitude and blazing kitchen fires, whence did their charms advance them to grease their masters' sofas which once they dusted. What wonder that the Alderman surrounded with nymphs like these, fair city Naiads swimming in greasy grandeur like sops in dripping — should worship the immortal Rubens? should laud him king of nature, should trace in his St. Elizabeths their wives, in his Madonnas their daughters, should hail his colour as the tone of nature and his luscious handling as the outline of a melting oil man's widow?[10]

Solid facts solid beef and solid gold needs must kill the visions of —— and M. Angelo — what would the *prudent* Ass dining *substantially* on thistles, care for a peach or nectrine dropped into his mouth? Why he scarce would feel them at all, or would, insulted with such a mockery of hope bray out his anger.

But God reveals not the beauties of ancient art to the wise and prudent but to babes; to the self abased, to the mourners in Zion. 'Even so Blessed Father. for so it seemeth good in thy sight.'[11]

I saw in my spec. glass the most wonderful miniature which note I well nor heedless let it slip. In it these 3 textures struck upon the eye instantly. 1st the firm enamel of a beautiful young face, with 2nd going down from the forehead smooth and unbroken over the shoulders, Hair, wondrous sleek, and silkily melting (in long hairs more thin than man can do) into 3d. a background of the crisp mosaic of various leaved young trees thinnishly inlaid on the smooth sky — so that there was an extreme soft between two kind of hards.

These trees brilliantly lighted up by the rising sun, those parts brightest against the line of the field which was in shadow but

[10] '*Oilman*, one who trades in oils and pickles.' (Johnson)
[11] Cf. Matthew 11:25,26

I Beheld Satan fall
Like LIGHTNING
From Heaven

Plate III

white with frosty dew and as light perhaps in tint as the illuminated trees which cut against its edge. The green rich and autumnal.

Note perhaps at sunrise the light makes more massy lumps of brightness than the sunset.

The mass particularly the corner to be very bright. Mark that the petty coat be white N.B. That dark stem close behind the cottage is that dotty kind and its dots are to be an intermediate background between the rich color'd light trees and the blue sky — its branches distinguished by their darkness — whatever you do guard against bleakness and grandeur — and try for the primitive cottage feeling gospel instead of law for we are not come unto the ma[ster][12]

Now begin to finish the cornfield-picture bit by bit finish it now as you go — and *execute* each bit with what refinement you can.

In the coast drawings try this way, begin sparing no pains to copy from the sketches carefully in pencil very faint and with the utmost correctness: then perfect those lines with a very fine pen so that the objects shall all be palpable and the outline very clean tho' faint

Then presently begin to insert those masses of little forms like the leaves of a near tree, which *serve instead of shadows* and *themselves make a tint* all this while fattening up the outline, till as near as you can get it you make it like the prints of the Georgics,[13] getting in the minutenesses too ere the colour be begun.

Sky, cool neutral twilight colour
moon brilliant silver
Cottage front Mother of pearl lustre
And the whole landscape lustrous
with the morning twilight

[12] The last few letters are illegible, and I have followed Geoffrey Grigson's conjecture of 'master'.
[13] Probably he meant Blake's woodcuts after Virgil's *Eclogues*.

Mem. A twilight in Saturn with the ring diverse color'd and joining and parallel to the horizon. The ring like streaks of light in the horizon and the highest light of the picture — and all manner of colors. Or it might be done with the ring oblique like an immense rainbow.

These very high elms fill up with all manner of richness the sinking of the building between the two towers

Looking at grass with one's face to the sun, he shines through each blade making masses of the most splendid green; inimitably green and yet inimitably warm so warm that we can only liken it to yellow and yet most vivid green. Now looking towards the sun, light transmitted through objects is warmest and reflected from them coolest so among these splendid masses some dewy points of grass reflect very cool, white and grey, and the earth in this position looking to the light appears coolest, and here it has the advantage of the contrast of the transparent grass so that in this effect where grass is warmest are to be found the coolest tints and touches to freshen it, but where earth in shadow (quite purple) comes immediately against grass in transmitted light the effect is indeed splendid.

 We observed the shadows in Greenwich Park in the morning so purple and cool that had the colour of the lights been also laid over where the shadows were to come, the shadow colour would exactly have been made with bold touches of purple made of brilliant blue and lake.[14]

[14] Palmer uses 'lake' here in its old sense of a red pigment.

I sat down with Mr. Blake's Thornton's *Virgil* woodcuts[1] before me, thinking to give to their merits my feeble testimony. I happened first to think of their sentiment. They are visions of little dells, and nooks, and corners of Paradise; models of the exquisitest pitch of intense poetry. I thought of their light and shade, and looking upon them I found no word to describe it. Intense depth, solemnity, and vivid brilliancy only coldly and partially describe them. There is in all such a mystic and dreamy glimmer as penetrates and kindles the inmost soul, and gives complete and unreserved delight, unlike the gaudy daylight of this world. They are like all that wonderful artist's works the drawing aside of the fleshly curtain, and the glimpse which all the most holy, studious saints and sages have enjoyed, of that rest which remaineth to the people of God.[2] The figures of Mr. Blake have that intense, soul-evidencing attitude and action, and that elastic, nervous spring which belongs to uncaged immortal spirits . . .

Excess is the essential vivifying spirit, vital spark, embalming spice . . . of the finest art. Be ever saying to yourself 'Labour after the means of excellence' . . . There are many mediums in the *means* — none, O! not a jot, not a shadow of a jot, in the *end* of great art. In a picture whose merit is to be excessively brilliant, it can't be too brilliant; but individual tints may be too brilliant. . . . We must not begin with medium, but think always on excess, and only use medium to make excess more abundantly excessive. . . . I was looking with Mr. L: at one of Bonasoni's emblems,[3] a rope-dancer balancing himself with this motto, *In medio est salus*. 'Yes,' said he emphatically, 'for a rope-dancer; but the rope-

[1] Among Palmer's most treasured possessions was the set of signed proofs of these illustrations, made by Blake for Dr. Robert Thornton's edition of *The Pastorals of Virgil* (1821). These remarks probably date from the winter of 1824-5. Here and in the following entries, Palmer's statements about excess, vision and imagination show the strong influence of Blake. The text for all the notebook entries, 1824-1835, is taken from *Life and Letters of Samuel Palmer* by A.H. Palmer, who almost certainly tidied up his father's prose.

[2] Yeats quoted this in 'Under Ben Bulben', calling it 'Palmer's phrase'. In fact Palmer had found it in Hebrews 4:9.

[3] Giulio Bonasone, sixteenth-century engraver and painter. 'Mr. L:' is of course John Linnell.

dancer only keeps the middle that he may be not a middling, but
an excessive fine performer. . . .'

Well would it be, if those who hope at last to produce works of
exquisitest beauty were constantly haunted . . . urged, and lashed
by this truth, that the more quietly they take things now, the
more pleasures they allow themselves, the less distressful the
anxiety of weighing but a little too light in the balances, the less
rigidly sublime the ideal goal, by so much will be the vale of life
the gloomier — the murkier the sunset with the thickening
horrors of a stormy night. Sometimes for weeks and months
together, a kindly severe spirit says to me on waking in the
morning the name of some great painter, and distresses me with
the fear of coming short at last; and I think it is then I do most
good.

Though I hope we shall all be severe outlinists, I hope our styles of
outline may all be different as the design of Michael Angelo from
his equal, Blake, and the outline of Albert Dürer from that of
Andrea Mantegna. There is no line in nature, though excessive
sharpness. Nature is not at all the standard of art, but art is the
standard of nature. The visions of the soul, being perfect, are the
only true standard by which nature must be tried. The corporeal
executive is no good thing to the painter, but a bane. In pro-
portion as we enjoy and improve in imaginative art we shall love
the material works of God more and more. Sometimes landscape
is seen as a vision, and then seems as fine as art; but this is seldom,
and bits of nature are generally much improved by being received
into the soul, when she thinks on such supernatural works as Mr.
Linnell's picture by Lucas Van Leyden. . . . Often, and I think
generally, at Dulwich, the distant hills seem the most powerful
objects in colour, and clear force of line: we are not troubled with
aerial perspective in the valley of vision. . . . Genius is the
unreserved devotion of the whole soul to the divine, poetic arts,
and through them to God; deeming all else, even to our daily
bread, only valuable as it helps us to unveil the heavenly face of
Beauty. . . .

It was given me this morning (16th October, 1825), to see that I had done wrong in seeking for Mr. Bennett's pictures,[4] visions more consonant with common nature than those I received, at my first regeneration, from the Lord. I will no more, by God's grace, seek to moderate for the sake of pleasing men . . .

The artist who knows propriety will not cringe or apologize when the eye of judgement is fixed upon his work. And the artist who knows art, ere he bring his work forward to the envious world, or hope for the admiration of the few select discerners, will elaborate it to his utmost thought; if indeed, material tablet can receive the perfect tracings of celestial beauty . . .

Young as I am, I know — I am certain and positive that God answers the prayers of them that believe, and hope in His mercy. I sometimes doubt this through the temptation of the Devil, and while I doubt I am miserable; but when my eyes are open again, I see what God has done to me, and I now tell you, I *know* that my Redeemer liveth.[5]

At Shoreham, Kent, August 30, 1826. God worked in great love with my spirit last night, giving me a founded hope that I might finish my *Naomi before Bethlehem*, and (to me) in a short time. . . . That night, when I hoped and sighed to complete the above subject well (it will be my maiden finished figure drawing), I hoped only in God, and determined next morning to attempt working on it in God's strength. . . . Now I go out to draw some hops that their fruitful sentiment may be infused into my figures[6]. . . .

[4] Palmer had received a commission from a Mr. Bennett (perhaps a relative), to whom he had delivered a group of five paintings and six drawings. Mr. Bennett's reaction is unknown.

[5] Job 19:25. If A.H. Palmer was right that this entry was written 'at twenty', it must date from the year preceding 27 Jan. 1826.

[6] Because of this line Geoffrey Grigson suggested (in *Britain Observed*, 1975) that Palmer had read Horace Walpole's *Anecdotes of Painting in England* (1762), in which Walpole regrets the absence from English art of such homely and picturesque objects as haycocks and hopgrounds. It seems to me even more likely that Palmer had been reading *On Painting. To a young Artist* by the Quaker poet John Scott (1730-1783), which includes a versification of the Walpole paragraph in question. Scott then goes on to list other suggestive topics for painting, such as village lanes in spring, when the clouds hang over newly green trees, 'Or where the orchard's sun-gilt branches spread / Their bloom of white, or faintly-blushing red' (*The Poetical Works of John Scott*, London, 1808, Vol. 39 of *The Works of the British Poets*, p. 148).

August 31. We do or think nothing good but it has its reward. I worked with but little faith on my *Naomi before Bethlehem* this morning and succeeded just in proportion. After dinner I was helped against the enemy so that I thought one good thought. I immediately drew on my cartoon much quicker and better. . . . Satan tries violently to make me leave reading the Bible and praying. . . . O artful enemy, to keep me, who devote myself entirely to poetic things, from the best of books and the finest, perhaps, of all poetry . . . I will endeavour, God helping, to begin the day by dwelling on some short piece of scripture, and praying for the Holy Ghost thro' the day to inspire my art. Now, in the twilight, let Him come that at evening-time it may be light.[7] God bless my father and brother and poor dear old nurse; who, though a misled Baptist, shall sing among the redeemed for ever. . . . The last 4 or 5 mornings I thank God that He has mercifully taken off the load of horror which was wont so cruelly to scare my spirits on awaking. Be His great name ever blest; He persists to do me good, spite of myself, and sometimes puts into my mind the unchangeableness of His promise, the reality of future things. Then I *know* that faith is the *substance* of things hoped for, the *evidence* of things not seen. . . .

Wednesday. Read scripture. In morning, ill and incapable, in afternoon really dreadful gloom; toward evening the dawn of some beautiful imaginations, and then some of those strong thoughts given that push the mind [to] a great progress at once, and strengthen it, and bank it in on the right road to TRUTH. I had believed and prayed as much or more than my wretched usual, and was near saying 'what matter my faith and prayer?', for all day I could do nothing; but at evening-time it was light; and at night, such blessed help and inspiration!! O Lord grant me, I beseech thee grant, that I may remember what THOU only showedst me about my *Ruth*. . . .

Thursday. Rose without much horror. This day, I believe, I took out my *Artist's Home*, having through a change in my visions got displeased with it; but I saw that in it which resolved me to finish it. Began this day with scripture.

Friday. So inspired in the morning that I worked on the *Naomi before Bethlehem*, which had caused me just before such dreadful

[7] For this favourite phrase of Palmer's, cf. Zechariah 14:7.

suffering, as confidently and certainly as ever did M. Angelo I believe.

Let not the painter say 'I have done many pictures, and therefore should be able to do this less carefully;' for each time invention is a new species though of the same genus. . . . If the painter performed each new work with that thirsting of mind and humility of purpose with which he did his first, how intense would be the result.[8]

Some of my faults.[9] *Feebleness* of first conception through bodily weakness, and consequent timidity of execution. No first-conceived, and *shapely* effect. No rich, flat body of local colours as a ground. No first-conceived foreground, or figures.

Whites too raw.	Greens crude.
Greys cold.	Shadows purple.

RIDGES OF MOUNTAIN ALONG OPEN COUNTRY.

(1) Base the subject on a neutral–tint effect like Varley's[10] little drawing, so that at the beginning the great shapes of the lights shall be forcibly announced. (2A) Invent at once the great masses of Local Colour, and aim at once at a splendid arrangement. (B) Blocks of local colour before the small varieties. (3) Carry on the drawing till real illumination be obtained. Investigate on some simple object what are the properties of illumination and shade. (4) If possible, complete at whatever struggle the foreground and figures at the time. (5) Let everything be colour, and not sullied with blackness. Think of some of Titian's things, as *The Entombment*. (6) CLEANNESS OF TINT. Try to get something beautiful in the first design.

[8] Written in 1830, according to A.H. Palmer.

[9] Probably dating from 1834-5. The second part of this worried entry consists of suggestions for his future work.

[10] Presumably John Varley (1778-1842), water-colour painter, astrologer, and famous but impoverished teacher; a friend of Blake.

THREE INSCRIPTIONS[1]

Weir End In one part of the wall the interstices had been fill'd with mortar so that the breadth of stones and mortar between were of the same colour — there was a gradation from the marked divisions to a mingling together in which the distinctions of stones were almost lost. (*A House and Garden at Tintern*, Plate IV)

[At top] Thorne 2 miles from Manston Mrs. Wooten — on Canterbury Road from Ramsgate.

[Under two sketches of barley] BARLEY — Average height as it stoops is between two and three feet. About as light as Rye but very golden — much lighter than wheat.

[Beside a sketch of oats] The lights here thro' haste are spotty and exaggerated. The shapes in reality are most elegant yet scarcely visible at first. Thro' the delicacy of the heightening, heightening without touches of dark —

[Under another sketch] OATS The most playful and elegant shapes are made out by high lights on a light ground. Height as it stoops about 3 feet. Deep toned woods come finely behind it.

[Beside a sketch of wheat] Wheat — General scheme. The golden-amber-or greenish straw the midd tint — ears darker and more red — Looking against sunset light the transparent husk of the ear forms a thin golden halo round it — the ears being darks off the transparent tone of the straw. This is varied with high poppies sometimes almost as high as the corn — with purple and white flowers and blue — sometimes little tendrils of flowers entwine the stalks of straw.

[Beside a close-up of a head of grain] WHEAT The same three-fold structure on the other side but the respective heights alternate.

[1] Each of these inscriptions accompanies a picture by Palmer which is reproduced in this book. The first may be compared with his letter from Tintern (p. 50) of 19 August 1835. The second is one of those 'studies of botanical minutiae' which Palmer mentioned in a letter to L. R. Valpy (pp. 227–8). The third is of uncertain date; it may well have been made on a visit to Cornwall or north Devon. Mimi Cazort, Curator of Drawings at the National Gallery of Canada, suggested to me that it might be Tintagel, and Palmer is known to have studied waves on Trebarwith Strand nearby (cf. *Letters*, p. 693). He visited Cornwall in 1848 and 1858.

Drawings such as these show the benefit Palmer had gained from John Linnell's advice in the 1820s to examine nature in detail, advice that he initially followed with some reluctance.

114

Plate IV *A House and Garden at Tintern*

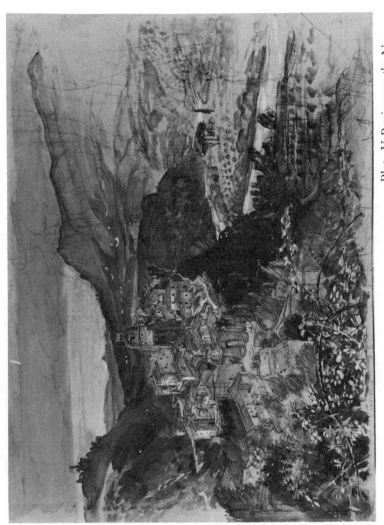

Plate V *Papigno on the Nar,*
below the Falls of Terni

Plate VI Study of Barley, Oats and Wheat

Plate VII *Study of Waves Breaking upon a Seashore*

[Beside three studies of wheat-heads] Profile not alternate units but each is one extremity of the frontal triad (with its husks) foreshortened. (*Study of Barley, Oats and Wheat*, Plate VI)

Windy day — tide coming in over sands. The two ridges below were terminated here and there by little waves. At B and C a leap of the foam about to fall — to the left of D — So: blown aside by wind. At AA the returned foam lifted upon the slope of the impending wave. The lower part consists of returning water and foam — Cloudy day under the bird central weight of foam pushing up each side (*Study of Waves Breaking upon a Seashore*, Plate VII)

MEMORANDA AND JOURNALS, 1839–1845

Was brought by the goodness of God into my 34th year.[1] Now I must either at once produce fine finished works, or 'live a fool and die a brute'. After wandering through labyrinths one comes back to first principles. The outline, after all, I believe to be the great difficulty; the only first step and great accomplishment of art. When a pure and expressive outline is on the paper, the prey is caught. The rest is like cooking and garnishing it.

Supposing lessons stop,[2] and nothing more is earned — avoid snuff, two candles, sugar in tea, waste of butter and soap . . . But it is more difficult at present to get than to save. Query. Go into the country for one month to make little drawings for sale?

Our professional experience, 1842. February 3, I went to the British Gallery, and found both my pictures and one of Anny's

[1] According to A.H. Palmer, this was written in his father's pocketbook on 27 Jan. 1839. The text of all the journals and memoranda, 1839–1845 (except for the sheet of notes dated 1844), is taken from *Life and Letters* (1892).
[2] A notebook entry for 1840, the year after the Palmers returned from Italy.

rejected. March. Mr. Ruskin and others were shown our drawings. Mr. Nasmyth was to name me as a teacher to Admiral Otway. I offered Miss B—, Addison Road, to teach one pupil for 10s per annum. Went to British Artists, and found one picture hung near the ceiling, another rejected, and Anny's *Job* rejected. Mine were the same pictures I sent to the B: Gallery, for the new frames for which I had paid £5 8s.

Monday, April 17, 1843. — Taking-in day at the Water Colour.[3] Thoughts as to my next year's painting if my unworthy life be spared. Try to make my things first Poetic; second Effective.

POETIC	EFFECTIVE
By doing subjects I love and greatly desire to do. BRITISH; ROMANTIC; CLASSIC; IDEAL.	By studying phenomena in the country, laying the great stress upon small — very small sketches of effects; always making, at the same time, at least a small pencil outline of the matter; and that I may not be solicitous to produce showable pictures in the country, let me now, at home, do all I can for the next Water-colour exhibition.

1844[4]

WHITE in FULL POWER from the first
Remember blazing days wherein it makes midd-tint local colors in sunshine seem dark
AND GRAYS COOLER THAN WHITE —
WHITE NOT TONED WITH ORANGE but in juxtaposition with the PRIMITIVES

[3] His prospects had brightened to some extent as a result of his election to associate membership of the Society of Painters in Water-Colours.
[4] Previously known only from an abridged version printed by A.H. Palmer in 1892, these notes, made in pencil and ink on both sides of a long sheet of grey cardboard, give an intimate glimpse into the mind of a struggling painter. They are published by courtesy of the Victoria and Albert Museum.

DEADLY DARK BROWNS LAID ON AT ONCE

SIZES — SKREENS 8th Imp LONG — perhaps upright with base of
frame measuring 17½ inches — ¼ imp with frame 17½.
KITCAT[5] — peculiar shapes as O or ○ in pairs —

To get vast space what a world of power
 does Aerial Perspective open!
—from the dock leaf at our feet— far — far
 away to the isles of ocean — and thence
 far thence into the abyss of boundless
 light — —— O! what heavenly grays does this suggest

 one flat tint relieves very distinctly from another
Stothard[6] spoke of the value of flat tints

For luxurious VEGETATION combined with ROCK —
 BORRODALE[7] and the banks of KESWICK — living at
 LODORE — crossing the mountains thence to WATENLATH
 occurs that 3 forking rock
 ALSO here are (or were) very grand fir trees — sycamores etc.

 CRAYON READINESS for SKIES AND EFFECTS
 D.V.

The RETREAT[8] GLOVER'S CHART of AERIAL and TEXTURAL
PERSPECTIVE CLAUDE'S UPRIGHT SLIPS.

[5] A kitcat measures 36 by 28 inches.
[6] Thomas Stothard, R.A. (1755-1834), genre painter.
[7] Borrodale, Keswick, Lodore and Watendlath are all found in the Lake District,
which Palmer was not known to have visited. On 20 February 1837, however,
the diarist Henry Crabb Robinson reported that Palmer visited him to enquire
about Westmoreland waterfalls. As Palmer's movements in the spring and
summer of 1837 are unknown, it seems more than likely that he did in fact visit
the Lake District then. (A.H. Palmer omitted this passage.)
[8] Presumably this refers to the tendency of cool colours, such as blues and greys,
to recede from the viewer; aerial perspective suggests that the background of a
picture should be less distinct in colour and outline than its foreground. John
Glover (1767-1849), a water-colour painter and teacher, is mentioned in George
Pyne's *Perspective for Beginners* (London, 1852) in the same breath with Claude as
a master of aerial perspective. But 'upright slips' eludes me.
 In 1825 Palmer had written in his journal, 'we are not troubled with aerial
perspective in the valley of vision' (p.00).

WHITE BUILDING in FULL SUNSHINE — RIGID IMITATION of relative and neighbour darks and colors

Foreground with Distance in full Sunset Blaze — for Corpo di Cava

SUNSET BEHIND TREES — for Deserted Villa

LANE with TREE SHADOWS and FLARES of LIGHT and Figure

FOREGROUND against DISTANCE

ONE BIT of MIDD DIST WOOD MOST RIGID

SLIGHT SKETCHES of APPLICABLE FOREGROUNDS.

LOCAL COLORS of DISTANCES — done with a
SUB PALETTE[9] Yellow Red Blue over the bright
RW UMBER MADD: BROWN Ultra Ash preparation —

STIPPLE or LABOURED VIOLENT
ADVance the foregrounds early On the strong preparers work
Think more then[10] work upon most tenderly Particularly on
distances distances —

If spared to 1845 September a batch of Imitation

WHITE BLACK and GRAY manifest the colors — and the colors
give White Black and Gray beauty and a value as color
 Mr. Cristall[11]

[*overleaf*]

The dazzling sunrise light when sun is [illegible[12]] less. — against dark angular mass of near rock and also[?] against dist city or prospect

[9] i.e., the pigments raw umber, madder brown, and ultramarine ash.
[10] Difficult to read; A.H. Palmer printed 'than'.
[11] Joshua Cristall (1767-1847), landscape painter.
[12] The faded pencil notes are extremely hard to read here, and my readings of the next few lines are far from confident.

The streaky sunrise light — or that which is gen [?] painted like streaky colors on plumage

Begin[13] Four large viz — The 2 Park Place sunsets — 3 Joshua (Harlech) and 4 The [illegible] —

LARGE

The Clear Cloudless Sunset — and do with tree stems — and sun shining through —

1 LONG — Clear sunset Avernus — and gray temple

2 Naples from Vomera Intense Italian Evenings light

3 The Corpo di cava Mountains [tiny sketch]

4 The hour after sunset — Harvest Moon rising

5 The Gleaning Field

6 Bay of Baiae

7 Children run

2 MIDDLE SIZE FLIGHT into EGYPT
 and Roman sunset — (on Rome)

NB Grey mist and cloud effects on mountain
 reserve for 8th Imp. and ¼ Imp. — or afterwards
 also Jacobs Dream — Noli me tangere — and
 Angels appearing to Shepherds

NB — The unhotpressed Royal London Board (Newman's)[14]
 measures 21¾ full by 17¾ rather full and cuts into 6 Long
 Shapes measuring 10⅞ by 5⅞ and half an eighth

[13] Palmer painted several of these subjects in the following years. Among others, *Jacob Wrestling With the Angel* was exhibited in 1844, *Florence and Val d'Arno* in 1845, and *The Gleaning Field* in 1848.
 Lake Avernus, Vomero, Corpo di Cava, the Bay of Baiae and Cevara are all places that Palmer visited in Italy in 1838-9.
[14] An artists' colourman in central London.

119

THE EIGHT SUBJECTS. SUNSET ON ROME — CIAVARA — FLORENCE
— ST. MICHAEL — CORPO di CAVA — DESERTED VILLA — NAPLES
— CHILDREN RUN — BUILDING THE SHEAF — BAY of BAIAE —

Where the scheme[15] is a great mass of dark under the sun, then
cool local colours below are called for, as ruins or gray rocks. And
I think the one vivid light on water from upper sky as observed at
Guildford among the deep middle-distant woods, very important
where it can be introduced. I think so bright a light as the sun
should be echoed somewhere; and for a more important reason, it
is wanted in orange twilight as otherwise there is no focus — the
sky affording no *point* of focus when the sun is gone.

Middle distance not lighted by the sun has, after the manner of
twilight after the sun dips, a delicate, warm light, from the golden
horizon. Cover the sun, and you find it not confused but clear,
though very broad and delicate, so that a little white might be
used. Tempera would do it.

Designs prudentially considered[16]

1st. SUBJECTS. A subject should be interesting either from its
BEAUTY, or ASSOCIATIONS, or BOTH; OBJECTS or SCENES, in-
trinsically BEAUTIFUL.

Claude brought together things in which all men delight.
Majestic trees, sunny skies, rivers with gentle falls, venerable
ruins and extensive distances. His ground was soft for pasture or
repose. The accident which most quickens such beauty, is LIGHT.

2nd. SUBJECTS in which ELEMENTS, or their combinations or
secondaries, are the principal matters, as such in which are
expressed DEW; SHOWERS or MOISTURE; THE DEEP-TONED,
FERTILIZING RAIN-CLOUD; DROUGHT, with its refuge of deep,
hollow shade, and a cold spring; the BROOK; THE GUSHING
SPRING, or FOUNTAIN; AERIAL DISTANCE.

3rd. LIGHT either produced by its great enforcer cast shadow,
or by great halved opposites, as when the sun is in the picture.

[15] This paragraph and the next were written below two sketches of sunsets in the
countryside, probably in the mid-1840s.
[16] Of uncertain date, probably mid-1840s. Palmer was no longer scoffing at 'the
wise and prudent'.

4th. DARKNESS, with its focus of coruscating light, and a moon or lanthorn. The precious and latent springs of poetry are to be found here.

FIGURES, which in landscape are an adjunct, should if possible be in ACTION, and TELL a STORY.

PRUDENTIALLY it is important (1) to ATTRACT the EYE. These attract the eye — BROAD EFFECT; STRONG CONTRASTS, as warm and cool, bright light and deep shade; VIVACITY; SPARKLE; FRESHNESS; EMPTY and FULL.

(2) TO FIX THE ATTENTION by FULNESS and INTRICACY;

(3) TO AWAKEN SYMPATHY by doing what WE STRONGLY LOVE.

(4) TO DELIGHT by close IMITATION, at least on the points which first meet the eye, and by EXECUTION.

Collins's, Princes Risboro', Bucks, 1845.[17] After having studied here for a month, my general impression with regard to effective painting and the conduct of picture is this.

The bask of beautiful landscape in glorious sunlight is in nature perfectly delicious and congenial with the mind and heart of man, but the imitative power is so limited — particularly so as to the lowness of the light pigments with which we imitate — that the above, when upon paper or canvas, should perhaps only be considered as the corpse which is to be ANIMATED.

The ANIMATOR is CHIAROSCURO. HOLES of DARK, BOLD CAST SHADOWS — the same PLAYFUL and INTRICATE sometimes, when cast from trees like (blueish) soft, cool gray, blotting or dappling over the finished matter (figures most beautiful under this effect). Where figures or sheep come in nearly front light against holes of shade under trees they are like plates or bassi-relievi of wrought gold.

[17] He made two or three watercolour drawings of Collins' Farm in addition to these revealing notes. A.H. Palmer believed that this period marked a turning-point in his father's work.

I have emended '*lowless* of the light pigments', presumably a printing error in 1892, to '*lowness*'.

If it be judicious to follow the manner of working sketches from nature in the working of pictures, then remember, that though the sketch becomes finished beyond comparison sooner, yet that the process seems slow and the means delicate. The use of a violent colour immediately shocks one, and it is dappled about and melted into delicacies.

PROCESS. 1. Chiaroscuro copied from sketch of effect. 2. Some realization of the solid matter, in which delicate drawing must take the lead, and ever accompany colouring. The working up of the pattern and textures is a slow work, even in drawing from nature, and this I think should not be hurried.

How is that wholesome, clean, and unpicturelike appearance to be obtained, which on every side delights one in every country walk? 1st by a more fresco-like treatment, not spreading juicy colour too widely. Secondly perhaps, also by remembering that the greater proportion of matter out of doors is a medium far removed from the coldest blue and the most gaudy yellow and orange. Hence a gray cottage side and a yellow tree tell in nature and have their just value. Thirdly by patience, in ripening the masses of illuminated matter; for what would nature be without its delicate playfulness of things into each other; its infinity and endless suggestiveness. Now this can be imitated in a hurry neither in copying out of doors nor in painting at home. Fourthly by keeping the variety of the palette ALIVE. For a bit of nature, however small, refuses to be copied by any impatient dab or idle spread of one colour. Think of a gray stem with lichens and mosses, rich as a cabinet of gems, or think of a single piece of rock. Now how contemptibly do we imitate this with a few dabs and patches of colour.

And all this is only one little corner of Art. The conclusion of the whole matter is this, that it is almost impossible to do rightly or wisely. That conceit, self-complacency, and indolence, should be incessantly hunted out of the inner man. That everything we do should be done with all our might, and that rest and recreation should be proportionately separated and entire. What a blessed thing is sleep to a mind always on the rack for improvement!

Her mother[1] was sitting at the end of the bed when Mrs. Linnell said 'I think she is gone.' Anny put her face close to Mary's, but could hear no sound of breathing. Her eyes were open and fixed, but her face turned deadly pale. . . . SHE WAS DEAD. Mrs. Linnell closed her eyes. The last I saw of her dear grey eyes was in the afternoon, when I watched them. The lids closing a little over them made it seem like a mournful and clouded sunset. She had appeared for the most part unconscious for two or three days, but on the morning of the day she died Anny was going to bed, when she held up one trembling arm and then the other. Anny put her head down between them, when she held her tightly round the neck for about a minute, and seemed to be thus taking a last leave of her mother. She had done so to me about two days before. She bore her sufferings and took her physic with the greatest patience, saying in the early part of her illness, 'I will take it to please you, dear Papa,' and sometimes said the same to her Mama before I came up.

Six weeks back from this evening, Sunday, 26th December, we spent a happy afternoon together, reading Schmidt's story of Antony, and before she went to bed she was playing at magic music.

Never hurry for exhibitions, but from the Autumn of 1850, D.V., carry on a continuous movement of works for sale. Endeavour after oil pictures. What are the secrets of a proper rapidity? 1st. Decision in the first design — seeing the *whole at once*. Trying after indicative formation of the central difficulty. After a studious and careful preparation, instead of aiming at finish aim to execute the mental vision with as little manipulation and as much inventive energy as possible; doing only what I see. . . . A more large and general system of study from nature; less task-work and fatigue. Investigation of effects, WAITING till they present themselves; then trying to catch them thus: —

1st. (A) A very small sketch of the Proportion of Darks in

[1] This entry describes the death of Palmer's daughter, Mary Elizabeth, at the age of three, in December 1847.

pencils or chalks: (B) A small coloured sketch of the same, merely for use, but the more complete the better as a *specimen* of the class of effect. Have an eye to the above this year, D.V., but let the ETCHING be the point of most painstaking.[2]

2nd. Sunsets or the like on some bold principle, or one sunset and one moon and firelight of the same story. Look carefully over Devon and Cornwall sketches for smaller subjects.

A deep, Gray Day a good subject. Coincident with other things will be an attempt at a New Style.

Forswear HOLLOW compositions like *Calypso* and *St. Paul*, and forswear great spaces of sky. TAKE SHELTER in TREES and try the always pleasing arrangement of white cloud behind ramification, and reflex in water; also sheep foregrounds.

Even Mr. —— finds that the directly poetical subjects are less saleable; so if I go upon this tack and lower the themes I must endeavour to compensate for contraction of span by intensity of expression and development.

I am inclined to think that a sketch in one colour, with all the principal parts and striking completed effect, would be a very sure foundation, and the painting from it comparatively easy. Try something like the solid BLOCKS of sober colour in De Wint.[3]

Why do I wish for a NEW STYLE? 1st. To save time. 2nd. To govern all by broad, powerful chiaroscuro. 3rd. To ABOLISH all NIGGLE. The MEANS. 1st. To work from a bold sepia sketch carried on so far that figure and everything should be already decided. 2nd. Not to be solicitous about the brightness of little specks of light, so as to hinder the full sweep of a great brush by which should be attained the full and right effect at a distance.

My chance of standing with others in execution will be to find my way to it by certainty of effect and parts in first design. 2ndly. By not in any way evading FORM. 3rdly. By painting with large and broad gradation (v. Gaspar Poussin), suggesting minutiae by large work. NEVER FORGET TINTORET'S scheme of CAST SHADOW.

Try to have in progress a number of small subjects in which extreme fewness shall be the charm — for I fear that I have neither power nor inclination to do anything which is not in some way or other strongly characterized. . . . Subjects to have ACTION.

[2] In 1850 Palmer joined the Etching Club and produced his first works in the medium.

[3] Peter de Wint (1784–1849), influential painter of landscape.

Action. HUNTING. DRIVING of SHEEP, Parting the flocks.
STORM in HARVEST. FORDING THE BROOK. Steadying the cart.
The fall of the Oak — felling.

The PRACTICAL SUGGESTION of 1850 is to open, D.V., some
connections for PRIVATE SALE; and 2nd, to collect and keep by
themselves all that I have for sale.

If I am spared to go again into the country I hope to begin a new
plan — not sitting down to local matter, but WALKING and
WATCHING. I ought to see Chiddingstone three miles from
Hever,[4] or some very picturesque village, for lines about mills,
old forges, or cottage doors, as these things are so useful where
husbandry figures are introduced. I ought to watch the operations
of husbandry. The MONTHS would make a good book of etchings.

Mr. R.[5] most kindly painted in one day before me an oil sketch
from my 'Margate' sunset — the mottled sky — to *show* me his
method and processes, of which he had before, with the same
kindness, imparted the general principles. His sketch seemed to
me to possess some of the finest qualities of Venetian painting;
and some of those points on which, before, I had felt doubtful
(particularly the cool reds and the heightenings with white, after-
wards toned, during the progress of the work), I saw to be
important parts of a great scientific whole.

Inferences from the following combined with my own notion.
A brilliant white ground. First painting, white, black, and grey.
A little copal and spike oil, with very stiff white, painted freely
and boldly with hog-tools, so as to get a permanent thread and
texture, from which the successive paintings should become less
and less impasted, filling up to rich, solid, waxy surface (in
appearance). Second painting by various means got up to the
intended colouring as soon as possible, only cooler than intended,
and the blues and greys kept very fresh.

[4]Hever Place is a few miles east of Shoreham. The entry is of uncertain date;
1850–1 seems a reasonable guess.
[5]John Reed, a neighbour in Kensington who became a close friend. This passage
was written in June 1852.

Farewell, soft clusters[6] — the only pretty things about the premises — ye are to be mowed this evening, and to leave a scraped scalp of 'RESPECTABILITY'! May, 1856.

Finest twilights[7] (with moon) of all, I think, which add to full splendour of colour the mystery of transparent vaporous gloom. Observed in Cornwall and at Margate after evening Church, July 18, 1858. In these days, there is an *immense power of light*; searching, vast depths of gloom, and woods are *very deep*. Do not forget; all is full of colour.

Obs: 1. Golden light catching on hillside of fine country with Rembrandt gradation and emphasis of woody hill in shade, of itself material for picture. Very *light* relatively to shade. Very full of rich golden colour, and velvety and real in texture. [*Sketch*.]

1st day at Hartland.[8] In valley towards Abbey. In wooded glens the most brilliant sunshine is very beautiful. And where the effect and arrangement are very vivid, one sees on half closing the eyes that the light is in detached *shapes or patches*.

I am equally impressed by the vividness of light and vividness of *colour*. These imply that the shadows must be struck on an intensely deep key, and then one must get their clearness. Sky-gray lights and reflected lights as one *can*.

1859. D.V., Sketches for Mr. Craven at once, and of use for other exhibition drawings. BEGIN at once. Try figures with bright local colour (pre Raffs:); compose more carefully; then at once paint the masses with oil-colour-like sweeps. Make washed gamboge and raw Sienna the key of yellow. If I can, get a foreground or two from nature. Try a silver morning, perhaps sunrise. Rich twilight. Remember principle. [*Sketches*] By models or otherwise, avoid looseness in the focuses. Think of subjects which have for some time been discontinued, as sheep under trees, or in fold; descending stubble-fields with village in deep distance, but always with

[6] Inscribed below a sketch of grass-tufts and dandelions growing on Palmer's lawn.

[7] Inscribed above a sketch of twilight.

[8] Near Clovelly in north Devon. A.H. Palmer dated this entry 1858.

figure story. Think of some passing event now India is done.[9] Why did the moonlight etching please everybody? Partly by structure and effect; partly because the matter was not above comprehension, whilst it was a kind of matter which I most strongly feel. N.B. It grew out of a most simple thing — houses at Margate with bars of moonlight. Could I find among my *effects* things as simple which would develop?

1859. What must I do to attain excellence?

Increase what I love.

What do I heartily love? Much!

Figures of antique grace and sentiment, and rich picturesqueness.

Intense depth of shadow and colour.

Mystery, and infinite going-in-i-tive-ness.

The focus, a well-head of dazzling light.

The utmost deep and heaped up Devonshire richness.

EFFECTS. Midsummer glowing
Twilight, and rising moon, with trees of intensest depth. . . .

Moonlight with firelight.

Sunsets. Dawn. Silver Sunrise. Sunset through trees.

Cloudy, fresh, dropping, spring morning. One focus of cream white cloud.

Supply Deficiencies.

Where am I weak? (or rather alas! where am I *not* weak?)

Design figures vigorously. Consult model *early*. Paint them neatly.

Conduct picture, so that from the first it may be sightly for its state. At the moment when I would shudder to show it let me pause and ask, 'why?' I ought to keep the shadows and half-tints flatter. Let me try to make the getting in exactly resemble OIL painting, with that broad suggestive smear in the half tints and in the landscape part of the lights. *Painted*, not glazed; as *e.g.* yellow ochre and emerald green for smooth grass — laid smooth, so as just to cover the paper. Even in skies — still more in landscape, lay the TINTS as nearly as I can of the relative intended depth, like a woodcutter — leaving the gradations for the finishing.

[9] In 1858 and 1859 he exhibited three water-colours called *Going to India*, *Returned from India*, and *A Letter from India*. The 'moonlight etching' refers to *The Rising Moon* (1857).

Thoughts on RISING MOON, with raving-mad splendour of orange twilight-glow on landscape. I saw that at Shoreham. Above all this, one pinnacle might catch the fire of the last sunlight.[10]

If it be the Divine will that I live on after this calamity[11] I must try to do my DUTY — my duty towards God and my duty towards my neighbour. My wife and child are my nearest neighbours. I must use my calling for their support. How can I make works which will cheer others when quite cheerless myself? Perhaps thus. 1st, choosing themes I *loved*, for I love no art themes now; 2nd, very simple and massive in effect; 3rd, getting in whole effect (after the figures are well designed) at a heat; 4th, sufficient model realization; 5th, delicate pencilling. Can etching be made productive? Vanity of vanities. August 28, 1861.

The 1861 Life's Balance Sheet.[12]

What I have lost or wherein consists my anguish
My elder son. I am left with the 'fearful' joy of an *only* son.

I have lost a wise son who could counsel me. A son whose culture was an honour to me. A son whose progress to intellectual maturity and probable eminence would compensate for my own decline and weakness.

Our conversation ranging through the years makes every subject recall him. Some of the South of England which I know best recalls him when I see or hear of it.

The Cornish Coast recalls it and Kynance Cove he so strongly loved. His books and papers remind me.

His prize essays and bookcase.

His own hard lot to have.[13]

[10] Written on the outside of a portfolio in 1860.

[11] The death of his elder son Thomas More Palmer in July 1861.

[12] The previous memoranda and journal entries, 1847–1861, have been taken from A.H. Palmer's *Life and Letters*. This 'balance sheet' was first published in *Samuel Palmer: A Biography* by Raymond Lister (London, 1974), although its source is a transcript made by A.H. Palmer. Aside from occasional sentences, no further journal-writings have been recorded from the last twenty years of Samuel Palmer's life. As he became more and more a recluse, he tended to rely on observations made in the past.

[13] Marked with a '?' by A.H. Palmer.

What I have gained or what set off of comfort there may be
The loathed and horrid saving of about one hundred a year.
I cannot have the torture of losing him again.
Being lost I can live in no anxiety as to losing him.
A *great consolation*. That I have been liberal and handsome in my
dealings with him, that he was always well fed — and to the very
utmost of my means made happy.
That he loved theology and chose the Church.
That he was Truthful Industrious Courageous
That he believed in the Gospel.

ANNOTATIONS TO PAYNE KNIGHT[1]

*Though not to be compared even with a third rate artist of Ancient Greece
in knowledge of the structure and pathology of the human body, he
[Michelangelo] appears to have known more than any of his con-
temporaries; and when he made his knowledge subservient to his art, and
not his art to his knowledge, he produced some compositions of real
excellence.*

He produced some compositions of real excellence!! Michel-
angiolo produced some compositions of real excellence!!!!! O!
Knight, had you spent your time in making works yourself
instead of writing about other people's, you might have known
better.

*Such are almost all those, which he designed for others to execute; such as
the Raising of Lazarus, the Descent from the Cross, and the Entombing
of Christ; in which he lowered the tone of his invention to meet the
capacities of the colourists, Sebastian del Piombo, and Daniel di
Volterra; and thus, through mere condescension, became natural, easy,
and truly sublime.*

What original Inventor but can assert the impossibility of this,
with respect to Michelangiolo and anyone else! He became
truly sublime by lowering the tone of his invention!!! Was this a
descent to Parnassus or an ascent to the Bathos?

[1] As a young man, probably about 1825, Palmer annotated *An Analytical Inquiry
into the Principles of Taste* (1808) by the connoisseur, member of Parliament and
numismatist Richard Payne Knight (1750–1824). Forty years later he annotated
his annotations.

. . . there has always appeared to me more of real grandeur and sublimity in Raphael's small picture of the Descent of God, or Vision of Ezekiel; and in Salvator Rosa's of Saul and the Witch of Endor, than in all the vast and turgid compositions of the Sistine chapel. Salvator, indeed, scarcely ever attempts grandeur of form, in the outlines of his figures; but he as seldom misses, what is of more importance in his art, grandeur of effect in the general composition of his pictures. In the wildest flights of his wild imagination, he always exhibits just and natural action and expression; of which the picture above cited is a remarkable instance.

Those artists who are so base that they do not attempt grandeur of form and yet lyingly pretend to grand effect are now called modest; but those who, as William Blake, do attempt and achieve both will, with him, by blind cunning and stupid wilfulness be set down impudent madmen: for our taste is Dutch; Rembrandt[2] is our Da Vinci, and Rubens our Michelangiolo! This is not an over-sounding of the depth of our degradation.

I knew the positive and eccentric young man who wrote the notes in these pages. He believed in art (however foolishly); he believed in men (as he read of them in books). He spent years in hard study and reading and wished to do good with his knowledge. He thought also it might with unwavering industry help towards an honest maintenance. He has now lived to find out his mistake. He is living somewhere in the environs of London, old, and neglected, isolated — laughing at the delusion under which he trimmed the midnight lamp and cherished the romance of the good and beautiful; except so far as that, for their *own sake*, he values them above choice gold. He has learned however not to 'throw pearls to hogs';[3] and appears, I believe, in company, only a poor good-natured fellow fond of a harmless jest.

[2] Later he revised his opinion of Rembrandt — though not of Rubens.
[3] Cf. Matthew 7:6.

III
Poems

TWILIGHT TIME[1]

And now the trembling light
Glimmers behind the little hills, and corn,
Lingring as loth to part: yet part thou must
And though than open day far pleasing more
(Ere yet the fields, and pearled cups of flowers
 Twinkle in the parting light;)
Thee night shall hide, sweet visionary gleam
That softly lookest through the rising dew:
 Till all like silver bright;
 The Faithful Witness, pure, & white,
 Shall look o'er yonder grassy hill,
 At this village, safe, and still.
All is safe, and all is still
Save what noise the watch-dog makes
Or the shrill cock the silence breaks
 — Now and then. —
 And now and then —
 Hark! — once again,
 The wether's bell
 To us doth tell
Some little stirring in the fold.

 Methinks the lingring, dying ray
 Of twilight time, doth seem more fair,
 And lights the soul up more than day
 When wide-spread, sultry sunshines are.

Yet all is right, and all most fair,
 For thou, dear God, hast formed all;
Thou deckest ev'ry little flower,
 Thou guidest ev'ry planet ball —
 And mark'st when sparrows fall.[2]

[1] This poem was copied in Palmer's most precise handwriting into his 1824–5 sketchbook. I have not printed any of the possible revisions that he scrawled in pencil above certain lines, especially late in the poem. Nor have I attempted to alter his idiosyncrasies of spelling, spacing and punctuation. 'Twilight Time' is printed by courtesy of the Trustees of the British Museum.

[2] Cf. Matthew 10:29 (and *Hamlet* V.ii.208-9).

Thou pourest out the golden day
 On corn-fields rip'ning in the sun
Up the side of some great hill
 Ere the sickle has begun.

Thou dear, reviled, murder'd God!
 Thy bitter cross, and thorny crown,
Instead of an eternal rod
 Bring blessings on Thy murd'rers down!

Here I, (full oft forgetting Thee,)
 Repose, beneath my cottage roof:
Outside, there spreads that ancient tree,
 Thy emblem in the Book of Truth.

Where shines Thy sun, a grateful shade,
 The widely spreading leafage flings
O! thus when persecutions burn
 Me shadow underneath Thy wings.

'Tis sweet to see at summer noon,
 The swelling bunches thick combine
And through much over-fruitfulness
 Dropping with wine.
Then round the clusters do entwine
The creeping tendrils of the vine.

Yet twilight-time doth please me more
 The reason I must needs suppose
Is that we love a parting friend
 And parting day draws near his close.

For sure, howe'er a poet young,
 Upon a fair young loving bride
Might doat and reckon ev'ry moment long
 Absent from her faithful side.

Yet did a lingering decline
 Her dear life slowly steal away; —
— Oh! if were such poor angel mine,

Whate'er she'd look, or do, or say
My mem'ry should much more hold fast
 Nor should one tittle from me part
'Till (besides her) forgetting all the past
 Broke my poor heart.

But now still lovelier doth begin to seem
The vanishing light, and like a dying saint,
 With faith-illumin'd face
 Changing apace
With hands both pressed on that holy book
 Fast by his heaving breast
 And he doth seem
 All in an heav'nly dream
And when he ceases any more to live
His pleased spirit newly unconfin'd
Does leave some trace upon her mortal earth
Some mark of her last parting extasy
Some dash of her unutterable bliss
The last kiss given by a friend dissever'd.
 While angel music haunts the air,
 Heard dispersed, here, and there,
 Or in distant choral swell
 As they take the spirit to dwell
 Ever, ever, ever, ever
 Fast by his spear-pierced side
 Who pitied, pardoned, loved and Died
 There to tell (though griefs no more)
 What did here once vex him sore.
 Or if one last tear up they call
 The Lord shall wipe it ere it fall
 Thus when darkness drear and dim
 Veils the perishing mortal sight
 And th' limbs begin to fail & taste
 Is lost of objects of delight
 Phoenix-like the soul doth rise
 And shoots, and sparkles in the skies
 Meanwhile this inferior world
 Seen with a poet's mystic eye

Shall upward point to Gospel themes
 And visions of eternity.

Then hail again thou glimm'ring light
 That now art well nigh set & gone
Still thou dost tinge the fleecy flocks
 And shinest on the water bright.
O thou that unto me dost seem more like
The dawning of a blissful day in heaven
Than the last close of one on this gross earth
 Thy visionary gleam
 Now of the pebbled stream
The little crisped waves doth tip
Where are the fairies wont to dip
Then wrap them in a daisy's cup
And by then the moon is up.
They all ready are and dry
To trip and turn with lightsome thigh
In magic circlets on the grass,
 Blythe their mystic hours do pass.
O would that man high in creation's class
So innocently used the passing time!
Then should heav'ns gates now dimm'd by fleshly veil
Admit the blissful soul to joys sublime
'Triumphing over death & chance and time'[3]
There her dear Saviour alway she might see
And kiss the healing wounds of Calvary,
And walk with antique saints & sing eternally.

[3] Adapted from Milton, 'On Time', line 22.

THE SHEPHERDS' HOME[1]

1

With pipe and rural chaunt along,
 The shepherds wind their homeward way;
And with melodious even song,
 Lull to soft rest the weary day.

2

Low lies their home 'mongst many a hill,
 In fruitful and deep delved womb;
A little village, safe, and still,
 Where pain and vice, full seldom come,
 Nor horrid noise of warlike drum.

3

There, almost buried from the sight
 Of travellers on the higher ground
Be rushing brooks, and sparkling bright
 Clear, shallow, pebbled streams are found
 Where many a fish doth skim & bound.

4

And intricate with fruit-bent boughs,
 And flowers, trim cottage gardens are;
And much delight of flocks and herds
 And sweet young maidens passing fair
 The sweetest flowers methinks that are
And better than the rose beyond compare
And fairer than the milky lilies do appear.

[1] Palmer copied this poem into his 1824–5 sketchbook with care; then, evidently feeling dissatisfied with it, he scrawled numerous possible changes beside the poem, without erasing anything from the fair copy. I have chosen to print the original text, rather than attempt a composite version (especially as many of the revisions, in literary terms, only make things worse). Suffice it to say that his alternative title was 'The old Churchyard'. Almost all the proposed revisions are legible in the Trianon Press facsimile of the sketchbook, published for the William Blake Trust in 1962. 'The Shepherds' Home' is printed by courtesy of the Trustees of the British Museum.

5

And there's a church-yard something raised
 Above the more unholy ground,
Where swains unnoted, and unpraised,
 In innocent sleep lay sound:

6

Free from press of stony tomb,
Or gloomy vault, shall they from earth's kind womb
 Joyous at the last trump rise
 Light of heart and win the skies
Whilst many more in sculptured marble found
Shall wake with horrid shriek and sudden sore astound.

7

 When I shall die
 My bones let lie
 Without a stone
 My grave upon

Quiet in this churchyard's nook,
 With clust'ring elm trees closed in;
For if dear God I'm written in thy book,
 What recketh it where else my feeble name is seen?

For I though base believe that Thou for me
Hast better things prepared than village gardens be:
By streams of life, and th'ever blooming tree,
To walk, and sing with antique saints, and see
Bliss above all, dear Lord, thy face eternally.

THOMAS MORE'S CHRISTMAS CAROL[1]

 While Shepherds in the wint'ry fields
 Kept watch about their flocks by night
 They saw an angel coming down —
 And round them shone a sudden light!

The angel said 'be not afraid;
Of joyful news I bring you word:
This day a wondrous Babe is born
A Saviour, who is Christ the Lord.'

'In swaddling clothes you'll find Him wrapped
Go shepherds! haste to Bethl'hem town;
And see Him in a manger laid,
Where oxen from the plough lie down.'

The angel ceas'd — but suddenly
They saw a host of angels bright
Come round him! and they sang this song
Which still we sing on Christmas Night.

'Let thanks be paid to God above
Because this blessed Child is given
And let bad men leave off to fight
And live in peace as we in Heaven.'

'And God will pardon all your sins
And you shall live with him above
If you are just and pure and good
And dearly one another love.'

Come children then, and sing this song.
Jesus, who was a child like you
Knows how to help you if you try
To be obedient kind and true.

All thanks to Jesus let us give,
And honor to His Mother blest
Who when the Shepherds were gone home
Full gently lulled her Babe to rest.

[1] Adapted from the familiar Christmas hymn by Nahum Tate (1652-1715). According to a pencilled inscription on the manuscript, Palmer composed 'Thomas More's Christmas Carol' in 1846, when the boy was nearly five years old. It is printed here by courtesy of Mrs. Joan Linnell Burton and the Linnell Trust.

VIRGIL'S FOURTH ECLOGUE[1]

Sicilian Muses, may we dare to sing
In loftier numbers to the quivering string?
Some souls there are who little heed or love
The lowly tamarisk or the vintage grove;
Yet, if we haunt the woodlands, let them bear
No trivial echo to our Consul's ear,
But solemn notes befitting this great shade,
By hoary tetrarchs of the forest made.
 At last they dawn; those latter days, so long
Prefigured in the old Cumaean song:
Fresh as the dew of earth's primeval morn,
Of this great series the first age is born:
The lost Astraea greeting us again,
The olive, and the just Saturnian reign:
Already the first fruit is largely given,
And a new progeny descends from heaven,
The links of iron ages to destroy,
(Thou, virgin ever helpful, speed the boy)
And with a golden race to fill the way
From Nile to Thule: give him to the day,
Purest Lucina: circling time explains
The Sibyl, and thy own Apollo reigns.
This, Pollio's favour'd consulate must prove,
Whence the great calends will begin to move,
And fraud, at his rebuke, and malice fled,
Release the nations from perpetual dread.
The youth himself will their divinity
Partake, when gods and heroes he shall see,
And they, intent, his providence regard,
The while, with gentle sway and just award,
And all his father's virtues newly tried,
An ever troubled world is pacified.
 Now, fairest boy, will the new-teeming earth
No culture wait, but pour to make thee mirth,

[1] Palmer began to translate the *Eclogues* in the 1850s, and although the task was more or less complete by 1872, he continued to tinker with the manuscript. The poems finally appeared, with illustrations, in *The Eclogues of Virgil: an English Version* (1883).

As toys of off'ring she can soonest bear,
Wild nard and errant ivy everywhere,
And with th'Egyptian lily twined in play,
Laughing acanthus: now the ewes will stray
Untended, and at eve the goats come home
Heavy with fragrant milk: the herds may roam
Loosely at will, nor even need to fear
In thickets the great lion crouching near.

 Thy very cradle quickens, osiers loose
To tendrils turn, with flowery shoots diffuse:
A softer couch the thymy ground puts forth,
Nor lavish blossom dreads the sudden North.
The serpent now shall die, and the false weed
Of poison die, each healing leaf succeed;
Common as grass, the balm of Syria give
Her fragrance, and the sick who taste shall live.

 Nor later than the day when thou canst read
Of heroes, busy with each generous deed
Thy father wrought, thus early bent to learn
What strenuous virtue dares, the field will turn
To gold, with the soft beards of ripening corn,
Grape clusters mellow on th'uncultured thorn,
Hard oaks with dew-like honey fill the bough.
Yet ancient policy may tempt e'en now
With fleets the fickle Thetis, may surround
Cities with walls, with furrows cleave the ground;
Heroes a Tiphys or an Argo bear,
Another Troy some great Achilles fear:
But, as thy triumphs with thy years increase,
Thy shafts, persuasive truth, thy triumph, peace,
Traders themselves will haul the bark ashore,
The nautic pine her barter'd wares no more
Unload; each clime, as genial as the rest,
In affluence of its own, completely blest.

 No harrows then the generous glebe will brook,
Nor purple vintages the pruning-hook;
The sturdy ploughman from his oxen now
Loosens the yoke; no fallows need the plough;
Nor shall the snowy fleeces learn to lie
With many a hue of counterfeiting dye;

But o'er the mead the ram himself bear wool
Or of a softly blushing purple full,
Or saffron; either shall spontaneous grow:
And feeding lambs in Syrian tinctures glow:
 Fate has decreed, the Parcae have approved,
And with one voice have said, divinely moved,
Roll on, blest ages, and from change secure,
And chance, let peace and equity endure.
 Dear offspring of the gods and our best love,
Great increase of the all-prolific Jove,
Assume thy honours and complete our bliss.
The time already hastens, and for this,
The world, though nodding with its ponderous round,
The lands, the tracts of ocean, heaven profound,
Together as in youthful prime rejoice,
And lean and hearken for thy sovereign voice.
 O that through lengthen'd years my breath may last,
(By no dull vapours wiser age o'ercast),
If only, moved by thee, I may rehearse
Thy story in imperishable verse;
Linus nor Orpheus may with such contend,
This, though his mother, that, the sire befriend;
Calliope with her sad Thracian sing,
Or Linus, prompted by the Delian string:
Pan, even Pan, if he would deign to try,
Arcadia judging, still the mastery
Must yield: the voice alone were mine; from heaven
The theme and the inspiring impulse given.
 Begin, thou little child, begin the while,
Thy mother to distinguish by her smile:
Ten were the weary months for thee she bore;
She clasps her boy and thinks of them no more:
Begin thy mother by her smile to know,
And those love-quicken'd eyes that watch thee so:
The son who may not these endearments prove
Nor gods will honour nor a goddess love.

IV
Essays

AN ADDRESS TO THE ELECTORS OF WEST KENT, BY AN ELECTOR

(extracts printed in the *Maidstone Gazette*, 11 December 1832)[1]

It is true we vastly, and beyond comparison outnumber the enemy: but then we are men of peace; and they are beasts of prey. We are strongest by day: they ravine in the night; for their optics are adapted to darkness. And it is now a very dark night for Europe. The Radicals are elated; for it is a dark and foggy night when thieves are always on the alert. They are housebreakers: we are quiet householders, who have drawn the curtains, and retired to rest!

Some have strangely refused to support SIR WILLIAM GEARY[2] on account of their being, from early associations, attached to the Whigs. Alas! it is but an ill compliment to the Whigs of sixteen hundred and eighty-eight, to mistake for their successors a rabble of incendiaries and jacobins. The policies promulgated by our adversaries are not those of MARLBOROUGH or CHATHAM, but of THISTLEWOOD and BRANDRETH![3]

[In allusion to the tardiness of the Tories in proposing reform]: But let it be so no longer! Put on, once more, the invincible armour of old English, of old Kentish Royalty. Strangle the snake corruption wherever you shall find it; and everywhere promote, in God's name, effectual reform: but leave not your hearths and altars a prey to the most heartless, the most bloody, most obscene, profane, and atrocious faction which ever defied God and insulted humanity.

[1] No copy of this pamphlet, Palmer's only venture into political oratory, seems to have survived. Fortunately the *Maidstone Gazette* quoted it extensively, before calling its arguments 'wild declamations and frothy nothings' by a 'Quack' and 'maniac'. These quotations were first republished in Geoffrey Grigson's book *Samuel Palmer: The Visionary Years* (1947).

[2] The Tory candidate for West Kent in the general election of December 1832. Like his party, he lost.

[3] i.e., the policies not of eighteenth-century aristocrats (Chatham is better known as William Pitt the Elder) but of nineteenth-century radicals such as Jeremiah Brandreth, a Derbyshire knitter hanged for treason in 1817, and Arthur Thistlewood, hanged after the 'Cato Street Conspiracy' of 1820.

You will NOT suffer those temples where you received the Christian name to fall an easy prey to sacrilegious plunderers! You will NOT let that dust which covers the ashes of your parents, be made the filthy track of Jacobinical hyenas!

Our mistakes lie in not clearly understanding *what it is* that we rent of our landlord. We may, perhaps, imagine that we pay him for the whole of the crops which we produce; and that the tithe cart[4] takes away a tenth of that produce, for the whole of which we have made our landlord a consideration: but it is no such thing: we never paid for that tenth: it was not charged in our rent. In short, we pay our landlord for the land; and if the other tenth were not removed by the titheman the landowner would take care to demand it in rent. It is irksome to be put to the proof of anything so self evident, where every argument is like a truism.

The best informed authors will inform us that the ancient landowners who built most of our parish churches, left to their children only nine tenths of the profits of the estates which descended to them: the remaining tenth they bequeathed in the shape of the present tithe, to their respective churches for ever: and that bequest was and is ratified by the laws of our country. Therefore the landowner who is possessed of a thousand acres, receives only the profit of nine hundred: tomorrow, were the tithe law repealed, he would have ten hundred, bona fide disposable to his own use and benefit.

As to the very ancient triple distribution of the tithe, which has been spoken of in certain quarters; one part to the poor; another to the parochial clergy; and a third towards the repairs of the Cathedral; a moment's reflection will convince us of its impracticability at present; when by the blessing of God our parish churches are so vastly multiplied; and I am happy to add multiplying. The solicitude of our enemies for the beauty of our

[4] In 1822 Cobbett had defined tithes as 'all that mass of wealth which is vulgarly called *Church property*; but which is, in fact, *public property*' (*Rural Rides*, ed. G. Woodcock, London, 1967, p. 47). The rebels of 1830 had demanded a remission of tithes from the Church as well as higher wages and lower rents. In some parishes only a reduction of tithes by the clergy enabled farmers to pay their workmen a living wage.

cathedrals is a little out of character: we may believe it to equal their sympathy for the poor: with respect to whom, be it remembered, that the clergyman pays his full share of poor rate upon his income; to say nothing of the innumerable private charities, and neighbourly benefits conferred on their parishioners, by the great majority of that amiable and venerable, though most shamefully calumniated order.

Brother Electors: we have been requested to return to Parliament two Gentlemen, who have, unhappily, ranked themselves under the standard of the so-called Radical Reformers. I would remind you that the Radicals have ever been found adverse to the agricultural interest: that, whatever they may pretend, they will, if possible, sweep away your protecting duties.

Farmers! They were the wretched leaders of this wretched faction, who, during the late dreadful fires, strenuously encouraged the incendiaries! Some of the most abandoned of them published cheap tracts for distribution among the poor, stimulating them to fire their masters' property. But now, if there be a Radical Parliament, the starvation produced by free trade, and the consequent reckless desperation of the peasantry, will supersede the necessity of all other stimulants. If, then, you patronize Radicalism, in any shape, you will have yourselves to thank for the consequences.

Already the fires have begun. Do you wish them to blaze once more over the kingdom? If you do, send Radicals into Parliament; make Radicals of the poor; and as those principles effectually relieve all classes from every religious and moral restraint, neither property nor life will be for a moment secure. Conflagration has already ravaged your harvests.

Landowners, who have estates confiscated or land in ashes: Farmers who have free trade, and annihilation impending over you: Manufacturers who must be beggared in the bankruptcy of your country: Fundholders, who desire not the *wet sponge*: Britons, who have liberty to lose: Christians who have a religion to be blasphemed: now is the time for your last struggle! The ensuing Election is not a question of party politics: much less, a paltry squabble of family interest: but Existence, or Annihilation to good old England!

FRANCIS OLIVER FINCH. IN MEMORIAM.[1]

On the twenty-seventh of August, 1862, the old Society of Painters in Water-Colours lost, in Mr. Finch, one of their earliest members, who had long enjoyed, in the highest degree, their confidence and esteem, and the warm affection of such as had the pleasure of knowing him intimately. He was the last representative of the old school of landscape-painting in water-colours; — a school which had given pleasure to the public for half a century, and contributed to obtain for Englishmen, in that department of art, an European reputation.

When he left school he was articled as a pupil to Mr. John Varley, from whose studio came also two of our most eminent living artists, one of whom has engraved, *con amore*, Varley's *Burial of Saul*;[2] and from such a work we may estimate the value of his influence and instruction. It led to the study of refined models, and pointed to sentiment as the aim of art. It will, probably, be acknowledged that the aim was essentially right, and that, if the old school did not arrest and detain the eye by intricate imitation, yet that it was massive and manly, and that its tendency was to elevate and refine. It is difficult to call to mind a single work by Mr. Finch that did not suggest happy and beautiful lands, where the poet would love to muse: the moonlit glade, the pastoral slope, the rocky stream, the stately terrace, and mouldering villas or casements opening on the foam — 'Of perilous seas in fairy lands forlorn.'[3] How the Society estimated his works was shown by their occupying some of the most conspicuous places on the walls.

He had imagination, that inner sense which receives impressions of beauty as simply and surely as we smell the sweetness of the rose and woodbine. When a boy he chanced to light on the poetry

[1] This essay was published in Alexander Gilchrist's *Life of William Blake* (1863) and in Eliza Finch's *Memorials of the late Francis Oliver Finch* (1865). Its subject (1802-1862) was a former Ancient and friend of Blake, who had become (though Palmer avoids saying so) a devoted Swedenborgian.
[2] The two eminent artists were probably William Henry Hunt (1790-1864) and John Linnell, who had not only engraved Varley's *Funeral of Saul* but also painted in some figures on the original (Linnell Trust).
[3] Keats, *Ode to a Nightingale*, line 70.

of Keats, and a plaster-figure maker, seeing him hang with longing eye over a cast of the poet's head which lay in his shop, made him a present of it, and he bore it home in triumph. At this time Keats was known to the public only by the ridicule of a critique.[4]

Those who were intimate with Mr. Finch will find it difficult to name a man more evenly and usefully accomplished. Besides modern languages and scientific acquisitions, he had large general knowledge. His conversation was never obtrusive, and it never flagged: it was solemn, playful or instructive, always at the right time and in the right place. An eminent friend, a sagacious observer of men, said that he never thought a friendly dinner-party complete unless Finch were at the table: 'It was like forgetting the bread.'

He had read much, and was familiar with the great poets and satirists; knew the philosophy of the mind, and had observed men and manners. Of those departments of knowledge which lay apart, his good sense enabled him to take, at least, the relative dimensions. Knowledge apprehends things in themselves; wisdom sees them in their relations. He taught his young friends that goodness was better even than wisdom, and the philosophy which is conversant with the unseen than any ingenuities of technical science. He said he thought we ought not to claim a monopoly of wisdom because we had discovered that steam would turn a wheel.

It is difficult to convey a notion of his musical genius, because the skill of amateurs, after all the time which is lavished to acquire it, so seldom amounts to more than the doing indifferently what professors do well; but it was not so with him: it seemed to be his natural language — an expression of that melody within, which is more charming than any modulation of strings or voices. The writer has felt more pleasure in sitting by his pianoforte, listening to fragments of Tallis, Croft, or Purcell, with the interlude, perhaps, of an Irish melody, than from many displays of concerted music. To music his friend resorted at the right time —

[4] Probably alluding to J. W. Croker's attack on *Endymion* in the *Quarterly Review* (1818), in which Keats was called unreadable, unintelligible and absurd. This article was soon blamed for hastening the poet's early death.

after his temperate dinner, as Milton directs in his 'Tractate'.[5]

Nor was his pen unused, and he could use it well.[6] 'His endeavour,' says one who knew him best, 'to benefit his young friends will be long and affectionately remembered, nor is it probable that those of maturer age will easily forget his gentle influence and wise counsel.'

Of his social and moral excellence it is difficult to speak in so short a notice, for the heart overflows with memories of his active kindness, and the skill is lacking to condense a life into a paragraph.

In all the domestic relations, he was exemplary; throughout his single and married life his good mother never left his house but for her grave, to which the unremitting kindness of her new relative had smoothed the passage. He did not work alone; were another resting by his side, it might be told that, with one will and purpose, there were two hearts equally busy in 'devising liberal things'.[7] His hospitality was not adjusted to his interest, nor his table spread for those who could repay beef with venison; but for old friends who were in the shade; for merit and virtue in distress or exile; for pale faces which brought the recommendation of sorrow. Let us bear with his simplicity. Perhaps when *he* 'made a feast',[8] he consulted a very old-fashioned BOOK as to the selection of his guests.

The writer willingly incurs the ridicule of those who believe goodness to be only a refined selfishness, when he looks back, as far as boyhood, to recall some single piece of slight or rudeness, some hard unkindness or cold neglect, some evil influence or moral flaw in his old friend's character, and cannot find it. Were there many such, sarcasm might break her shafts.

Our great satirist[9] said that, if his wide experience had shown him twelve men like Arbuthnot, he never would have written the 'Travels'.

A symmetrical soul is a thing very beautiful and very rare. Who does not find about him and within him grotesque mixtures, or

[5] In Milton's Tractate *Of Education* (1644), music is recommended after a meal 'to assist and cherish nature in her first concoction'.

[6] Another painter with literary aspirations, Finch wrote undistinguished sonnets, a collection of which had been privately printed.

[7] Adapted from Isaiah 32:8.

[8] Cf. Luke 14: 13, 16.

[9] Swift.

unbalanced faculties, or inconsistent desires; the understanding and the will at feud, the very will in vacillation; opinions shifting with the mode, and smaller impertinences which he forgives, if they are not his own, for the amusement they afford him?

Let those who knew Francis Finch be thankful; they have seen a disciplined and a just man — 'a city at unity with itself'.[10]

SOME OBSERVATIONS ON THE COUNTRY AND ON RURAL POETRY[1]

It was in the pleasant vale of Bickley that an accomplished friend, to whose conversation I am indebted for some of the happiest hours of life, sat down under a tree and solaced himself by repeating aloud in the sonorous original, passages from one of Virgil's Eclogues. 'O you poor lost creature!' cried an acquaintance who had accidentally wandered to the spot, and thus detected his weakness. To a sharp man of the world, both verse and philosophy are superfluous: routine and the market have shaped and set him to a mediocrity for which epic is too high and the bucolic too lowly; and if he believe all poetry to be useless, by what diminutive of contempt will he designate its pastoral mood; with its wax-jointed pipes and poetic sheep which never come to mutton? Facts and mutton are his universe: his morning paper comes in with the water-cresses, and almost as wet; there he reads all that can be collected concerning everything: what can man do more? We must not tell him that perhaps his back is to the light, like those men in Plato's cavern; and that though his eyes are wide open, he may be watching shadows.

There are others to whom rural poetry may have become distasteful for a very different reason. Their good taste may have been revolted by the Strephons and Chloes of the coffee-house poets, in what is sometimes called the Augustan age of our

[10] Adapted from Psalm 122:3.

[1] This essay was first published as a preface to *The Eclogues of Virgil: An English Version* (1883). According to A.H. Palmer, it was written after the translations were more or less complete; the artist was still working on it in the year of his death.

literature; and much more so perhaps, by a glance at the Arcadia of Louis the Fifteenth; at crooks tipped with silver and tittering shepherdesses who left their 'cher moutons' for a day's holiday to enjoy the tortures of Damiens, played at cards while the executioner rested, and when it came to the tug of dismemberment, pitied the horses!

The influence which settled upon our literature at the Restoration, was so sickly and unnatural, taste and morals being alike corrupted, that purity and healthy freshness, picturesque vigour and artless beauty — all that we enjoy in the country and that is pleasing in idyllic verse, vanished in the contact, and a manner supervened so spurious and tawdry that its phrases have become ludicrous. Such are 'purling streams' and 'verdant meads'; and 'tinkling rills' must be dispensed with, although, perhaps, we came first upon them near the 'White walls' of the 'Paraclete'.[2] Such is the course of literature and art; like the coast wave of the Atlantic, which rises slowly, abruptly falls, and is dispersed in spray: the author of *Comus* was scarcely gone, and it had fallen to this! The Sicilian Muse was painting hand-screens!

But counterfeits imply a genuine currency, and of this we have abundance in the rural wealth of Greece, Italy and England: the pure gold of Fletcher, in his *Faithful Shepherdess*, fears no comparison with Tasso or Guarini; and with what shall we compare Virgil's bees? His Eclogues, universally read and quoted, after nearly two thousand years, have come down to us attended by an array of critics and commentators, which may remind us of the camp followers of Xerxes. In 1749, Professor Martyn had bestowed upon them a volume of loving labour, yet without prejudice to the researches of Mr. Conington and others, more than a century later. Indeed these little poems, a pamphlet in bulk, seem to resemble natural phenomena which investigations never exhaust.

Wisely have our forefathers discerned in verse one of the noblest instruments of education, and made the greatest poems our school books; for these present us with stories and examples more winning than precept, and dispose us to think and speak justly, to do or suffer nobly: their attraction may withdraw the young from many follies, many questionable or vicious amuse-

[2] Pope, *Eloisa to Abelard*, lines 158, 348.

ments; for they arrest the fancy, that roving lawless faculty, and so far preoccupy it, that it is less likely to become the cage 'of every unclean and hateful bird'.[3] When the seven more wicked spirits found the house swept and garnished, they found it also empty.

We might be grateful to the poets, if the benign influence of their art did nothing more than make us love the country; and while we are yet uncorrupted, open to us a world of innocent pleasures; enriching us as it were, with a new sense, which invests familiar objects with meaning and beauty, disposing us to quiet habits and simple manners, and acquainting us with such relics and fragments of the golden age, as Astraea did happily leave behind her.[4]

Have we a patrimony: — what if these attractions persuade us to reside upon it? Our capital is over-peopled, and human lungs are breathing an atmosphere which decomposes stone; the Western end of the New Palace having begun to peel or crumble, before the East was finished: then the whole was permeated by alarming smells from the river, which no future Denham[5] is likely to select either for his theme or his 'example'. It is said that out of town we merely vegetate; better so than wither: one would think that with less dissipation there would be more time for improvement: is it progressive to tread upon an author's corns in the crush of some London soirée, and vegetative to read his best thoughts in his best words at Penzance?

No little will be the gain to a young man of competent estate and education, if he determines to begin life where the best and wisest men have desired to await its close; if he prefer unsullied air, a buxom wife and rosy children, to the 'London season', late hours, jaded and failing beauty and a sickly nursery; if, with Cowley, he would choose 'a small house and large garden',[6] rather than a large mansion with none: if he prefer sunshine to smoke; bean-fields, violets and new-mown hay, to reeking drains; the blackbird's carol to the enharmonic feline opera of the pantiles: and should poetic sympathies have at all influenced his

[3] Revelation 18:2. For the wicked spirits, cf. Matthew 12:44.
[4] Greek goddess of justice, the last of the immortals to leave the earth after the Golden Age.
[5] Cf. *Cooper's Hill* by Sir John Denham (1615-1669), lines 189-190.
[6] Cowley, 'The Wish', line 10.

choice, he will not be thankless, when he considers either what he has gained or what he has escaped: nor will they be thankless, who, having worked their way to competence, have been persuaded to a timely retirement.

> Methinks I see great Diocletian walk
> In the Salonian garden's noble shade,
> Which by his own Imperial hands was made:
> I see him smile, methinks, as he does talk
> With the ambassadors who come in vain,
> T'entice him to a throne again.
> 'If I, my friends,' said he 'should to you show
> All the delights which in these gardens grow,
> 'Tis likelier much that you should with me stay,
> Than 'tis that you should carry me away:
> And trust me not, my friends, if every day,
> I walk not here with more delight,
> Than ever, after the most happy fight,
> In triumph to the Capitol I rode,
> To thank the Gods, and to be thought myself almost a God.'[7]

It is not the recluse or disappointed who have most loved the country, but those whose position gave them the choice of all that is coveted in courts and cities. Lord Clarendon,[8] the father of a queen, remarks that true politeness was never the offspring of a court; and that when country gentlemen were content to dwell among their own people, the wisdom and frugality of those times were such, 'that few gentlemen made journeys to London but upon important business, and their wives never; by which providence they enjoyed and improved their estates in the country, and kept good hospitality in their house, brought up their children well, and were beloved of their neighbours.' And so far were they from incivility and ignorance, that, in the opinion of able judges, Professor Goldwin Smith[9] among the number, 'Our

[7] Emperor of Rome from 284 to 305 A.D., Diocletian abdicated after a long illness. Urged to resume the throne in 308, he refused. This is the last stanza of 'The Garden' by Abraham Cowley (1618-67).

[8] Edward Hyde, 1st Earl of Clarendon (1609-1674), author of *History of the Great Rebellion and Civil Wars in England*. His daughter Anne married the future James II.

[9] Goldwin Smith (1823-1910), author of *A Constitutional and Legal History of England* and many other works.

nobility and gentry were more highly educated under the later Tudors and earlier Stuarts, than at any other period of our history. Their education was classical; but a classical education meant then, not a gymnastic exercise of the mind in philology, but a deep draught from what was the great and almost the only spring of philosophy, science, history and poetry of that time.' And the battle fields of the civil war bore strenuous evidence that the softer studies had been amply complemented by public spirit, courage and practical energy.

In the fertile vale of Avon in Wiltshire where anciently, within a distance of thirty miles, stood fifty mansions or manor houses, it was said as many years ago, that there were then only eight remaining. Each of these with its village or hamlet, was a little polity, in which rule and subordination might be only harsher names for guidance and loyalty: there were no extremes of wealth and destitution, of insolence and servility.

Fancy would renew the antlered and oak-ribbed dining hall; the occult still-room; the few but all-sufficing books: even the spinet or later harpsichord, which 'had a tongue with a tang'[10] and was the better for it: those mullioned windows looking out upon the farm-houses and smaller cottages, nestling deep in their gardens and orchards: the moated grange with its chapel and dwarf clock-tower: all these presenting no frightful inequalities of condition, but only so much as might stimulate industry, and give occasion for neighbourly help and beneficence.

Whither were these old families dispersed, after they had ceased to live 'among their own people'? It may be that some of their descendants were doing nobler work in crowded cities; arresting the advance of disease or crime; and that in scant leisure, turning over their old school books, georgical verse revived agrarian instincts, and seemed to refresh the foetid neighbourhood, like a Tramontana from the Apennine: for rural poetry is the pleasure ground of those who live in cities. It repairs in a measure the natural link which has been broken when man has been removed from the cultivation of his native earth, and sees little from the windows that can make vision desirable: it is then that verse presents to fancy what is lost to sight; and when all the foulnesses without are frozen down into a black fog, he may call for lights,

[10] *The Tempest*, II. ii. 49.

refresh the fire, and have tolerable weather with the poets.

The rural Muse has found favour with men of every class and calling; from the recluse student, to Octavius and Maecenas; often where the habits of life seem to be least congenial. It was Charles James Fox[11] who said, 'There is nothing like poetry!' The Pastorals of Virgil were still in his hand, thrown as he was upon evil times in evil company. By night, on the St. Lawrence, General Wolfe, having repeated Gray's *Elegy* to some of the officers of his staff, told them he would rather have written that poem, than achieve the victory for which, a few hours later, he was content to have given his life.

Lavater's aphorism bids us hold loosely to the man who 'does not love bread, music, and the laugh of a child.'[12] Next of kin to this unpleasant person, is the man who has no relish for the country: unspoiled men love it. When we read the lives of heroes and great statesmen, do we not follow them with peculiar interest from the camp or the senate to their cherished retirements? Fancy lingers with the Imperial gardener at Sardis,[13] with the returned dictator tilling his four acres; and is better entertained while King William is teaching Swift to plant cabbages after the Dutch fashion in Sir William Temple's kitchen-garden, than when expediency, political or commercial, is suffered to do its work in Glencoe or on the isthmus of Darien. When we turn away from such things, there is a refreshing contrast, and the resolving of civic percussions into sylvan peace, makes a kind of music; there is something like congruity and loyalty: we are pleased to see the 'mighty hunters' relenting; the disturbing forces moving in sympathy with their planet; the pompous creature whose pedigree is dust, leaning with some dutiful regard towards his homely mother.

To those who are engrossed with politics or the cares of government, rural scenes and sympathies and their cognate verse afford, not recreation merely, but a wholesome moral counter-

[11] Charles James Fox (1749-1806), foreign secretary under three administrations.

[12] 'Keep him at least three paces distant who hates bread, music, and the laugh of a child' — *Aphorisms on Man* by the Swiss poet Johann Kaspar Lavater (1741-1801). Blake had annotated this, 'The best in the book!'

[13] In the *Oeconomicus*, 4.20 ff., Xenophon describes a visit paid by Lysander, a Spartan, to the Persian king Cyrus the Younger at Sardis. The king showed his visitor round a park which he had made himself, and discoursed on the benefits of agriculture.

poise and complement. Tactics and a nimble tongue may furnish the politician, but homelier matters are wanted to complete the man. Neither the fame of his eloquence nor the scope and symmetry of his affluent wisdom suffice to present us with the whole of Edmund Burke: the portrait is rounded with all its genial hues at Beaconsfield.[14] Such episodes of history — digressions rather, into somewhat of the honest and natural, of the kindly and benign, make pleasant changes in our reading; and truly the readers of history need refreshment. Jaded with the weary chronicle, the old iteration of lust, perjury and violence, if we shut the book and walk out into the fields we seem to have stepped upon another planet. 'Can these fresh meads,' we ask, 'can these wholesome furrows, be part and parcel of an expanse which has endured such pollution, covered so much innocent blood?' Yet history must be read, because the past is the explanation of the present, and the horoscope of the future; but ever and anon it will be well for us to make holiday among the quiet people by whose healthy labour we subsist and eat the fatness of the earth: then the happiness of Virgil's husbandmen in the second *Georgic* will be the better understood, and the honour of their calling, in contrast with the flattered abject, who 'seeks to ruin families and cities, that he may drink from gems and sleep on Sarran scarlet.'[15]

It is nothing to the purpose that he and the farmer might have changed manners had they changed places; that was in Virgil's mind when he praised a country life, for he was simple enough to suppose that it had a moral influence upon our common nature; nor was he aware that the cultivation of the earth was a stupefying employment, and the peasant skilled in the varieties of farm labour, a log: no! 'Non omnia possumus omnes'[16] — that dis-covery was reserved for us. How could Virgil anticipate our progress, with whom the 'bucolic mind' has become the synonym of fatuity? But those who are 'behind the age', and not very anxious to overtake it, will discern in their ancient friends — in the Ploughman[17] who lives in Chaucer's verse, and his kindred,

[14] In his last years Burke is said to have occupied himself by attending to the trees, the farm and the neighbours of his Buckinghamshire estate.

[15] Virgil, *Georgics*, II. 505-6.

[16] 'We can't all do everything' — Virgil, *Eclogues*, VIII. 63.

[17] Almost certainly referring to *The Plowman's Tale*, an anonymous medieval poem which Palmer believed to be Chaucerian (cf. p. 177).

something better than a barbaric foil to the intelligence of the modern artizan — especially to the hapless one dwarfed within some one of the minute subdivisions of labour, ever putting heads upon pins, or slave in waiting to the machine which can do it more quickly. As to the proprietor himself, or the farmer of a moderate estate, with all its varieties of soil, aspect and irrigation, we cannot fail to perceive, if we are suffered to relapse into common sense, that its full cultivation amidst all casualties demands the same kind of ability, the same perception, enterprise, prudence and flexibility, as go, in a larger measure, to the making of a great general or statesman; and this perhaps partly accounts for the zest with which in their leisure or retirement, such men have entered into the details of farming or gardening; for these presented all the advantages of recreation without idleness; change of air, of scene, of associations; the strain and anxiety removed, and the skill which could manage senates brought into gentler play upon materials more tractable than the 'unruly wills and affections of sinful men'. Untoward weather, blight and stubborn soils, are but the rubs and penny forfeits of a game, to the veteran minister who has curbed or baffled popular insolence and caprice, overbearing tyranny and implacable faction. No wonder that he desires to escape. It is a seemly close, when one who has really loved and served, it may be saved his country, living wholly for others; when such an one, now in sylvan seclusion, cloistered by shadowy woods, perhaps by his own ancestral oaks, finds leisure to peruse himself; to commune with his own heart and revise the imaginations and desires of the interior polity: —

> In such green palaces the first kings reign'd,
> Slept in their shade and angels entertain'd:
> With such old counsellors they did advise,
> And, by frequenting sacred shades, grew wise.[18]

Neither the wisest men nor the best poems are usually inconversant with the country, for in epic and tragic story, when the action transpires within the walls of cities, the illustrations and imagery are remote. The spear of Satan opens a glimpse of 'Norwegian hills'[19] and distant ocean; Aeschylus renders

[18] Edmund Waller, 'On St. James' Park', lines 71–4.
[19] *Paradise Lost*, I.293.

158

Cassandra's last warning by a bucolic metaphor;[20] nor does imperial Tragedy demean herself, or fail to touch the heart, when she expresses utter bereavement by a mischance of the poultry yard: —

> He has no children. All my pretty ones?
> Did you say all? — O hell-kite! All?
> What, all my pretty chickens and their dam
> At one fell swoop?[21]

Thus do remote allusions and changing imagery set off the narrative with the foil of a broad contrast: similes connect the excursive opposite with the coherent story, through a partial resemblance in the particulars, and oftentimes we have a two-edged rhetoric in the complex figure, when the things compared are in some respects like, in other the reverse; so that the same comparison, at once enriches the subject-matter by analogies, and, as opposites manifest each other, enforces it by a contrast.

It has been observed that in Milton's 'woody theatre' (*Par. Lost:* Book 4: line 141) the single word 'theatre', both illustrates the position of the trees in ascending ranks on the hill side, and adds to the sylvan quiet by glancing at its reverse, the noise and movement in a place of public concourse. This rebound from contact sends the fancy on many a magic jaunt fleeter than the witches' to Blockula.[22] There is little affinity between fallen spirits and fallen leaves; but Milton takes occasion, from their likeness in respect of contiguous multitude, for a brief escape from the 'burning marl', to cool rivulets of 'Vallombrosa'. Was that 'broad circumference' the shield of Satan? — Now, we are in Valdarno, and it is the moon, expanding her mysterious landscape in the Tuscan's glass.[23]

It would seem then, that in heroic verse, the comparisons and allusions of themselves, apart from the interest, pathos, or passion of the story, gratify several of the desires of the mind and fancy: among others, our love of agriculture in its numerous

[20] 'What? will cow gore bull,/The black-horned monarch?' (*Agamemnon*, translated by Philip Vellacott, London, 1959, p. 81).

[21] *Macbeth*, IV. iii. 216-9.

[22] In 1669 eighty-five people were burned to death in Sweden for having seduced some three hundred children into flying to a large meadow called the Blocula.

[23] Cf. *Paradise Lost*, I. 286, 288, 290, 296, 303.

aspects, of grand or luxurious scenery, of the pastoral and sylvan, of romantic legends and dim antiquity: that they refresh us with contrast, change and surprise; with likeness discovered in the unlike, which is akin to wit, and with its reverse, allied to satire; and that the expansive imagery, humouring our discursive instinct, presents us on either side, while we keep the main road of the story, with changing vistas and glimpses of boundless prospect.

If these then be but the accessories of epic story, how absolute must be the unity, how massive the proportions, which such an array of ornament does not encumber or confuse! What other verse can stand beside it? With Pindar's leave, were it not better that the limit of Aristotle's criticism should be the limit of the art? It is well for us that the poets did not think so; else, what bequests we should have lost; estates (for such are all good poems) in which each has a real, but all a common property: where were the *Idyls* of Theocritus, the *Eclogues*, the *Georgics*, the minor poems of Milton, his *Comus* and its parent spring the *Faithful Shepherdess*?

Now in these, however justly the style was attempered to the matter, and although in some of them, rustic or archaic phrases might be a tasteful choice, yet it was not found needful to degrade the action or circumstance, the characters or diction, because the scene was removed from camps and courts, which can claim no monopoly of true heroism or elegance. Nay, in Virgil's hands, the theme itself, the subject of a pastoral too, rises above the old heroic argument and leaves it far below: the fourth and sixth Eclogues indicate events — the creation of the universe and the final restitution, compared with which, the fall of Troy, nay, even the founding of Rome, are but an interlude. What is wanting of elevation or delicacy to the dialogue in *Comus*; or to its author's consummate verse in that noiseless victory of the wilderness, *Paradise Regained*? And if it were seemly to compare other matter with the sacred text, it might be asked whether the suffering and patience of the bucolic patriarch Job, are not more sublimely celebrated, than, elsewhere, any scenes of slaughter, or varieties of mutilation.

In the age of Louis the Fourteenth, when war was supposed to be the proper employment of gentlemen, rural culture a servile drudgery, it was not unlikely that a French critic, Fontenelle, would censure loftiness of thought as a breach of pastoral decorum, and that the Eclogue which delighted Cicero would

seem grotesquely absurd to the eulogist of the Academy.[24] The condition too of the French peasantry was deplorable, and pastoral poetry is read at a disadvantage when nothing that we have ever seen resembles it; for we lose the pleasant refreshment of alternate fact and fiction, of their sisterly distinctness within a family likeness; but classic art, unless in the satiric mood, deals with crime and misery only when they may be sublimed into the elements of tragedy. Whenever misgovernment or encroaching wealth, garden filching, enclosure, and violation of common right, are making the country life a term convertible with stinted food, squalid habitations and sordid manners, bucolic poetry departs: the rural Thalia may blush, may weep, but cannot sing.

Dr. Johnson, who was not less learned in the structure and economics of verse, than obtuse sometimes to its more subtle and distinctive essence, defines a pastoral to be 'a poem in which any passion is represented by its effects upon a country life';[25] and observes that it admits of all ranks of persons, because all ranks inhabit the country; and that therefore it does not exclude, 'on account of the characters necessary to be introduced, any elevation or delicacy of sentiment'; nor any intensity, we may add, of pathos and passion, because natural feeling is the same everywhere, and is less disguised as it is removed from courts and factions: the joy is innocent, the sorrow unselfish. That is a diseased compassion which waits for commotional stimulants; which cannot be touched by the lament for Daphnis, or the episode of Eurydice; but sympathizes rather with fallen pride or detected crime than with oppressed innocence, or struggling virtue, or truth, faithful to the death; a spectacle more noble than the reappearance of Achilles or the field of Arbela. The poet himself who described a more stupendous conflict, who opened all the sources of terror in the meeting, not of Hector with Achilles, but of Satan with Death, was of higher instinct than canine and quarrelsome;

> Not sedulous by nature to indite
> Wars, hitherto the only argument
> Heroic deemed; chief mastery to dissect

[24] The literary critic Bernard le Bovier, Sieur de Fontenelle (1657-1757), perpetual secretary and eulogist of the Académie des Sciences.
[25] *The Rambler*, No. 37, 24 July 1750.

With long and tedious havoc fabled knights
In battle feign'd; the better fortitude
Of patience and heroic martyrdom
Unsung; — [26]

It was probable that the hold of the earliest epic upon the imagination of mankind would, somewhat illogically, connect the idea of heroic verse with a siege and a city; with warlike pageants and animal prowess rather than with

that which justly gives heroic name
To person or to poem.[27]

The scene of the *Iliad* being warlike, though its subject is the evil of wrath, set the fashion that way; although the *Odyssey* was teaching, or was about to teach, a nobler lesson of equanimity and fortitude. Virgil sang of arms, but of arms and the man; the pious and all-enduring man Aeneas; and of much besides, which the poet loved better and esteemed more noble than homicide. In the sixth Eclogue, when Cynthius touches his ear, he apprehends the inner sense of the admonition not to exchange the crook for the falchion; on this he prunes his wing for a loftier flight, and leaves the battle fields to the dogs and vultures.

A bird deprived of her wings is not more incomplete than the human mind without imagination, a faculty distinct from the spiritual and rational, yet having a common language; for the language of imagination is poetry, and it is in poetry that both sacred aspiration and secular wisdom have found their noblest utterance.

For no small portion of their renown, the greatest nations have been beholden to their poets, not so much from the lustre of their names, as because their living words from age to age, continued to educate the leaders of the people, keeping before them the ideas of justice, magnanimity and fortitude, exemplified in persuasive story. Robust nations which were merely warlike, without arts or literature, though useful to weaker races by the infusion of new blood, after they had shed what they could of the old, muster in

[26] *Paradise Lost*, IX. 27-33.
[27] *Paradise Lost*, IX. 40-1.

162

history without adorning it; they were formidable as locusts are formidable.

It may savour of paradox to number poetry with the useful arts, for the very reason that among all those who come within its influence, it develops imagination; an endowment often contemned as idle or mischievous, incurring perhaps the discredit of a purblind and vagrant fancy which is mistaken for it: but disciplined imagination in equipoise with learning and judgement is very active, practical and materially productive; what it sees within, always desiring to make and embody without. Foreknowing the end it can best devise the means, going to work the shortest way, with least alteration and no waste of material; while a more prosaic and tentative industry, rather feeling its way than seeing it, is officiously busy before it is quite known what is to be done: and often we have seen in affairs little or great, private or public, a change in the very aim or purpose when the work was half completed. The ideal faculty was absent; it had not defined the aim or created the motive: when those are clear, the progress will be steady; when the purpose is noble, much may have been achieved though we fall somewhat short of the mark.

To the prolific industry of the imagination of the earlier ages we owe more than half the attraction of foreign travel: it was that prophetic and aquiline vision which devised each great monument of antiquity, transformed the quarried marble, and in later ages conceived the cloistered minster and aerial spire.

Imagination radiates through many avenues of thought; through some which are remote from the demesnes of fiction; quickening perception, suggesting analogies, and wakeful to the minutest research and most delicate experiment: that it should be 'brilliant and active' in the laboratory, is the judgment of Sir Humphry Davy, of whom it was said that he would have been the best poet of the day if he had not been the best chemist; and indeed, the most romantic fancy, weary for a time of griffins and giants, might find itself at home there, amid the feuds and affiances, the transformations and vagaries of inorganic matter.

What a scope is here for busy idleness, for futile experiment and puerile curiosity, bewildered by the number of its toys! Yet these wayward elements, marshalled by human intelligence, and combined by ideal forethought for specific purpose, are no less a thing than Chemistry; the science which in alliance with mechanics,

restores the appliances of lost civilization, and has contributed so much of the necessaries, comforts and ornaments of life. Mechanism, inspired by an Idea, has quintupled speed by an elastic vapour, and made lightning our messenger.

Seeing then that the ideal energy is practical and prolific, impregnating our designs and speculations through so wide a range as from its own cognate arts and heroic poesy to the alembic and retort, it would seem strange that men not wanting in depth and sagacity, should regard it with indifference or distrust, and censure its direct expression in measured verse as a kind of idleness. Would that it had never been worse; had never given some colour of prudence to Locke's advice in his *Thoughts on Education*, that if a son have the poetic vein, his parents should labour to have it stifled and suppressed as much as may be. In Locke's day the gift of poetry had been shamefully prostituted, and if, like Milton, he had esteemed it a divine endowment, he would the more have revolted from the ungrateful sacrilege: but although disposed to judge it by its abuse, he could scarcely have ignored what is so obvious both in ancient and modern history, its better influence upon many nations, throughout many ages; of the *Iliad* notably, bequeathing to pagan antiquity the idea of the Great; the great in conception and speech, in action and endurance; of the *Odyssey*, presenting the image of prudence and fortitude in Ulysses; instructing men in the affairs and perplexities of life, and restraining them by the fear of a 'personal, watchful and retributive Providence'.

Plato knew the persuasiveness of verse, when in the two books of his *Republic* he censured its licence: dreading its power, Edward slaughtered the bards. It was shrewdly said, 'Let any one make the laws of a country, if I may make the songs';[28] for its national lyrics are the animal spirits of the body politic. Its graver verse tempers public morals and even the established faith. Dr. Maitland in his *Eruvin*, has observed, perhaps not without reason, that the *Paradise Lost* has done much to shape the popular theology.[29]

[28] Often attributed to Confucius, but not found in this form in his works. The sentiment may have been first expressed by Andrew Fletcher, in a letter written to the Marquis of Montrose in 1704.

[29] *Eruvin* (1831), essays by the religious writer Samuel Maitland (1792-1866).

The influence of poetry pervades all civilized life; the more so from its point and brevity and because metre and rhyme are easily remembered. It sets wit and philosophy to music, its satire is the keener for its polish, and it disguises medicinal truth in nectar. It is certain that Shakespeare and Pope have left us an informal code of morals and manners, more pregnant than didactic treatises. The loss would be perceived like a deprivation of the air we breathe without thinking of it, if their influence could suddenly be effaced from the conversation of educated Englishmen. A friend once remarked, 'I have been reading Pope for the first time, but I have been hearing him all my life.'

If those who are cumbered or paralyzed by worldly cares or prosperity, find the ideal too insubstantial for their touch, let them not impeach its reality and force, until they have observed its counterpart in the material world; where, through the whole ascent, swiftness and power are gained, as matter becomes less gross and ponderable: oaks are shattered by a fluid (if it be so much), and steam or gases break the mountain, or heave it up from the depths of the sea. What else is the tornado, than an invisible and permeable element which, in its playfulness, is the balm of spring? Poetry, in its flexible strength and mercurial temper is like the 'delicate Ariel'; now, charming the isle with fitful music; now dispersing himself in sudden flame; entertaining the lovers with a fairy masque, or chafing the sea and rolling the thunder.

And this noblest eloquence, this extract rather, and etherial spirit of eloquence, accosts us, as Sir Philip Sydney has observed,[30] with no pedantic formula or crabbed rudiments, but draws us with the sweetness of its music from the jars and discrepances of outer life, touching and tempering every wry passion, and, by a strange alchemy, transmuting grief and terror into fascination and delight: liberal and pliant to our instincts and frailties, play-fellow of youth and solace of age, it rounds backward as it were, its maturest wisdom towards the intuitive desires of our child-hood, and in its noblest achievement of ode or epic, offers just what we were best pleased with in the nursery, a song or a story.

[30] Adapted from Sidney's explanation in *The Defence of Poesie* why the poet is monarch 'of all Sciences'.

Yet there will never be wanting some who are in the old cry, 'What, so much for a song!' even were that song Spenser's; not to mention the Imperial regret that Virgil had escaped decapitation.

NOTE TO VIRGIL'S EIGHTH ECLOGUE[1]

'Say, may I venture in some riper year
To sing thy exploits — ?'

Virgil more than once gratified his warlike friends by enquiring whether he might one day venture to make their exploits the subject of a poem; but he took good care never to attempt it: —
 'Laudato ingentia rur
Exiguum colito.'[2]
He knew his art too well. Many years must elapse before events can be seen in their just proportion; prejudice and passion and surprise having passed away, and accident from essence.

The mind of a great poet is thrown back into antiquity, whence he symbolizes the present: sometimes in various mood, refreshing attention or awakening sympathy by allusion to passing affairs; adding mystery by these flashes of the hour, to the twilight of an ideal past: but he who lays his story in the present, is little likely to grasp it, for contact is not vision, and he has no vantage ground of observation; but is himself an atom of his subject, a fly upon the axle.

[1] Of Palmer's scattered explanatory notes in *The Eclogues of Virgil: an English Version*, this alone seems worth reprinting. He provided no annotations to the fourth eclogue, published on pp. 140–2.
[2] *Georgics*, II. 412–3. In Dryden's translation, '. . . commend the large excess/Of spacious vineyards; cultivate the less.'

V
Late Letters

THOMAS MORE PALMER[1]

Sept[r]. 28. 1844 Guildford

My dear Thomas More

I went *so* fast in the steam-coach! how you would like it! Here
are high hills, and the birds sing in the trees; you shall go with me
some day. Ask GOD to make you a good boy; and mind what
your Mamma says to you at the moment!

Learn to spell and to read this backwards and forwards: and if
you read it well to me when I come home I will buy you a cake.★

Who loves Thomas More?

PAPA!

★Some would say 'This is inciting him to a laudable action from a
base selfish motive'. I answer that the love of cake is not base —
and that although the love of self denial and suffering is nobler it is
a virtue which blossoms later. I thought of promising many kisses
when I came home, but believed he would like cake better.

THOMAS MORE PALMER

 Collins, Princes Risboro'
September 14th 1845 Buckinghamshire

My dear Thomas More

The Blessed GOD has been very kind to you. He has given you a
Father and Mother who are always trying to do you good. *We* do
good to *you*; and what a nice thing it would be if *you* could do good
to any one else. GOD loves those people who do good to others.
When the Lord Jesus came down from Heaven, and lived in the
country of Judea, He went about everywhere doing good: and we
should try to do as He did.

Well! — I can show you how to do great good to your Sister
Mary. Poor little Mary cannot read: and she will never be able to
read if she do not learn her letters.[1] Now I wish you to help me to

[1] Palmer's first child Thomas More Palmer (1842-1861) was two years and eight
months old at the time. This is the earliest letter to the boy that has survived.

teach her. When you were as little as Mary, I used, every day to show you some of the letters and ask you what they were called. You should get a large A and B and C out of the box of letters, and ask Mary what each one is called, and tell her, if she does not know. You may play at PEEP BO! with the letters. Hide the letters behind a book: — then, suddenly pop one of them up — so that Mary may see it — and call out its name very loudly, and then ask Mary to call out. When she has done so, drop that letter behind the book, and pop up another: only do not begin with more letters than A B and C. When I come home how delighted shall I be if you have taught Sister Mary a few of her letters!

Ask your Mamma to fix some time in the day, for playing at peep bo with the letters. Perhaps tea time would do; when you and Mary have finished your bread and milk. But you should teach your Sister a little every day — and ask Mamma to remind you of it. You should begin the very day you receive this letter. If I had not taught you your letters every day — you could not now have read a chapter in the Bible nor the Pilgrim's Progress nor Sandford and Merton[2] nor the Songs of Innocence nor any of your pretty story books. I hear that Lady Stephens[3] came to see you, and I hope that you had been a good boy that day; for Lady Stephens loves good boys very much. How pleased I was when your Mamma wrote to say that you had been a very good boy!

Well, dear Thomas! Pray to our good GOD to make you better and better — and then, your Angel who watches over you will never go away.

Begin to do something which may please GOD. I think you can scarcely do anything better than teaching your Sister: — and if you begin today, and I find on coming home that you have taught her A, B and C; it will delight

<div align="right">Dear Thomas More — Your affectionate Father
SAMUEL PALMER</div>

P.S. If you wish to send me a letter — tell your Mamma what to say and she will write it for you.

[1] Mary had been born the previous year.
[2] *The History of Sandford and Merton* (1783–9), a children's book by Thomas Day.
[3] Palmer had taught and painted on Lady Stephen's estate in Dorset.

HANNAH PALMER[1]

Your charms my dear Annie are no weak inducement to lure me back. To me you are fairer than at 17 and though by this time I have got pretty well used to your scolding your love is always fresh and always precious. I hope to prove myself worthy of it by renewed exertions in Art.

JOHN LINNELL[2]

Thursday eveng [1851-2(?)] 6 Douro Place

Dear Sir

The note which Annie has sent to Mrs Linnell — with the unhappy tidings of a second miscarriage was written yesterday. I write a line to say how she is at present. Mr. Reynolds was here this morning and in answer to my question said he did not consider her in danger but that he might be mistaken. I said we were unwilling to alarm you and asked if he thought we should write. He said he thought I ought. Poor Annie is very weak indeed — with the loss of so much blood and scarcely able to rise in bed to take her food — but I suppose Mr. Reynolds considers her better than yesterday as he has only been here once today.

I should be glad of any additional information as to what it may be proper to do in Mr. Reynolds' absence when the faintness

[1] Few of Palmer's many letters to his wife have survived. This fragment (which exists only in a transcript made by their son A.H. Palmer) was tentatively dated August 1848 by Raymond Lister, who suggests that it may have been written from Devon.

[2] The Palmers moved to Douro Place, Kensington, in the spring or early summer of 1851, the same year in which John Linnell moved his family from London to Surrey, and Palmer's letters in the following years include several references to Hannah's poor health. Their third child Alfred Herbert was born in 1853, and in the absence of mention of him or his nurse Emma, I have provisionally dated this letter 1851-2. This may, however, be a few years too early.

Hannah's note to Mrs. Linnell has not survived, apparently, nor have any further letters by Palmer on the same topic. This letter is printed here for the first time by courtesy of Mrs. Joan Linnell Burton and the Linnell Trust.

comes over her. Annie has had a little of some boiled chicken for her dinner today — before that she was ordered to take nothing but raw eggs beaten up with a little milk.

I am sorry to send such bad news but will write again giving an account, as I earnestly hope, of some improvement.

I remain
Dear Sir
Yours very truly
S Palmer

HENRY WENTWORTH ACLAND[1]

6 Douro Place
Victoria Road
Feb. 1852　　.　　　　　　　　　Kensington

My dear Sir

Oxford, which I once saw, instantly loved, and left with moistened eyes, is so associated in my mind with all that is august and venerable that I should be loth to disturb the Aristotelian meditations of any of its professors by putting a trivial question.

Perhaps however you would kindly tell me the name of that Villa Garden at Rome whence by your recommendation I made two sketches of the city and Vatican. The possessor of a large drawing I made from them very much wishes to know the point of view.[2]

I think, after crossing the bridge of St. Angelo we turned to the

[1] Sir Henry Wentworth Acland (1815-1900), whom Palmer had met in Italy. An amateur artist, close friend of both George Richmond and John Ruskin, Acland became a distinguished physician and scholar. Elected a Fellow of the Royal Society in 1847, he was appointed Aldrichian Professor of Clinical Medicine at Oxford in 1851 and Regius Professor of Medicine in 1857.

Palmer's five surviving letters to Acland are printed here for the first time by courtesy of the Bodleian Library, Oxford. (Much of the second letter was included in *Sir Henry Wentworth Acland, Bart . . . A Memoir*, by J.B. Atlay, 1903, and in the 1974 edition of Palmer's *Letters* edited by Raymond Lister.)

[2] Palmer painted several large watercolours of Rome. The rough sketch in this letter seems to resemble *The City of Rome and the Vatican, from the Western Hills*, in the Fitzwilliam Museum, Cambridge.

left — ascended a short steep hill and entered the deserted villa garden by a gate made in the old city wall. The view was something of this kind [*Sketch*] only St. Peter's was much nearer than I have made it. If you forget the name of the villa perhaps you would kindly name something in the neighbourhood from which the point of view might take its name.

It would give me great pleasure to see you some day in Douro Place and to talk a little about the Eternal City — and about *another* city, very dear to me, which some ill natured people say lies in the direct road to the former![3]

Believe me
Dear Sir
Very Faithfully Yours
S. *Palmer*

HENRY WENTWORTH ACLAND

6 Douro Place
Victoria Road
Kensington

July 8 1854

My dear Sir

As I am endeavouring to cure an obstinate cold, the pro-babilities are against my reaching York St[1] on Monday evening. Mr Richmond however will show you some drawings.

I do not think that a month's lessons teach so much as a week's 'cram'. I ought to watch your principal subject till it is safe — and at other times of the day secure for you, in writing and otherwise a hand book of information which beside any new suggestions might set all your present artistic knowledge in order for future use, and be applicable equally to all scenery and subjects.

These six days being wholly devoted to you I do not think I could say less than 12 guineas and expenses including travelling expenses, without sustaining loss by going away from engage-ments due in London at this time.

[3] Notably John Linnell, one of whose poems, 'Pope-Awry', begins, 'Ye mongrel monks, ye snobs of Rome!' and goes on to call the activities fostered by the Oxford Movement 'superstitious pranks'.

[1] George Richmond lived at 10 York St. in west-central London.

This would end the business part of the affair; after which I should like to spend another week in a manner which would benefit myself — viz in exploring the neighbourhood for hints or subjects; going to Mr Halliday's oaks Watermouth Cove[2] etc. — and I should have the greatest pleasure in your society. We could go out for light sketching and see what was to be seen. But Devonshire, lovely as it is, is so rainy that it would not be safe to trust to anything but the most settled weather — and just now, is the only time I can manage.

<div style="text-align:right">

I remain
My dear Sir
Yours faithfully
S. *Palmer*

</div>

P.S. I am delighted to hear about the sunset — to do this you should be on the cliffs at the right moment every evening.

I have explored Clovelly and do not think you will find it so good as Ilfracombe — the village too is unhealthy. Ilfracombe is a centre about which I remember having seen the best matters in the county — in strange nooks without a name but which I think I could find out. I have long suspected that the rise of the rivers aloft on such places as Exmoor must be peculiarly interesting but they are out of the question.

Whether I come or not I would advise you above all to be *methodical* and arrange your time in masses — a week of severe study — then a rambling time without any severity at all. This is the way to compress months into weeks — even into days.

Pray get the ordnance map of the district you go to.

HENRY WENTWORTH ACLAND

July 54 6 Douro Place Victoria Road Kensington

My dear Sir
I was very sorry to be deprived of the pleasure of meeting you yesterday, as Mr. Richmond wished; but there was a meeting of the Etching Club which was peremptory.

[2] A bay near Ilfracombe on the north coast of Devon.

1. Taking into consideration the sunset subject you propose as well as the 'little bits' Margate is the only place at a less distance than North Somersetshire where both can be carried out. I shall never forget the suns there setting in the sea — close by is a farm with some sea-blown trees of which Mr. Richmond made a very beautiful drawing.

2. I would carry out my proposal of the business week and the poetic week there if a decision were come to in a few days — but should not like to wait very long as I am anxious to secure the fine weather which the rising glass promises, and see a tempting opening to Bolton Abbey.[1]

BUT by some fatal attraction, most seekers for a house in the neighbourhood of the North and South forelands finally imprison themselves in Ramsgate. Should that be your lot I will if you please spend the whole of six days with you there or in any place nearly adjacent coming over from Margate (only a few minutes by rail) and returning thither at night. I should not much like, myself, to take children there — as hundreds in all stages of every disease are huddled together on a strip of shore called the 'Ramsgate sands' — and it is only when the tide is out that yours can escape them.

Broadstairs is a very small cove or bay in the cliffs resembling a Dutch oven both in shape and temperature. It differs, in that children are roasted instead of apples and that there is a small picturesque pier. Should you go there a house on the top of the cliff might be cool and healthy. Thither I could come from Margate daily — departing in the evening as from Ramsgate — until the dawn of the second week. Walmer Dover Deal Folkestone I have not seen. I have no objection to go for a week to either. An artist told me that Sandgate is really a very pretty place — I might find some of these latter places answer for the second week which will be an important one for me as I am anxious then to enlighten my mind by watching nature as well as sketching or making memoranda. Therefore it is that I could not dwell in Ramsgate and should be sorry to lose the Margate sunsets — unless meeting with some beauty nearly equivalent: but such is often found unexpectedly.

[1] The temptation was never great enough for Palmer, who loved the south of England, to visit Yorkshire.

Margate is said not to be 'select': perfectly true I dare say — but what sea-side places are? Were you at Margate I should be happy to be there for a fortnight as proposed. At first it appears flat — shocking to Alpine souls — insipid to the lovers of epigrammatic landscape — but the ground everywhere gently undulates and is covered with crops of corn — and those trees, I know, may be turned to good account. They are full of birds and there are alas! so few besides that a lodging among the branches you need not fear. Fort Crescent is pretty quiet and on the other side of the dotted line[2] you may be as still as you please. If you give up the sea view Cecil Square has good houses very near it.

If you give up the sunset over sea I should fancy Sandgate would be pleasant — or St. Leonard's; or better — a house pretty high immediately above Hastings.

I am much pleased by your compliment to my little drawing. — It is an attempt to suggest the sentiment of the ridge beyond Sevenoaks and Knowle. Merely considering what is usually called 'picturesque' matter, Hastings most likely, would be best of all, but below the cliff it is very hot.

A line, as soon as you have decided[3] would oblige

<div style="text-align:right">

Dear Sir
Yours faithfully
S. *Palmer*

</div>

P.S. Pardoning the abrupt change of subject, allow me to suggest that as country towns are very unequally drained, the nose and eye should be equally consulted in the choice of a house. For want of this Dr. James Johnson[4] found a 'change of air' at Brighton which destroyed him in a few days and nearly killed his children.

[2] Below the text of this letter Palmer has drawn 'A very bad map of Margate', showing the town, the sea, and 'Another ocean of corn fields'. Beside his sketch of the town are the words, 'The chrome yellow people live here This is the "parade" '. Palmer spent holidays in Margate as a boy, and returned several times in later years.

[3] It is not certain whether Palmer did accompany Acland on a sketching expedition. However, in his letter to Acland of August 1855, he refers to 'the little drawing I did with you'. Furthermore, Acland is known to have passed 'the early summer' of 1854 at Walmer, south of Deal on the Kentish coast; when he returned to Oxford, he organized the resistance against the city's last great cholera epidemic. And J.B. Atlay, in his *Memoir* of Acland, states that from Palmer's 'artistic advice and teaching he had received much advantage' (cf. pp. 174, 469).

[4] Dr. James Johnson (1777-1845), author of popular medical works.

HENRY WENTWORTH ACLAND

6 Douro Place
Aug 8 [18]55 Victoria Road

My dear Sir

I think the poem must have been Fletcher's 'Faithful Shepher-
dess'[1] — full of the ideal — of concentrated and essential truth —
differing from mere descriptive poetry as truths from facts — as
the imaginative from the perceptive among men. Drayton,
Browne, in his Britannia's Pastorals; Phineas Fletcher in the
'Purple Island'[2] etc. are of a like kind and for the lovers of early
morning, preeminently Chaucer; as you probably have noticed in
the 'Complaint of the Black Knight'.[3] Nor is he without a noble
moon of which I have longed to attempt an illustration

> The ploughman plucked up his plough
> When midsummer moon was comen in
> And said his beasts should eat enow
> An lie in the grass up to the chin
> They been feeble both ox & cow
> Of them nis left but bone & skin
> He shook off shere & couter off drowe
> And hanged his harness on a pin —

There we have the action of the figure hanging up the harness and
the background of the oxen half buried in fragrant and flowery
herbs — [Sketch[4]]

[1] John Fletcher's *The Faithful Shepherdess* (1608-9) had a profound effect on the
young Palmer. In a fragmentary late letter to Leonard Valpy, Palmer says that he
found there 'all my dearest landscape longings embodied' (*Letters*, p. 1012).

[2] Michael Drayton (1563-1631) and William Browne (1590-1645) wrote in the
mainstream of English pastoral, but the inclusion of Phineas Fletcher (1582-1650)
is a little surprising, for *The Purple Island* is not so much pastoral as an extended
allegory of the body. Presumably Palmer did not have in mind the 'Pancreas . . .
who ne're complains' or the 'Urine-lake drinking his colour'd brook'.

[3] The following eight lines of poetry come not from *The Complaint of the Black
Knight* (an early work by John Lydgate) but from *The Plowman's Tale* (anonymous,
though considered to be Chaucer's work by Dryden among others).

[4] In this tiny sketch a full moon is rising on the left side of the picture above a village
nestling in a valley, with a vertical figure on the right. A prominent diagonal
extends towards the top right-hand corner. The context suggests summertime
with resting animals. All these elements are present in the first of Palmer's large
etchings, *The Rising Moon* or *An English Pastoral* (1857). Several of them recur in
The Weary Ploughman (1858), in which oxen are prominent.

Solemn woody hills and the rising moon like a golden shield behind them you will find the Faithful Shepherdess in Beaumont and Fletcher.

Many times I have wished to know how drawing was going on in Oxford but the demon procrastination has mislaid my pen. If there is anything I can communicate by letter which will be of the least use while you proceed with your drawings, be assured my dear Sir that nothing will give me more pleasure.

I enclose a little washed gamboge purified from its green tint and semiopaque a colour which stands alone for brilliancy *here* and *there* but not answering the valuable purposes of common gamboge in transparent vegetation. I wish I had had a little of the washed G: for the light around the sun in the little drawing I did with you. No pigment has so much colour with so little loss of light — but if kept upon the palette in any quantity it will put the eye wrong. Should the paper become damp it can be soaked off. It easily dissolves in water and can be rubbed up in a saucer by the finger but has a strange trick of coming out of any paper in which it is wrapped — so I keep it in a bottle.

I have very little of it and dread the labour of making more but should you become enamoured of it, can send an accurate account of the process — which your laboratory assistant will carry into effect.

It seems to me that Keats was full of the *interior* sight though he started in an exceptionable school — see his poem on autumn — only a few stanzas.

Mr Richmond told me you were going to Cornwall. Should you go to Tintagel — and down from the village straight to the sea having the castle to your left and passing a machine for shipping slates — just at the water's edge turn your back upon the castle and the fine cave beneath and you will see a fine bit of shore rock thus [Sketch] Mr Creswick[5] says the neighbourhood of the Lizard (Helstone) is most romantic (see Caynon's Cove)[6] — the

[5] Thomas Creswick (1811-1869), R.A. and member of the Etching Club.
[6] Kynance Cove, on the Lizard Pensinsula in Cornwall.

wildest caves — and I hear that St Ives Bay is most Italian; and what a place for sunsets!

An engagement waiting for me I must conclude

Wishing you every success I remain

<div style="text-align:center">My dear Sir</div>

<div style="text-align:center">Yours ever faithfully *S. Palmer*</div>

ALEXANDER GILCHRIST[1]

Aug. 23rd, 1855. Kensington

My dear Sir,

I regret that the lapse of time has made it difficult to recall many interesting particulars respecting Mr. Blake, of whom I can give you no connected account; nothing more, in fact, than the fragments of memory; but the general impression of what is great remains with us, although its details may be confused; and Blake, once known, could never be forgotten.

His knowledge was various and extensive, and his conversation so nervous and brilliant, that, if recorded at the time, it would now have thrown much light upon his character, and in no way lessened him in the estimation of those who know him only by his works.

In him you saw at once the Maker, the Inventor; one of the few in any age: a fitting companion for Dante. He was energy itself, and shed around him a kindling influence; an atmosphere of life, full of the ideal. To walk with him in the country was to perceive the soul of beauty through the forms of matter; and the high, gloomy buildings between which, from his study window, a glimpse was caught of the Thames and the Surrey shore, assumed a kind of grandeur from the man dwelling near them. Those may laugh at this who never knew such an one as Blake; but of him it is the simple truth.

He was a man without a mask; his aim single, his path straight-forwards, and his wants few; so he was free, noble, and happy.

[1] Alexander Gilchrist (1828-1861), author of *The Life of William Blake* (published posthumously in 1863) from which the text of this letter is taken.

His voice and manner were quiet, yet all awake with intellect. Above the tricks of littleness, or the least taint of affectation, with a natural dignity which few would have dared to affront, he was gentle and affectionate, loving to be with little children, and to talk about them. 'That is heaven', he said to a friend, leading him to the window, and pointing to a group of them at play.

Declining, like Socrates, whom in many respects he resembled, the common objects of ambition, and pitying the scuffle to obtain them, he thought that no one could be truly great who had not humbled himself 'even as a little child'.[2] This was a subject he loved to dwell upon, and to illustrate.

His eye was the finest I ever saw: brilliant, but not roving, clear and intent, yet susceptible; it flashed with genius, or melted in tenderness. It could also be terrible. Cunning and falsehood quailed under it, but it was never busy with them. It pierced them, and turned away. Nor was the mouth less expressive; the lips flexible and quivering with feeling. I can yet recall it when, on one occasion, dwelling upon the exquisite beauty of the parable of the Prodigal, he began to repeat a part of it; but at the words, 'When he was yet a great way off, his father saw him,'[3] could go no further; his voice faltered, and he was in tears.

I can never forget the evening when Mr. Linnell took me to Blake's house; nor the quiet hours passed with him in the examination of antique gems, choice pictures, and Italian prints of the sixteenth century. Those who may have read some strange passages in his *Catalogue*,[4] written in irritation, and probably in haste, will be surprised to hear, that in conversation he was anything but sectarian or exclusive, finding sources of delight throughout the whole range of art; while, as a critic, he was judicious and discriminating.

No man more admired Albert Dürer; yet, after looking over a number of his designs, he would become a little angry with some of the draperies, as not governed by the forms of the limbs, nor assisting to express their action; contrasting them in this respect with the draped antique, in which it was hard to tell whether he

[2] Adapting Mark 10:15.
[3] Luke 15:20.
[4] *A Descriptive Catalogue* (1809) to Blake's ill-fated exhibition of frescoes and watercolours; it was as much a manifesto as a description.

was more delighted with the general design, or with the exquisite finish and the depth of the chiselling; in works of the highest class, no mere adjuncts, but the last development of the design itself.

He united freedom of judgment with reverence for all that is great. He did not look out for the works of the purest ages, but for the purest works of every age and country — Athens or Rhodes, Tuscany or Britain; but no authority or popular consent could influence him against his deliberate judgment. Thus he thought with Fuseli and Flaxman[5] that the Elgin Theseus, however full of antique savour, could not, as ideal form, rank with the very finest relics of antiquity. Nor, on the other hand, did the universal neglect of Fuseli in any degree lessen his admiration of his best works.

He fervently loved the early Christian art, and dwelt with peculiar affection on the memory of Fra Angelico, often speaking of him as an inspired inventor and as a saint; but when he approached Michael Angelo, the Last Supper of Da Vinci, the Torso Belvedere, and some of the inventions preserved in the Antique Gems, all his powers were concentrated in admiration.

When looking at the heads of the apostles in the copy of the *Last Supper* at the Royal Academy, he remarked of all but Judas: 'Every one looks as if he had conquered the natural man'. He was equally ready to admire a contemporary and a rival. Fuseli's picture of *Satan building the Bridge over Chaos*[6] he ranked with the greatest efforts of imaginative art, and said that we were two centuries behind the civilization which would enable us to estimate his *Aegisthus*.

He was fond of the works of St. Theresa, and often quoted them with other writers on the interior life. Among his eccentricities will, no doubt, be numbered his preference for ecclesiastical governments. He used to ask how it was that we heard so much of priestcraft, and so little of soldiercraft and lawyercraft. The Bible, he said, was the book of liberty, and Christianity the sole regenerator of nations. In politics a Platonist, he put no trust in demagogues. His ideal home was with Fra Angelico: a little later he might have been a reformer, but after the fashion of Savonarola.

[5] The painter Heinrich Fuseli (1741-1825) and the sculptor John Flaxman (1755-1826).
[6] Now in the Auckland Art Gallery. The *Aegisthus* is lost.

He loved to speak of the years spent by Michael Angelo, without earthly reward, and solely for the love of God, in the building of St. Peter's, and of the wondrous architects of our cathedrals. In Westminster Abbey were his earliest and most sacred recollections. I asked him how he would like to paint on glass, for the great west window, his *Sons of God shouting for Joy*, from his designs in the *Job*. He said, after a pause, 'I could do it!' kindling at the thought.

Centuries could not separate him in spirit from the artists who went about our land, pitching their tents by the morass or the forest side, to build those sanctuaries that now lie ruined amidst the fertility which they called into being.

His mind was large enough to contain, along with these things, stores of classic imagery. He delighted in Ovid, and, as a labour of love, had executed a finished picture from the *Metamorphoses*, after Guilio Romano. This design hung in his room, and, close by his engraving table, Albert Dürer's *Melancholy the Mother of Invention*, memorable as probably having been seen by Milton, and used in his *Penseroso*. There are living a few artists, then boys, who may remember the smile of welcome with which he used to rise from that table to receive them.

His poems were variously estimated. They tested rather severely the imaginative capacity of their readers. Flaxman said they were as grand as his designs, and Wordsworth delighted in his *Songs of Innocence*. To the multitude they were unintelligible. In many parts full of pastoral sweetness, and often flashing with noble thoughts or terrible imagery, we must regret that he should sometimes have suffered fancy to trespass within sacred precincts.

Thrown early among the authors who resorted to Johnson, the bookseller, he rebuked the profanity of Paine, and was no disciple of Priestley;[7] but, too undisciplined and cast upon times and circumstances which yielded him neither guidance nor sympathy, he wanted that balance of the faculties which might have assisted him in matters extraneous to his profession. He saw everything through art, and, in matters beyond its range, exalted it from a witness into a judge.

[7] Joseph Johnson (1738–1809), publisher and democrat; Thomas Paine (1737–1809), radical author; Joseph Priestley (1733–1804), scientist. Blake was far more sympathetic to the politics of such men than Palmer wished to believe.

He had great powers of argument, and on general subjects was a very patient and good-tempered disputant; but materialism was his abhorrence: and if some unhappy man called in question the world of spirits, he would answer him 'according to his folly', [8] by putting forth his own views in their most extravagant and startling aspect. This might amuse those who were in the secret, but it left his opponent angry and bewildered.

Such was Blake, as I remember him. He was one of the few to be met with in our passage through life, who are not, in some way or other, 'double-minded' and inconsistent with themselves; one of the very few who cannot be depressed by neglect, and to whose name rank and station could add no lustre. Moving apart, in a sphere above the attraction of worldly honours, he did not accept greatness, but confer it. He ennobled poverty, and, by his conversation and the influence of his genius, made two small rooms in Fountain Court more attractive than the threshold of princes.

> I remain, my dear Sir,
> Yours very faithfully,
> *Samuel Palmer*

HANNAH PALMER

[April/May 1856] [Kensington]

I feel that I cannot neglect family reading and prayers without positive sin, and trust some plan may be devised by which it may be continued. The master of a family is, in a measure, responsible for the souls of his wife, children, and servants; and cannot answer at the Judgment Seat, 'Am I my brother's keeper?'[1] . . . I think, if possible, it will be best for me to go out of town with More directly his holidays begin, which I think is the middle of June; but then we may have bad weather. On the other hand, NOW seems to be the time for weather useful to me. It is always a perplexity. It is quite true, as your father says, that my subjects are wasted upon such little drawings, but then comes the difficulty — not one large drawing was sold at our private view.

[1] Genesis 4:9.

[8] Proverbs 26:4.

How very touching and beautiful are the collects and psalms just now. I trust you will prepare for Holy Communion on Whit Sunday. It is specially a day of grace and sanctification to the faithful. In the bustle of life we see nothing but illusions: getting to church in good time and reading the psalms for the day before service begins, the poor world-withered heart begins to open like shrivelled leaves in a gentle summer shower; and then we see things as they are, if we have kept our evil passions under discipline during the week, living in love and charity with ALL MEN. For this is the condition; If *from your heart* 'ye forgive not men their trespasses, neither will your Father forgive *your* trespasses' 'With what judgment ye judge ye shall be judged.'[2] You know Herbert's lines, 'The Sundays of man's life', etc.[3]

If we duly weighed God's blessings we should see and feel that the greatest of all was in the ability to go to church; whether a cathedral, or the humblest of those grey turrets which are, to the Christian's eye, the most charming points of our English land-scape — gems of sentiment for which our woods, and green slopes, and hedgerow elms are the lovely and appropriate setting. Landscape is of little value, but as it hints or expresses the haunts and doings of man.[4] However gorgeous, it can be but Paradise without an Adam. Take away its churches, where for centuries the pure word of God has been read to the poor in their mother tongue, and in many of them most faithfully *preached* to the poor, and you have a frightful kind of Paradise left — a Paradise without a God. For the works of creation will never lift the soul to God until we have been taught that our Lord Jesus Christ is the 'Way', and that 'no man cometh to the Father'[5] but by Him. Let not our thoughts wander to queer architecture like that of good Mr. G——'s[6] church, or to the dresses of the people. Ever remember when inclined to criticise persons or places, our Lord's 'What is that to thee? follow thou me.' We cannot be too severe upon our natural censoriousness and impertinent curiosity — our profane

[2] Matthew 6:14 (adapted) and 7:2.

[3] 'Sunday', lines 29-35.

[4] A central tenet of his artistic faith, not always remembered in discussions of his work.

[5] The Biblical quotations in this paragraph are from John 14:6, John 21:22, and Proverbs 24:21.

[6] Unidentified.

levity, and longings after something new. 'My son, fear thou the Lord and the King; and meddle not with them that are given to change.'. . .

JOHN REED[1]

January 26 [1858] 6 Douro Place

My dear Reed.

Planets and systems rolling through millions upon millions of miles of dark, empty space are dismal matters to think on, and repulsive to our human feelings, as crushing man and his concerns into less than a point — an atom. Whereas the Torso Belvedere is more truly sublime than an infinity of vacuum; and the Sistine Chapel, as an inspiration from the Spirit of Wisdom, than any of the material wonders of the universe. It is the work of God upon mind, which must needs excel His working upon matter, as the subject is greater, although the Infinite Wisdom the same. I have long believed that these vast astronomical spaces are real to us only while we sojourn in the natural body, and that the soul which has put on immortality will, so far as soul can be cognisant of space, find itself larger than the whole material universe.

How easily can the Divine Will annihilate, for a given time and purpose, the 'laws', as we call them of matter. Our blessed Lord although 'clothed upon'[2] with His resurrection body, came and stood in the midst of the disciples, 'the doors being shut'. 'The Spirit of the Lord caught away Philip,' and he 'was found at Azotus.'

And we find that the most powerful agents in the world of matter itself, are those which seem least to partake of material solidity. The electric fluid blasts the oak and shivers the battlement; and to this subtile fluid and the elasticity of steam, we owe the two inventions which have abridged space and almost annihilated time. Probably the spirits of 'just men made perfect', have no impediments of space and time to sunder them; and if the

[1] A deaf-and-dumb oil painter, formerly a neighbour in London.
[2] For the Biblical references in this paragraph and the next, cf. 2 Corinthians 5:2, John 20:26, Acts 8: 39-40, Hebrews 12:23, and John 14:2.

planets of this and other systems be the 'many mansions' of our Father's house, there may perhaps be no difficulty or delay of communication between them. The rush of the autumnal meteor may be a snail's pace compared with the motive Will of inter-planetary travellers.

At present however, after all the railways have done for us, the case is very different, as engagements of one kind or other leave us with time too little even to avail of the express train: and thus it is with me, or I would certainly have run down to see you long ere this. It is not enough to have you in my heart, for I want to see your face, and feel the warmth of your smile; or the warmth of your scolding, if *I* happen to smile on certain occasions when you think I ought to look very severe indeed! But thank you most cordially for your sincerity. You are one of the very few who seem to care for my soul, and what kindness is comparable with that? I enjoyed much the paper you just sent me — all but the Chinese affair.[3] To say nothing of the massacre of an innocent populace, is it not like a big boy insulting a little one? Is this the first time that, on the shores of China, our commercial greediness has played the fortune-hunting bully?

Saul slew his thousands, David his ten thousands, but the lust of gain its millions. Burke, speaking on the East Indian Bill, described Lahore as exhibiting for years, an unintermitted but alas *unequal* struggle between the goodness of God to replenish, and the wickedness of man to impoverish and destroy.

I can sympathize with your fatigue after 'many parties', having been obliged to go to several myself very lately. The night after one of these meetings with really fine pianoforte playing and Italian music, Mrs. P. read me George Herbert's life, which, though I had often read it before, was better than a dozen of these midnight dissipations. Cards and music are the great destroyers of conversation. If I were an absolute monarch and wanted to clench the people in a hopeless tyranny, I would take off the duty on cards, and have thousands of reams of cheap music at every stationer's. A poor soul enervated by opera music, cares neither for itself nor its country.

Think of English daughters and English mothers, squalling

[3] 'Possibly the bombardment of Canton': A.H. Palmer's note.

voluptuous love bravuras, while the household and the nursery are left to the tender mercies of hirelings!

Talking thus of parties, I must make an exception to some occasionally given by artists. Artists have a good deal of real humour in them, and see the point of a joke better than most people. . . .

What poor, fun-loving babies we are — here, just upon the verge of eternity. All is a puzzle and heterogeneous heap of inconsistencies so wild and strange that, but for their daily experience, they would be incredible.

Thousands lavishing, thousands starving; intrigues, wars, flatteries, envyings, hypocrisies, lying vanities, hollow amusements, exhaustion, dissipation, death — and giddiness and laughter, from the first scene to the last.

> I remain, dear Reed,
> Yours affectionately,
> *S.P.*

JOHN LINNELL

Feb[y]. 1859 6 Douro Place

My dear Sir,

After reading attentively your letter of the 5th inst. I gave it to Annie. She assures me that her letters to you contained no taunts nor reproaches. You speak of proof given at sundry times of a desire to help being all forgotten through the one refusal.[1] I can assure you that since her visit when she was doing those drawings for the queen,[2] she has ever been talking of your kindness at that time, and at many others and has seemed to me to receive kindness with exemplary gratitude. She has been ready to fly to the ends of the earth for her father: her filial reverence has amounted

[1] Linnell's wife was in poor health, and Linnell refused to invite More to recuperate from his illness at their home in Surrey. The Palmers, meanwhile, were refusing to write to Mrs. Linnell without mentioning their convalescent son. The ill feelings caused by this disagreement were never forgotten; after 1859, relations between Palmer and Linnell were mostly curt and constrained.

[2] Unexplained. Not only are there absolutely no records of such drawings, Hannah had done little artwork since the early 1840s. But it seems an odd moment for Palmer to make a private joke.

to worship. I have not yet asked your attention to any obser-
vations of my own, but really wish I knew in what way More has
offended you; for every grandfather's house is open to his grand-
children: no mother is left to beseech it as a favour, especially for a
convalescent child. *Grandfather desires it* as a reciprocal pleasure,
and as one of those pleasures by all the ties of nature most dear to
his heart. It is as much a matter of course for his grandchildren to
stay with him a little in the holidays as to go back to school again
when they are ended. The grandchildren are grateful enough, for
they generally are such favourites as to be a little spoiled by
over-kindness while they stay.

Surely More must have seriously offended you in some way of
which I am not aware, to be thus cut off from Grandfather and
Grandmother and those Uncles and Aunts whom he always
speaks of as his oldest friends.

He is no longer a romping boy, fond of practical jokes but a
diligent student embedding himself in Greek. He is never idle for
a moment, but a very pleasant and intellectual companion: just
the kind of person whose visits would be agreeable to his aunts,
and I flatter myself not disagreeable to his uncles, not disturbing
any family order, doing any mischief, or causing uneasiness to
any one.

I have not yet asked, and am not in this letter asking you to
invite him, but merely stating a few facts connected with a matter
to me wholly inexplicable. Least of all is it my intention to write
any syllable which may irritate. But allow me to place before you
a strange contrast, and to ask you to look at it for a moment as if
we had no personal concern in it. Here is a youth of seventeen; we
will call him Tom Smith, or anything else. Tom is acquainted
with some of the most clever and agreeable people in his neigh-
bourhood. His society is sought after. He is most dangerously ill.
The crisis is past and Tom begins again, with writing desk on bed,
to make use of the time he never wastes. A friend sits in tears
reading some verses sent him by poor Tom from his sick bed, and
wishes that his own boys may but turn out like Tom Smith.

The head master of a first rate school comes *three times* to see
Tom in his illness, and when Tom returns the call begs he will
make free use of his choice library, borrowing any books he likes.
When quite convalescent, his mother writes to his grandfather in
the country asking him to let Tom stay there a little to get strength

again and his grandfather refuses. Now I am not, at the present moment, complaining of this, but merely stating it as a mysterious contrast between the bearing of acquaintances and of almost the nearest possible relation.

Here is no importunity, for I am at this moment asking nothing, nor reproach, nor, I hope, a shade of temper, for I am calm, selecting the fewest and most peaceable words. It is only a juxta-position of facts to which my experience gives me no clue.

People say 'Of course his grandpapa will have him down to Redstone; that is what he wants.' One says 'Ah well he will get set up at Redstone' another — 'But *why* does he not go to Redstone?' These questions are very unpleasant to his mother, as she has to explain that, so far as she can divine, it is no fault of More's. If she did not, his character would be ruined, as they must of course suppose that to be uninvited by so very near a relation, when an invitation might renew his strength and prolong his life, he must have committed some heinous crime which we had hushed up; and this would exclude him from the society of our friends and be a blot upon him for life. I think you will agree with me that I have written here not one angry or disrespectful word, nor can I remember ever having done so. On one occasion I spoke warmly in the time of our dear daughter's illness and for that I expressed my sorrow. I have abstained from giving an opinion upon the line which you have taken. In a matter so nearly concerning my son's prospects, in life, it would have looked almost like sullenness had I said nothing. I do not wish to entail upon you the trouble of an answer although I keep among my treasures letters received from you in times that have passed away.

<div style="text-align: right">

I remain
Dear Sir
Yours truly
S. Palmer

</div>

HANNAH PALMER

I feel a strange relief since the squally, strange change in the atmosphere. Before the two thunderous days, it was what I call gasping weather; but since, although very close for this airy place, there is a delightful humidity in the air. I felt while the rain was pouring down, the refreshment which I suppose a plant feels under the same influence, after drought. I DREAD the DUST of town, which withers me whenever I get out; and if I could have my choice would prefer a month's incessant rain. You must see what an affliction it must be to me, anxious as I am after high excellence, to be as it were dodged and disappointed in all my attempts to get a sight of beautiful nature and strength to use it.

I hope, D.V., when I return, to make a struggle for regularity as to the breakfast-hour; to get four hours clear, good work before dinner; and then, for the *present*, to take the rest of the day easily; and when I get, D.V., stronger, to adopt Mr. Cope's[1] plan of a Saturday holiday. But again I dread the dusty drought. Dr. Bell will order me out, but I feel like Cain, 'Whither shall I go?'[2] What a mockery to go out for health and refreshment into that dreadful granite-dust. And am I to see nothing of that external loveliness which is my spring of successful work? O! that I were nestled among those granite taws of dear Devonshire, 1500 feet high. As soon as the Turners come,[3] I shall be out enough you may be sure, in the direction of Brompton, but I must see some out-door beauty, or my mind will perish.

[1] The painter Charles West Cope, R.A., godfather of Palmer's younger son.
[2] Cf. Genesis 4: 12-14.
[3] Turner had left nearly 20,000 drawings and paintings to the nation. Apparently Palmer expected to see a selection at the South Kensington Museum.

HANNAH PALMER

[? June] 1859 [Hastings]

I have been very quiet and undisturbed here, which is much in my
favour. I do not care about these things on my own account. I
could go quietly like a poor sheep under the first hedge and lie
down and die, so far as that goes; but as a living flour-mill which
has to grind corn for others, it is a source of alarm to feel that the
machinery is quite out of order . . . I seem doomed never to see
again that first flush of summer splendour which entranced me at
Shoreham; for what with east wind and mist I have seen little but
Indian Ink. . . . I have begun some designs to send to Manchester,
but determining not to work much yet, have made little way. I
was quite hurt to hear about poor dormouse's death. His life was
too like what my own will be — short and unquiet. . . . Joy and
thankfulness, or a broken-hearted old age, a man must look for
from his children. I have only just enough strength to discharge
my duties if everything goes well and rightly; but domestic
sorrows will soon break me up utterly . . .

ALEXANDER GILCHRIST[1]

May 3rd, 1860. [Kensington]

My dear Sir,
 Late as we parted last night, I awaked at dawn with the question
in my ear, Squalor? — squalor?
 Crush it; it is a roc's egg[2] to your fabric.
 I have met with this perverse mistake elsewhere. It gives a
notion altogether false of the man, his house, and his habits.
 No, certainly; — whatever was in Blake's house, there was no
squalor. Himself, his wife, and his rooms, were clean and orderly;

[1] This brief letter was published in Gilchrist's *Life of William Blake*. I have appended
fragments by Palmer from other pages of the biography; these may or may not
have been parts of a single letter to Gilchrist.
[2] Referring to the fabulous bird in the *Arabian Nights* whose egg is fifty paces in
circumference.

everything was in its place. His delightful working corner had its implements ready — tempting to the hand. The millionaire's upholsterer can furnish no enrichments like those of Blake's enchanted room.

> Believe me, dear Sir,
> Yours most truly,
> S. Palmer

Money he used with careful frugality, but never loved it; and believed that he should be always supplied with it as it was wanted: in which he was not disappointed. And he worked on with serenity when there was only a shilling in the house. Once (he told me) he spent part of one of these last shillings on a camel's hair brush. . . . He would have laughed very much at the word *status*, which has been naturalised into our language of late years.

Blake knew nothing of dignified reserve, polite *hauteur*, 'bowings out, or condescension to inferiors', nor had he dressed himself for masquerade in 'unassuming manners'. Somewhere in his writings occur these lines, droll, but full of meaning —

> The fox, the owl, the spider, and the bat,
> By *sweet reserve* and modesty grow fat.[3]

He delighted to think of Raphael, Giulio Romano, Polidoro,[4] and others, working together in the chambers of the Vatican, engaged, without jealousy, as he imagined, in the carrying out of one great common object; and he used to compare it (without any intentional irreverence) to the co-labours of the holy Apostles. He dwelt on this subject very fondly. . . . Among spurious old pictures, he had met with many 'Claudes', but spoke of a few which he had seen really untouched and unscrubbed, with the greatest delight; and mentioned, as a peculiar charm, that in these, when minutely examined, there were, upon the focal lights of the

[3] Blake wrote this couplet with reference to the painter Thomas Stothard. It appears both in his 1808-9 notebook (but with a beetle instead of the spider) and in the *Descriptive Catalogue* of 1809 (but with a mole instead of the bat). Cf. *Complete Writings* (ed. G. Keynes, Oxford, 1974), pp. 545, 575. Palmer's second sentence, including the Blake quotation, was omitted from the 1974 edition of his *Letters*.
[4] Polidoro da Caravaggio (c. 1495-1546).

foliage, small specks of pure white which made them appear to be glittering with dew which the morning sun had not yet dried up. . . . His description of these genuine Claudes, I shall never forget. He warmed with his subject, and it continued through an evening walk. The sun was set; but Blake's Claudes made sunshine in that shady place. . . . Of Albert Dürer, he remarked that his most finished woodcuts, when closely examined, seemed to consist principally of outline; — that they were 'everything and yet nothing'. . . . None but the finest of the antiques, he held, equalled Michael Angelo.

If asked, whether I ever knew among the intellectual a happy man, Blake would be the only one who would immediately occur to me.

HANNAH PALMER

May 1861 [Kensington]

To-day, Thursday, is like yesterday — thorough influenza weather. East wind, damp, cold, and fog. The houses in Albert Place loom through a dirty yellow fog, and the top of a tree in Kensington Gardens is but just visible. The gloom just now is overpowering. The London smoke is hovering over like a pall. The cold makes one's fingers ache after washing.

A horror came upon me this morning lest I should have killed More by finding so cold a place as High Ashes[1] . . . Since the *balmy* weather ceased (Balmy!) we have been obliged to have winter fires; and as to outlining, designing, inventing, it has been quite out of the question. Depressed as I am, I have still the English *will* about me — to fight to the last and die at my post. I think, D.V., I may yet conquer by taking in a whole system-full of new blood from nature.

Half-past eight. The darkness increases, and the foul smells of London come in through every crevice. . . .

[1] In April 1861 Hannah Palmer and her two sons moved to High Ashes, a rented farmhouse near Abinger in Surrey, for the sake of Thomas More's health. Palmer continued to live in London until late in May.

EDWARD CALVERT

July 11, 1861 At James Linnell's, Esq., Red Hill, Surrey

My dear Calvert.

As you are the *first* of my friends whom I sit down to make partaker of my sorrow, I will not wait for black-edged paper, which is sent for.

You I take first, for you were first in kindness when dear little Mary was called away, and your *kind*, *kind* heart will be wrung to hear that at our lodging at High Ashes, near Dorking, on Leith Hill, my darling Thomas More left us at a quarter to six. It was effusion of blood on the brain.[1]

I can write no more, dear Mr. and Mrs. Calvert, and do not know where I shall be for the next few days.[2] Broken-hearted, I remain Your old, old friend,

S. Palmer

My poor wife is at High Ashes, where the dear fellow died.

WILLIAM BLAKE RICHMOND[1]

James Linnell's Esq
Red Hill
July 1861 Surrey

My dear Godson

I have not yet seen the drawing, beautiful, I have no doubt, which has helped so much to charm my poor wife's sorrow — but never was anything done, at once so timely and so precious.

[1] He may well have had a cerebral tumour; he was certainly suffering from heart disease.

[2] Palmer was driven to his brother-in-law's house soon after More's death, and he continued to live in the Redhill district for the rest of his life.

[1] William Blake Richmond (1842-1921) had been a close friend of Thomas More Palmer and painted the youth soon after his death. He would more than match the worldly success of his father George Richmond, becoming Slade Professor of Fine Art at Oxford at the age of thirty-seven.

Would it be too much to ask you to make me a little sketch of your old playfellow as you remember him when living?

If it were only a pencil line that might *keep* before me his *living look* — which I could talk to as it hung up — I should not feel so utterly desolate.

This is Monday morning, just at dawn. I never now can sleep after that time. The lark has risen, and birds are singing in the oak wood close by — but *this* I *think* — though it has kindly been kept from me, is the last day on which anything of that dear one whom I have cherished for near twenty years will appear above the earth.

Our birth day was the same of the month — Jany. 27 O! that today I were about to be laid beside him — yonder rising sun would then be no discord to me. To all of us, Dear William life must taste more or less of suffering — but I *do* hope *yours* will know no such sorrow as this.

'Those who sleep in Jesus will God bring with Him'[2]

<div align="right">

Believe me

Dear William

Yours affectionately

S. Palmer

</div>

O! that the dead could speak to us — I call him — but there is no answer —

MRS. GEORGE[1]

March 10, 1862 [Red Hill]

Dear Friend.

Worthless otherwise than as a curiosity, behold the handwriting of a real hermit. I always honoured solitude, and it is grateful. My dear, kind books gather round me in the evening, and in their sweet society I am as little miserable as one can be who, in this world, must never more be happy.

[2] I Thessalonians 4:14.

[1] An elderly London lady who had showed great kindness to the Palmers after Thomas More's death.

We English people feel the domestic instinct at tea-time very much, and would fain *then* see the family circle complete. The magic chain is broken! Well, the remaining links? They are away; so I set a chair for 'Trot': up jumps poor puss, and between us we make a segment of a circle, at all events. Even the dumb creatures have gratitude and love in their measure, and the time will come when we shall know that the sagacity which finds a new planet is less essential to the perfection of our nature than gratitude and love. 'Trot', like her betters, has a pair of eyes — an eye of love and an eye to the milk-jug. Like her betters, she purrs *for* her milk — *unlike* many of them, she purrs *afterwards*.

Yes, our family circles and our friendly circles get broken, and like the poor spider, we hasten to mend the broken web. But the spider beats us at this kind of work; it is poor cobbling with us, after all. *My* gallant barque has foundered, and *now*, like the hunted witch, I

'Sail in an egg-shell, make a straw my mast
A cobweb all my coil.'[2]

This is our state. These are our *Facts*, as old familiar friends and some dearer than friends fall off — all our coil a cobweb!

Then comes the voice from Heaven, bidding us open our eyes and see, and stretch out our hands and *grasp* the ANCHOR OF THE SOUL. . . . Believe me,

Affectionately yours,
S. *Palmer*

[2] Probably adapted from Jonson, *The Masque of Queens*, lines 264–6.

MISS WILKINSON[1]

May 29th, 1862. Furze Hill House

Dear Miss Wilkinson.

Jacob told Pharaoh that his days had been evil although Joseph was found. What must mine be now? Perhaps in mercy they may be made few; therefore let my words be few, and if possible useful to others — that is, in a very humble way: for aspirations, and poetic dreams, and even the decent, moderate hope that a son might make amends for his father's shortcomings, are no more. Still, I may perhaps not be wholly useless if I can circulate little cookery receipts, or any — the most insignificant hints which may help oil the creaking wheels of our bodily life — hints jerked out in defiance of all style, or connection, or elegance. Nay, as David said to his most decorous wife, 'I will be yet more vile',[2] and at once suggest a FLEAFUGE (no useless matter in Spain or Italy) in the shape of a great lump of camphor. Any one who thinks it indelicate to say or write FLEA, on due occasion, deserves to be most soundly bitten. Mosquitoes, I read, may be banished by burning pieces of camphor the size of a hazel-nut. Would that we had known it at Pompeii. I grieve to think that you have again felt that difficulty of breathing. When accompanied by obstruction in the throat, a few whiffs of tobacco are sometimes most efficacious, not in the coarse shape of a cigar, putting tobacco into the mouth, but through the rational and refined medium of a CLAY PIPE. Clay is injurious to the lips, therefore take a little thin paper, and gum it round the mouth end — or, to be perfectly elegant, the oral end of the pipe.

I read with much interest and, I trust, not without improvement, your remarks on certain advantages which render advancing years less depressing; but here I have a sad advantage of you, taking comfort in their very fewness. I hope and believe it will be otherwise with you, when you have attained to my years; though before I was stricken down we had *then* this in common, not to be

[1] Next to nothing is known of Miss Wilkinson, not even her Christian name. She may well have been a former neighbour and pupil of Palmer's in London.
[2] 2 Samuel 6:22.

197

without affliction; and this, in moderate measure, is an essential blessing. What a repulsive creature is a man who has had it all his own way! — A creature without sense of social duty, who lives to make himself comfortable. Men have puzzled themselves for such a definition of their species as should clearly separate the inferior species. I will not attempt a definition, but hazard this. *A brute does what is pleasant, a man does what is right*. No definition can be hammered out of this, for unfortunately there are thousands of two-legged brutes, and very good-natured ones too, who live for the very purpose of doing what is pleasant. I think *all*, rich and poor, should work — do something useful, five hours a day at least. I am *obliged* to work, for I dare not leave leisure for such a grief as mine. There is a time for prayer and a time for sleep; every other *moment* I am obliged to snatch from the monopoly of grief. But seeing the face of a friend does us much good; and we seem for the moment cheerful and merry, so that if we had the pleasure of seeing you here, I do not think we should make you gloomy. Matter for sketching abounds, even from the windows, and they say the sea air may be smelt as it sweeps hither uninterrupted from the Brighton downs which bound our horizon.

I am very glad to hear about your three drawings; and, so far as finished drawings are concerned, quite agree with you that they cannot be too much finished, or rather let us say they cannot be too much *studied*; for the word finish has come to have an evil meaning, such as the attempting to paint what nobody ever saw, every leaf on a tree — such as the drawing attention to the genera and species of vegetation in the foreground of a landscape, which no one strongly impressed with a beautiful scene would so much as notice. The art is, while thoroughly *knowing* the species, to render them truly, lest the eye *should* be attracted by them through fallacious drawing or colour — to give the lesser truth of their own identity, governed by the greater truth of their relation and subordination to the whole. No right line sufficiently extended can pass through the centre of a sphere without touching two points of polar opposition. Art is such a sphere. The best artist, in some two points of his work, will give the extremes of the definite and the indefinite if he can, and the lesser intensities of both elsewhere. When, where, and how is a life's study, to be helped by carrying in the pocket something like Reynolds's blot book. 'The indefinite half is the more difficult of the two', as

Millais said to me when we were looking at the Turner Gallery. I never looked at the slight sediment at the bottom of a coffee-cup without getting a lesson. When I think of a pocket sketch-book of soft printer's paper (plate-paper), a piece of charcoal, or very soft chalk, and a finger to blend it about, I think of improvement — mastery. Towards the art of giving a completed look to work, nothing helps more, I think, than the principle of emphasis and gradation (like a comet) in the relief of masses; and, if you can, in every touch. This, with the polar quality of massive opposition, distinguished Titian.

You doubt whether hasty sketches are of any use for improving yourself. Quite agreeing with you as to what are usually called hasty sketches, allow me to suggest that the art of completed work is twofold. First the art of imitating what is before us with all its detail (I am speaking of pictures done out of doors), which imitation represents nature asleep; and secondly the knowledge of the phenomena. These bring it to life. The latter can be treasured up only by continual observation, and a little memorandum-book and pencil carried always in the pocket. Often, the sketches *must* be rapid, as the effect is momentary. Thus alone can the action of moving figures be caught; and the action and expression are almost everything. They are best caught by single lines; [*Sketch*] then you can by the side of the line go on from recol-lection, and then a little larger, with the light and shade, and writing the colours of the draperies. At home you can draw it about three inches high, unclothed, making use of an anatomical book or casts, till the main masses are right, and proceed to lay on the drapery. [*Sketch*] Of course the figure being draped in nature, you sketch it so, but the lines of the limbs and body are the great things if you can get nothing else. At home, when you design a figure for introduction into your subject, after the first blot you should draw it faintly, undraped, so as really to know what the action is, and then add the dress. A little figure study always going on is of golden use to the painter of landscape or architecture, and gives an increased value, artistic and pecuniary.

Mr. Newman[3] made me eight or ten of his cedar colour-boxes without partitions, and a little deeper than usual, in which I

[3] An artists' colourman in London.

possess a fine sculpture-gallery, having filled them with casts from the finest antique gems. These are most useful for reference, when working out lines caught from nature. I assure you there is nothing far-fetched in this. All the best landscape-painters have studied figures a great deal. Mr. Rogers[4] used to prize a Claude of his the more because the figure was painted by Claude himself. I would advise you to collect casts from the best antique gems whenever you can get them. The enamelled roundness of a well-modelled figure is invaluable as a foreground. To tell you all that is in my heart, I believe the two great parts of art to be SENTIMENT and STRUCTURE. Under structure, beginning with human anatomy, I include all the organizations and atmospheric or other visible phenomena of this material world about us. If you say, 'Who is sufficient for these things?' I can answer only with a groan. But we must do our best, at all events apportioning our effort according to priority of claim (securing what is most important first), and when we do not see what to do — doing *nothing* till we have *found out* what is to be done. *Writing* our difficulties; which writing compels us to think clearly of them, during which effort they will often vanish. Abhorring 'muddle' — abhorring half work, and preferring play; not working on after the attention is fatigued; keeping by us a lump of tangled string as a visible representation of 'muddle', and stamping upon it every morning directly we put our shoes on. We *may* hate and stamp upon 'muddle', because it is not a living being. It is the negative pole of sin; and the Psalmist exhorts those who love the Lord to 'hate the thing which is evil'.[5] I do not *hate* the Devil, though I fear him and hate his *doings*, but I *do* hate muddle, hurry, indecision of purpose.

Pray beware of sun-strokes. Pray do not work too long together. Pray do not over-tire yourself, but avoid triflers and morning callers, and take plenty of REST and SLEEP. Believe me, dear Miss Wilkinson,

Yours most truly,

S. *Palmer*

[4] Samuel Rogers (1763-1855), collector and poet.
[5] Psalm 97:10.

LAURA RICHMOND[1]

December 1862 (?) [Red Hill]

My dear Laura,

In case you should 'cut' me when you marry, I 'make hay' with my letter writing, 'while the sun shines'.

If any friends of yours want a large and beautiful house and garden close to a railway station, for three months, here they are. Lady Mostyn[2] wants to let hers for that time. . . .

I have been in London for five days, and hoped to get to see you, but every moment was occupied, and it was impossible.

I was going to say 'I think Fuseli's smaller Picture (Oedipus) in the International, one of the finest works there', but I correct myself. We have laid aside diffidence nowadays, and drop the 'I think'. We used to say 'Black is black, I think'. Now we say 'BLACK IS WHITE'. We don't *think* it; we know it; and you will observe an equal advance in confidence of manner and originality of thought. I will therefore make a few assertions *à la mode*.

1. If the essentials of Art may be comprised in two words, those words are ANATOMY AND SENTIMENT.

2. We must know the construction of whatever we would imitate.

3. Claude was the greatest landscape-painter who ever lived; and there is a grand picture of his from Sir Culling Eardley's at the British Institution, which enraptured dear Mother Radcliffe: see her journal.[3] The drawing of the trees is sublime. In a smaller picture (Mr. Wynne Ellis's) is a bay, exquisitely painted. There is a long Cuyp, very fine.

4. Mrs. Radcliffe far exceeds Sir Walter Scott in descriptions of scenery.

5. Stories from the classics are peculiarly fit to be painted at the present time. Their connection with an exploded mythology has not in the least impaired their beauty and freshness; for their

[1] Laura Richmond (1841-1915), later Buchanan, daughter of George Richmond. This date was suggested by A.H. Palmer, and may not be accurate.

[2] Another resident of Red Hill.

[3] Mrs. Radcliffe was much impressed by a landscape of Claude's which she saw in 1805 at Belvedere House, the seat of Lord Eardley. The precise identity of the paintings to which Palmer refers here is uncertain.

freshness, being the freshness of first-rate poetry, is eternal; and to every man gifted with imagination, they come home at once — fascinate and bind him as with flowery wreaths wet with the morning dew. If you tell such a man that they are obsolete, he will smile at you with a peculiar smile; for, by the very constitution of his mind, he and they are contemporaneous, and you might as well tell him that beef is obsolete while he is in the act of eating his dinner.

Fancy any one talking this 'stuff' to Nicholas Poussin!

6. Classical subjects are peculiarly fit to be painted just now, as a protest against the degraded materialism which is destroying art.

7. Hogs live in the Present; Poets in the Past; or with the grace of alliteration — The Past for Poets; The Present for Pigs. The Present is not.

8. Richardson is one of our best novelists.

9. Sir Thomas Lawrence found Fuseli in tears, while contemplating the Farnese Hercules.

A test of Taste. Do I love Virgil, the Antique, Michelangelo, Milton, Nicholas Poussin and Claude? Or, more compactly thus, Do I love the Giulio Romano in the National Gallery?[4]

It is easy to make assertions, you see.[5] As a general rule, those who are best qualified make fewest. It is, however, a fact that Lady Mostyn's house is to be had; at least it was so a few hours ago, when Lady Mostyn told my wife so. . . .

As I live in the deepest dejection of spirits, a letter would refresh me, but I like a long one full of matter. If much engaged, do not write at all. Believe me, dear Laura,

<div style="text-align:right">Yours affectionately
★ ★ ★ ★</div>

The highest art is what you see in the Belvedere Torso — another assertion — I am getting on, you see!

But what is art, even the highest, compared with the 'Cup of cold water given to a disciple in the name of a disciple'?[6]

[4] *The Infancy of Jupiter*, acquired in 1859.
[5] Palmer then crossed out the above assertions in pencil and wrote, 'I am not answerable for what is scratched out.'
[6] Adapted from Matthew 10:42.

Let those who drink water *give* water. Let those who drink claret *give* claret.

Let not those who drink claret give water, lest they should want a little to cool their tongue. This is truth — another assertion. Howard[7] drank water and gave claret. He gave *himself* to those who were 'sick and in prison'.[8] Read Burke's eulogy. Be often reading Burke. Read the finest treatise extant on political economy, Mr. Ruskin's *Unto this Last*. I wish I had time to learn it by heart. You will find Mr. Ruskin's papers in *The Cornhill Magazine*. . . .

LEONARD ROWE VALPY[1]

June 1864 Furze Hill House

My Dear Sir.
. . . You read my thoughts! — It is really very curious. Here is the evidence. 1st. The last touch was put to *The Chapel by the Bridge* the moment before I opened your letter: 2ndly. All the time I was writing my last, Mr. Chance's[2] name was on the tip of my pen, as the very man for the work; but I thought it hardly fair to introduce a rival to whomsoever you might usually employ. By the bye, my wife is Mr. Chance's cousin, she being Mr. Linnell's daughter, and Mr. C. his nephew: 3rdly, and most curious of all, you ask me to show you anything I may be upon 'which specially affects my inner sympathies'. Now only three days have passed since I did begin the meditation of a subject which, for twenty years, has affected my sympathies with sevenfold inwardness; though now, for the first time, I seem to feel in some sort the power of realizing it.

[7] John Howard (?1726-1790), prison reformer.
[8] Adapted from Matthew 25:36.

[1] Leonard Valpy (1825-1884) was a London solicitor who, after buying Palmer's watercolour *Twilight: the Chapel by the Bridge* in 1863, had requested an alteration (a diminution of its light). Valpy was to become Palmer's most important patron. Encouraged by him, Palmer created a series of eight watercolours illustrating Milton's *L'Allegro* and *Il Penseroso*; they are his finest late paintings.
[2] J.H. Chance, a picture-framer.

It is from one of the finest passages in what Edmund Burke thought the finest poem in the English language: —

'Or, if the air will not permit,
Some still removèd place will fit,
Where dying embers through the room
Teach light to counterfeit a gloom,
Far from all resort of mirth,
Save the cricket on the hearth.'[3]

The lower lines a companion subject out of doors.

'Or the bellman's drousy charm
To bless the doors from nightly harm.'[4]

I am trying the former small — the size of your *Chapel*. The student, in his country, old-fashioned room, meditating between the lights: the room dimly bronzed by the dying embers (*warranted without 'RAYS'!*) and a very cool, deep glimpse of landscape, and fragment of clouded moon seen through the lattice, just silvering the head and shoulders: the young wife in shade, spinning perhaps, on one side of the fireplace. Should I displease myself with it, the 'dying embers' may revive within my own fire-grate; if the contrary, it will give me much pleasure to show it you *by and bye*.

I carried the Minor Poems in my pocket for twenty years, and once went into the country expressly for retirement, while attempting a set of designs for *L'Allegro* and *Il Penseroso*, not one of which I have painted (!!!), though I have often made and sold other subjects from Milton. But I have often dreamed the daydream of a small-sized set of subjects (not however monotonous in their shape yet still a set; perhaps a dozen or so), half from the one and half from the other poem. For I never artistically know 'such a sacred and homefelt delight'[5] as when endeavouring in all humility, to realize after a sort of imagery of Milton.

Your strong feeling for the poetic in art will make Blake's *Life* a treat. It is abundantly illustrated too, and is a book to possess. I had the honour of knowing that great man, and can vouch for

[3] Milton, *Il Penseroso*, lines 77-82. Quoting from memory, Palmer writes 'dying' in place of 'glowing' embers.
[4] *Il Penseroso*, lines 83-4.
[5] Milton, *Comus*, line 262.

many of the anecdotes; disavowing, however, all adherence to some of the doctrines put forth in the poems, which seem to me to savour of Manicheism.

Mr. Butts's visit to 'Adam and Eve' had grown in the memory, I think. I do not believe it: it is unlike Blake.[6] This and the above are all I carp at.

Mrs. Palmer and I spent an evening with Mr. and Mrs. Gilchrist, looking over a number of Blake's drawings; and were so riveted and unaware of time, that a first look at the watch told three in the morning! Our servants were frightened! As we are early people, they thought we must have been slain and disposed of in a ditch.

I hope to do myself the pleasure of calling when I venture to London, and am very pleased to think that your three subjects still interest you, and prove a resource in the intervals of your severer studies. What should I do without resources, writhing, as I have been now for three years, in agony for the death of my son, full of promise, and just going to Oxford? Believe me, dear Sir,

Yours very truly,

S. Palmer

[6] Blake's patron Thomas Butts was reported by Gilchrist to have claimed that he once found Mr. and Mrs. Blake sitting naked in a summer-house, reciting passages from *Paradise Lost*. Blake's later biographer Mona Wilson quoted part of a letter written by Palmer to Anne Gilchrist on 22 December 1863, which was not printed in *The Letters of Samuel Palmer*. It reads: 'I have one and one only suggestion to make, or rather one protest to lodge against what I believe to be a misconception of Mr. Butts, Junr. concerning the Lambeth garden scene — I most certainly do not believe it as he seems to have related it. Many years ago I remember a wandering rumour of something distantly like it — probably the very thing which, told him by his father, grew unconsciously in his memory. Precisely as he tells it, I disbelieve it, because *it is so very unlike Blake*.' (*The Life of William Blake*, third edition, edited by Geoffrey Keynes; Oxford, 1971, p. 84.)

LEONARD ROWE VALPY

September, 1864. Red Hill

My dear Sir.

. . . I hope I can give a good answer to your *L'Allegro* and *Il Penseroso* inquiry. They have occupied much time and thought; and viewed in the whole, the parts, the relations: then laid aside for work that was pressing, but not until the first survey was complete and I felt that I could do the whole.

Yesterday, some of the designs came to me unawares, and an impulse to begin the 'Straight mine eye' and 'Lonely tower'.[1]

How different is the inward *sight* of a thing to speculations about it! For years, off and on, has the former subject teazed me, owing to something in the text. I had been over it again, and at last given up the quest — when suddenly, as I could not go to the thought, the thought very kindly came to Mahomet, and unlike anything I had expected.

Milton's nuts are worth the trouble of cracking, for each has a kernel in it. Monkeys and illustrators are apt to make faces, when they crack and find nothing.

That mystery which cannot be commanded, that immaterial and *therefore* real image, that seed of all true beauty in picture or poem falls into earthly soil and becomes subject in a great measure to the conditions of matter, and fails or fares as the soil permits — the desert sand; the ploughed fallow; the rich, garden mould. To say that the seed does everything is fanaticism. Milton saw both; the former which in his prose works he expressly asserts to be divine; yet what a soil was *he* preparing who knew Homer almost by heart at sixteen!

I doubt whether the best images can be made use of by an imagination which is not coupled with large reasoning power; and we know what, in ripe years, was Johnson's verdict — that excepting Butler, there was more '*thinking*' in Milton than in any of our poets. He said, 'I admire him more than I did at twenty.'[2]

Yours of the marble settings is indeed a refined and comely thought. It set before me a series of works 'severe in' 'beauty'; but

[1] *L'Allegro*, line 69, and *Il Penseroso*, line 86.
[2] Cf. Boswell, *Life of Johnson*, Oxford, 1934, Vol. II, p. 239.

such works as with their several marbles were to be fitted again into compartments of national or sacred buildings, rather than the veiled recluseness of pastoral or Georgic; and should not what borders the work be quite even in tint? If we had gone to that remarkable man — that great patron of British genius, if men had their dues — to Mr. Butts I mean, I think we should have come away best pleased if we could remember nothing about the frames. To do this, however, there must be good workmanship, for we may say of frames as of good men that they are at their best when they nullify themselves.

Blake often expressed a wish to take me himself to Mr. Butts', but ere a day was fixed, 'came the blind Fury'.[3] What a show, with such a showman! What a casket of a house! What prince of his own choosing ever got together under his broad roofs so many precious thoughts? Yes, so many, even if they had been bolted to the bran, and a third part burnt as refuse?

You say 'my thoughts were confined to the realistic aspect of the poet's thoughts. Would that it were given me to rise higher, but each must be content', etc. 'It is something to be able to *feel* a degree of elevation, when examining such outpourings as those picture thoughts of Blake.' Something indeed! Something, it seems to me, with which you may rest not merely content, but thankful.

We are all of us more or less influenced by the fashions of the day, and the arts of the day are influenced, like its literature, by materialism: but you are *aware* of the influence, and anyone who loves Milton as you do, and does not *hate* Blake cannot be much tainted.

Truth in art seems to me to stand at a fixed centre, midway between its two antagonists Fact and Phantasm.

You have too much taste to like the fantastic, so that must not be set down against you, but on the credit side of the account. Perhaps your very realism *is* imagination or something very like it — something which will develope into it, as you become better acquainted with the inner circles of art. Mr. Carpenter[4] is the chancellor of *our* university; our Bodleian is that quiet printroom at the Museum. Below, in the Townley Gallery, is the sure test of

[3] Adapted from Milton, *Lycidas*, line 75.
[4] W.H. Carpenter, Keeper of Prints in the British Museum.

our imaginative faculty — the sleeping Mercury.[5] More than two thousand years ago the sculptor bade that marble live. It lived, but slept, and it is living still. Bend over it. Look at those delicate eyelids; that mouth a little open. He is dreaming. Dream on, marble shepherd; few will disturb your slumber.

We will go our ways, and feed upon our 'facts' — our 'bits of nature' and our bits of fish; our fresh herrings on a deal board with all the grain in it. 'As nat'rul as life — ain't it, master 'Gustus', says the nursery maid — 'And the herring, why it looks as if we could scrape the scales off with a knife!'

'So move we, each his own desire to find,
A substance, or a shadow, or the wind.'

<div style="text-align: right">

Believe me, dear Sir,
Yours very truly,
S. Palmer

</div>

JOHN REED

May 26 '65 Furze Hill House Red Hill Surrey

My dear Reed.

The dry desolation in which my frightful loss has left me stays my pen, not from neglect of my friends, but from reluctance to waft any of the gloom which should be kept to myself.

Would that you were here in my nice orderly little study! we should have many a hearty laugh as we used to do: mine, perhaps, all the heartier, for that merriment grows rank when happiness has ceased. '*Sorrow laughs*' says the immortal BLAKE, 'Joy weeps.'[1] Alas! How true! I deserve the stick (who does not more

[5] A Graeco-Roman sculpture now referred to as *Endymion the shepherd boy asleep on Mt. Latmos*. The carving inspired a drawing in Palmer's 1824-5 sketchbook, and at least two later paintings and an etching, all entitled *The Sleeping Shepherd*.

[6] A.H. Palmer printed the latter part of this letter not only in his *Life and Letters of Samuel Palmer* (1892) but in an essay in *The Portfolio* (August 1884). The original has not survived. A.H. Palmer's two versions differ slightly, and at a few small points I have preferred the earlier publication.

[1] 'Excess of sorrow laughs. Excess of joy weeps' — one of the Proverbs of Hell in *The Marriage of Heaven and Hell*.

or less?) in never answering a most kind new year's letter of yours which went to my heart. That would seem to be stony soil, as no answer fructified from it; but you would pity if you knew my strange difficulty in attempting to write anything genial or pleasant. When I tell you that dear Herbert is so delicate, though without any specific disease, that we hardly think he will live to grow up, you will the less wonder. He is going on for 12 yet only learns a little at home in the morning. I give him half an hour and find him delightful to teach quite as quick as —

'There comes my fit again'.[2]

Now I *will*, life being spared for a minute, 'talk about something pleasant' as I recommended my father to do when myself, having been a naughty baby boy, he began an exhortation which I feared would end in a whipping.

How unnatural a thing is death. How few are out of their teens at sixty! How few people have even put away their toys. They have only changed them — grown out of their pellet and pop-gun into partridge shooting. Their calling in life, which ought to be loved, is but the schoolroom and rabbit-shooting their holiday. But something must perhaps be allowed for the inevitable barbarism of Northern nations which have always been fond of war and hunting. From our passion for the former Erasmus said he could not call the English a civilized people. We prick up our ears when we smell blood! What a farce it is, the notion that either education or the conveniences of commerce will stop war. There must be a total change in man's heart. Monarchies are so strong and the democratic multitudes are so organized that there seems to be every preparation for incessant and perpetual war all over Europe — even Russia feels the early vibrations of the earthquake. Literally our earth is honeycombed, so to speak, with cells of fire, and it would seem most probable that even by its agency the earth should undergo some mighty elemental change before the moral renovation when 'He shall come whose right it is to reign'[3] . . .

Yours most truly

S. *Palmer*

[2] Adapting *Macbeth*, III. iv. 21.
[3] Adapting Ezekiel 21:27.

MISS JULIA RICHMOND[1]

Septr the something 1866

Furze Hill House Mead Vale Red Hill

My dear Julia,

I would do anything I could to please you, but a LETTER is really quite out of my power. Letters should be so artless you know, so negligently elegant; they want a natty native-grace-Gainsborough-kind-of-a-touch: — at least so the critics say — and I really don't think we want any more of them: letters I mean; — or either; we have Pope's and Cowper's and Gray's. Cowper's name is with me on the synonym of elegance, and some say that Pope's smell of the lamp, but I like oil, and would recommend you to breakfast upon Betts's cocoa with oleaginous globosities bobbing about as you stir it like porpoises of the deep.

And if this is 'too rich', for gross it is *not*, then a slice of roast beef and a pint of home-brewed. — Perhaps we grow, both in mind and body, to be somewhat like our diet, therefore, though it should never be gross, it need not be nervous, vapoury, fantastical, like strong green tea: much less, narcotic; (by the bye, they are now making 'cigarettes' for the ladies) like that detestable tobacco — the substitute for food, which they cannot afford to buy, with our half starved field labourers. I am told that the target practice is in every case impossible until cigars are relinquished — London-season-ladies go to opium at once. The labourer's pipe smells comfortable in a country lane on a chilly autumn evening, as he is plodding home from the furrows — and we have no reason to complain of Milton's single pipe and glass of water before going to bed for he rose early and soar'd without roaming*; — but all these things have their mental analogies. There is a kind of green-tea-poetry and smoky philosophy of which we may have too much. Shelley, if I remember, in his ode to the lark, assures that bird that after all he is no lark at all but a spirit! a spirit! 'I say — none of that!' the bird might have replied, as the Tower Warder to dear Mr. Finch when he saw him sketching the armour.

[1] George Richmond's daughter (1839-1906), who was a former pupil of Palmer's.

210

Poetry may be *too* transcendent, and so may music may it not? Are paradox muddle and bombast the 'three graces' of literature? 'What have ladies to do with literature?' Who said that? O you brute! Tell me barbarian, are there not ladies, *many* ladies in England who have made Cowper a pocket companion? And who can read Cowper without being the better morally and mentally? 'He's flat,' is he? What, because he doesn't bother you about the 'mystery of Being', and that kind of thing. Flat, I suppose as fine music is flat after the barbaric crash of unprepared German discords.

I beg pardon dear Julia, I was rebuking that demon who whispered something about ladies not reading. O, *don't* they read? Did not they rush to hear Carlyle lecture against all sorts of vanities, with rings on their fingers, a French novel in the carriage and a poodle looking out of the window? Besides they read Milton — O yes! *once* — *quite through*, as a pious duty — and think the battle of the angels 'awfully sublime' — as it is. Upon the whole I think women, (when not rebellious,) better creatures than men: — less irreligious less selfish and self indulgent, but their views of the sublime are peculiar. I remember that John Varley whose lady pupils were legion (*angelic* legions you will understand) was dreadfully 'put out' by this peculiarity. 'Why, they think Salvator Rosa more sublime than Claude!' he used to say — and rub his face, and look as cross as he *could* look for he was the soul of good nature.

And now, as I am *not* writing a letter, (I mean what I say) but scribbling over a piece of paper because you tell me to do it — and lest you should think I can ever be cross with *you;* — this being the case, I will digress to the Babbacombe rocks near Torquay and to those about that coast — much of which I have not seen — to mention that Mr. Horsley[2] long ago described them as most various and gorgeous in colour. You could not get a long ride I fear through Newton up to Hay Tor rocks over Ilsington — 'wild country that' to adopt the modern construction — Chudleigh too is at some distance, but worth seeing, if you don't stop short, as the tourists do, on the wrong side of the chasm, gaping at the

[2]J.C. Horsley, R.A. (1817-1903). He once called Palmer the 'king of the Etching Club' (Linnell Trust).

opposite cliff — while the real spectacle is what they are standing upon. — I found it all strewed with Pic Nic bottles and broken plates.

As 'ladies *read*' let me recommend you Fairfax's Tasso[3] even though you may have read the original. He was born with music on his tongue, and moreover was Queen Elizabeth's godson!!!!!!!!!!!!!!!!!!!! There's a climax! perhaps he kept a gig!

To sit in shoes wet with salt water *will* give you cold — I caught a violent cold sketching 3 or 4 hundred feet above the sea after sunset in Cornwall. Anecdotes I have none, except that I think a distinguished person was married at Reigate the other day but I know it only by report.[4] Now dear Julia write me as many letters as ever you like — they always give me pleasure — (Oyez! you'll write me *such* Devon descriptions that I shall seem to be sweetly smothered in cream.) Do tell me all about that dear country but I really *can't* write anything rational — so you see, unanswer'd letters of yours will be a virtuous iteration of returning good for evil.

Many happy returns of your coming birth day with all my heart

Yours affectionately

S.P.

★See last couplet of Wordsworth to the Lark,[5] one of his best I think.

[3] Edward Fairfax (d. 1635), author of the first complete translation into English of Tasso's *Jerusalem Delivered*. But he was not the queen's godson.

[4] John Linnell, whose first wife had died in 1865. On 18 September 1866 he married Mary Budden.

[5] *To a Skylark:* 'Type of the wise who soar, but never roam;/True to the kindred points of Heaven and Home!'

HENRY WENTWORTH ACLAND

Octr 29/66 Furze Hill House, Mead Vale, Red Hill, Surrey

My dear Dr. Acland,

I write a line to say that the cakes of White which were posted to you at Reigate Octr 22nd, having been made long since, may perhaps want a little more vehicle, the ingredients of which I subjoin.

(The cakes were made with glue, but this will not keep for occasional use unless you add a little oil of spike.) And then, not very well.

Mix with one ounce of best Gum Arabic in thick mucilage a piece of best honey as large as a hazel nut — or, if it be fluid, about a salt-spoonful — first having mixed with the gum, *with a spatula*, 4 or 5 drops of creosote. Never mind the discolouration keep it stopped from dust.

If the white in its present state dry chalky, that is, if the finger nail will scratch it up — a very little of the above when you rub the cakes up for use will set all right. Add a little water to the gum mucilage now and then; thus it will keep long.

I add Mr. Blake's receipt. Glue as a vehicle was recommended to him by St. Joseph in a dream or vision, he said.

Don't think I am laughing: I have not yet shrunk into such inspissated idiotcy as grins at everything beyond its own tether.

I have tried Russian isinglass which has less colour, but does not work so pleasantly as the glue.

Blake's White.[1]

Get the best whitening — powder it.

Mix thoroughly with water to the consistency of cream.

Strain through double muslin. Spread it out upon backs of

[1] The only other reference to this pigment in Palmer's extant writings occurs in his long letter to George Richmond of October 1828, in which he tells of heightening a colour sketch 'with Mrs. Blake's white, which is brighter, and sticks faster than chalk . . . it seems such a quick way of getting a showy, but really good effect . . .' (*Letters*, p. 38). Blake's fondness for glue is very likely responsible for the early darkening of many of his tempera paintings.

213

plates, white tiles are better, kept warm over basins of water until it is pretty stiff.

Have ready the best carpenters' or cabinet makers' glues made in a very clean glue pot, and mix it warm with the colour: — the art lies in adding just the right portion of glue. The TEST is, that when dry upon the thumb nail or on an earthenware palette it should have so much *and no more* glue as will defend it from being scratched off with the finger nail.

This, and the cleanliness of the materials are the only difficulties.

Now I proceed to show how you may get a Better article with less trouble.

Get your Whiting ground very finely upon a perfectly clean stone; — grinding some to waste first, to get any remains of other colour out of the grain of the stone: — keep this, of a stiff consistency, in a bottle stopped from dust, leaving room for water between the pigment and the cork. As long as you remember to keep the white under water it will always be fit for use when you are ready with the glue.

Mr. Eatwell artists' colourman, of Dorset St. Portman Sq. W. will grind the whitening as above and send it you in a bottle — on giving some notice before-hand. Upon him you can depend. I always deal at Newman's for drawing materials but this is out of their line.

Were the arts a part of Oxford education, even the under graduates would be at this moment in mourning for the deplorable loss you have sustained in the Wellesley Collection.[2] I went three several times to London to study the Claudes alone some time before the sale — and have secured 2 of his etchings and a Bonasoni. All the best things were bought for Paris; — bought by dealers at retail prices they tell me.

Thus we suffered the Lawrence collection to be broken up.[3] —

[2] The extensive collection of drawings owned by Sir Henry Wellesley (1791-1866), principal of New Inn Hall, Oxford, was sold at Sotheby's in June and July, 1866.

[3] According to the *Dictionary of National Biography*, Sir Thomas Lawrence (1769-1830) owned 'the finest collection of drawings by the old masters ever made by a private person'. After the King and the British Museum had declined to buy it, it was auctioned.

Erasmus[4] was right, we were semi-[bar]barians then, — but seem now to be advancing towards cannibalism. I shall beg my friends to take a substantial luncheon before they favour me with a call.

<div style="text-align: right">

Believe me
Dear Dr Acland
Yours most truly
S. Palmer

</div>

The pleasant way of using the white or any other colour is to have a great deal ready spread upon an earthenware palette — kept clean in paper; not to wear out good brushes, grubbing into the dirty hutches of a tin colour box.

JOHN PRESTON WRIGHT[1]

March 68 [Red Hill]

My dear Mr. Wright

One of our family[2] (permit me to say, neither Mrs Palmer nor myself) at prayers this morning turned pale and nearly fainted through TIGHT STAYS. It is the business of the Devil to deface the works of God, and of God's loveliest work these hateful corsets cramp and impede the vitals, utterly destroy the shapeliness and grace, which we in our hopeless barbarism fancy they improve, and even twist and distort the bony structure. They impair the action of the lungs and heart, corrupt the breath, prevent ease and gracefulness of movement and sometimes any sudden movement at all but at the cost of sudden death. To call these Babylonish gyves Satanic would be to libel him against whom St. Michael would not bring a railing accusation: we can not father them on Belial if with Milton we concede him somewhat of the 'graceful and humane'.[3] Asmodeus perhaps devised them — certainly some ugly drudge and servile incubus of the Pit.

[4] Erasmus criticized the English affection for war.

[1] A young friend of Palmer's who in 1868 was a deacon; he was to be rector of a parish in Shropshire for more than forty-five years.

[2] Mentioning the incident later (*Letters*, p. 781), he uses the phrase 'One of the "helps" '.

[3] *Paradise Lost*, II. 109.

Blessed was the day in which Matthew Arnold christened us 'Philistines'.[4] Here is a case in which health and shapeliness and graceful movement are sacrificed to Custom our great all worshipped Dagon:[5] physicians protest, artists are scandalized, and yet we know nothing better than to run in the rut, glide in the groove, and goose goes after goose, stooping under the gateway to a paltry and pernicious fashion worthy of the Fegee Indians who eat their aunts.

As another evidence of our incurable barbarism take our predilection for 'little feet'. We should despise any nation which admired large feet and smirk with a conceited grin at our superior civilization, not perceiving that largeness and littleness are equally deformed and that the beauty of any part lies in its just proportion to the whole.

If the express permission 'Ye may all prophesy one by one'[6] had not been feloniously filched from the laity and I were endeavouring to 'improve' the above faintness of the tight laced, I would call especial attention to its synchronism with family prayers. 'Observe dear brethren *when* it was that she nearly fainted in her steel and whalebone' 'At prayers this morning'. Now here we have our modern Christianity in a nutshell, the pretence of 'serving two masters' at once. God and the World, faith and the fashions, self denial and show. Now if the way to Heaven be narrow and few find it, it would seem to be uphill work at all events; so to be consistent I suppose that when you are driving your cart or your carriage up a steep hill you call out for any little boys you may see playing in the road to come in a body and hang on behind! Hang on behind do I say? Nay, it's religion that hangs on behind when fashion has the reins — hangs on while it may till folly and dissipation jolt it off altogether. Dear brethren I add no more, feeling that what is not sweet should be short.

'How shockingly irreverent' say the pharisees as they strut homewards. Well! if this is the 'brethren prophesying one by one', one is too much for me; did you notice the school children smiling in the gallery when he talked of calling the street boys to

[4] Arnold is often said to have introduced the term into English in his essay on Heine (*Essays in Criticism*, 1865), although Carlyle among other writers had used it decades earlier.

[5] 'The national deity of the ancient Philistines' (O.E.D.)

[6] I Corinthians 14:31.

hang on behind? Really this trifling with sacred things is most offensive. We shall meet I suppose at Lady Riot's masked ball on Friday. Good Morning.

MRS. GEORGE

October, 1870. Red Hill

My dear Mrs. George.

I can't grub about here like a hog crunching acorns, without feebly endeavouring to express my sense of your generosity. It is said that souls like yours feel as much pleasure in giving, as mob-made souls, whether royal, patrician, or plebeian, in receiving. But I have been wondering whether it is possible that even *you* can have felt as much delight in sending Herbert that splendid fowling-piece as he in its fruition. . . .

It was a grand moment yesterday, the showing it to the Alma[1] veteran, Herbert's drill-master. The Sergeant thought the stock quite a master-piece, and kept fondling it after the manner of a doll.

Would that the French and Prussians were playing with dolls at this moment, instead of waging one of the most needless, reckless, and profligate wars which will have to be recorded in modern history; rendering, through all time, the hatred of these contiguous nations equally intense and inextinguishable. Since the moral millennium people about 1844 were prophesying, in their blind ignorance of human nature, a lasting and almost immediate pacification of the world, there have been little else but wars and tumults, and I think there is every reason to fear that it will grow worse and worse, till the end of the present dispensation.

The majority are not good: Education may make them wiser, but not better; for though it may refine and elevate the intellect it can never change the heart.

Now 'knowledge is power'. Therefore, by educating, we increase the power of a creature who is not good. Hence it will

[1] A battle of 1854 in the Crimean War.

result that though people will become too wise to suffer encumbrance of national debts for wars like *this*, they will be more warlike and more formidable than ever where there seems the certainty of a very great gain, or a very great revenge.

Not that I depreciate education: on the contrary, the subject is my hobby; but mere secular education, though it will withdraw people somewhat from the more gross and vulgar vices, will rather increase than assuage pride and ambition, two great movers of war. Great knowledge is always humble, but among the masses of the best educated few will ever attain to greatness; and it is as symptomatic of the vastly clever, well-informed man to be proud, as of the great man to be humble.

You seem to be, like myself, 'lashed to the helm' of home; yet it is a pity that you should not get a glimpse of our green fields ere they are mantled in snow. How I should enjoy another morning among your books.

Only think of your rat family in the dresser drawer! I knew a very poor old man in Kent who had been a smuggler. Life had passed roughly, yet he had one, only one comfort left, *a rat-pudding*! He took no steps to catch them; but, governing his appetite by patience, calmly awaited the desired return of the village rat-catcher. Then, having carefully cleaned, skinned and prepared his delicacies, the difficulty was always where to borrow a saucepan; for the petticoat government of his wife and daughter debarred him from the use of his own utensils. However, he always found some neighbour or other kind enough to supply him, and at last he sat down, with a thankful heart I believe, to the only solace left him until that last one of the sexton and the spade. We are such geese of routine, such fools of fashion, that if rat-pie — I beg pardon, *tart*★ is the genteel word; — if rat-tart became a favourite at Balmoral, in a short time they would be seen on every dinner-table in London, with the tails elegantly coiled and arranged outside the crust, like the claws on a pigeon pie — there I go again — pigeon *tart* I mean. What a thing it is to be naturally vulgar!

When at Margate with Herbert, I had peculiar opportunities of collecting evidence as to haunted houses, and spent almost the most interesting evening of my life, in a family meeting (convened for the purpose), of alleged eye-witnesses. My impression was that, making all allowance for imposture and mistake, there

was a residuum of evidence which no candid mind could resist. I think you must have some curious information on the subject, and should like to talk it over with you. Meanwhile, believe me,

Yours affectionately,

S. Palmer

★How beautiful a thing is refinement! What a difference between 'Rump-steak-pie' and 'OX TART!'

F.G. STEPHENS[1]

Nov. 1, 1871 Furze Hill, Red Hill

My dear Sir,

If my life-dream must be told, it begins with good parents, who, thinking me too fragile for school, gave me at home the groundwork of education; sound Latin, so far as it went, with the rudiments of Greek; and my father, having notions of his own, thought that a little English might not be superfluous.

Could my simple story answer any useful purpose, it would do so by warning young students to avoid my mistakes, and in recording, if space allowed, traits of wisdom and goodness in friends with whom I have providentially been connected. In my father, for instance, who, by little and little, made me learn by heart much of the Holy Scriptures. He carried in his waistcoat pocket little manuscript books with vellum covers, transcribing in them the essence of whatever he had lately read, so that, in our many walks together, there was always some topic of interest when the route was weary or unattractive.

I remember, too, the priceless value of a faithful and intelligent domestic, my nurse, who, with little education else, was ripe in that without which so much is often useless or mischievous: deeply read in her Bible and *Paradise Lost*. A Tonson's *Milton*, which I cherish to this day, was her present. When less than four years old, as I was standing with her, watching the shadows on the wall from branches of elm behind which the moon had risen,

[1] Frederic George Stephens (1828-1907), a founder of the Pre-Raphaelite Brotherhood, a bad painter but a prolific and distinguished art-critic. He discussed Palmer's work in *The Portfolio*, Vol. III, No. 35 (Nov. 1872), from which the text of this letter is taken.

she transferred and fixed the fleeting image in my memory by
repeating the couplet, —

'Vain man, the vision of a moment made,
Dream of a dream and shadow of a shade.'[2]

I never forgot those shadows, and am often trying to paint them.

At thirteen, or a little earlier, I lost a most affectionate mother;
the original, it was said of Stothard's 'Lavinia', in one of my
grandfather's works.[3] Another, the *Guide to Domestic Happiness*,
has its niche among the *British Classics*.

Soon afterwards it was thought right that I should attempt
painting as a profession. Perhaps this arose from misinterpreting
an instinct of another kind, a passionate love — the expression is
not too strong, — for the traditions and monuments of the
Church; its cloistered abbeys, cathedrals, and minsters, which I
was always imagining and trying to draw; spoiling much paper
with pencils, crayons, and water-colours. It was in the blood: my
great-grandfather was a clergyman, and his father, Samuel
Palmer, was collated to the living of Wiley in Wiltshire, in 1728.

On my fourteenth birthday, I received a letter from the British
Gallery, announcing the sale of my first exhibited picture, and an
invitation to visit the purchaser, who desired to give me further
encouragement. No doubt it added zest to the plum-pudding; but
I was unacquainted with artists, and time was misused until my
introduction to Mr. Linnell, who took a very kind interest in my
improvement, and advised me at once to begin a course of figure-
drawing, which was, in some sort, carried out at the British
Museum; but sedulous efforts to render the marbles exactly, even
to their granulation, let me too much aside from the study of
organisation and structure. 'The painter,' said Mulready, 'cannot
take a step without anatomy'. Yet having thus learned to read, if I
may so express it, the surface, he will investigate its most subtle
inflections and textures, for if he have not learned to perceive all
that is before him, how can he select? how can he approach the
mastery of knowing what should be omitted? Hence Mulready
remarked, that no one had done much who had not begun with
niggling.

[2] Edward Young, *A Paraphrase on Part of the Book of Job*, I, 187-8.
[3] 'Martha Palmer was the model for a drawing by Thomas Stothard in *The Refuge*
by William Giles' (Raymond Lister's note).

About this time Mr. Linnell introduced me to William Blake. He fixed his grey eyes upon me, and said, 'Do you work with fear and trembling?' 'Yes indeed', was the reply. 'Then,' said he, 'you'll do.' No lapse of years can efface the memory of hours spent in familiar converse with that great man. But I must descend.

Forced into the country by illness, I lived afterwards for about seven years at Shoreham, in Kent, with my father, who was inseparable from his books, unless when still better engaged in works of kindness. There, sometimes by ourselves, sometimes visited by friends of congenial taste, literature and art and ancient music wiled away the hours, and a small independence made me heedless, for the time, of further gain; the beautiful was loved for itself, and if it were right, after any sort, to live for our own gratification, the retrospect might be happy; but two-and-twenty centuries of yore the master of philosophy[4] taught men to distinguish between happiness and pleasure.

In 1837, I married. The 'wedding trip' was a residence of two years in Italy. Real life began, and soon brought among its troubles the loss of our little daughter. We moved from the scene of affliction to Kensington, where twelve years were spent, and we became acquainted with eminent and excellent neighbours whose friendship I have the privilege to retain and gratefully acknowledge.

In 1861, after the loss of our elder son, who 'died in harness', full of noble purpose, we came hither, and from the window at which I am writing, I can see on the slopes of Leith Hill, a woodland ridge, behind which, in Abinger churchyard, the hope and ornament of my life lies alone under his simple monument till it is opened to place me by his side.

<div style="text-align:right">

I remain, dear Sir, yours very truly,
Samuel Palmer

</div>

[4] Aristotle; cf. particularly *Nicomachean Ethics*, Books I and X.

PHILIP GILBERT HAMERTON[1]

February, 1874 Furze Hill

Dear Mr. Hamerton.

Your son's etching[2] has given pleasure to other than 'parental' eyes. 'What a sweet little etching,' said my wife, who saw it lying on the table, 'It is like an old master.' There is something touching in the sight of a beginner full of curiosity and hope. My yearning always is, 'O! that he may escape the rocks on which I split': years wasted, any one of which would have given a first grounding in anatomy — indispensable anatomy, to have gone with to the antique. The bones are the master key; the marrowless bones are the talisman of all life and power in art. Power seems to depend upon knowledge of structure; all surface upon substance. Knowing *this*, and imbued with the central essence, we may venture to copy the appearance, perhaps even imitate it. It does not seem to me that we have the alternative of copying or imitation, but that copying as upon oath precedes and is the condition of imitation. . . .

Thank you for the newspaper extract,[3] which is curiously the reverse of what you have been teaching the public, viz. the scope and compass of etching, its unlimited power of expression, and ductility in the hand of every artist to his individual purpose. Here, in the extract, it is curtailed to a function much better realized by lithography. Surely a rather uncertain chemical process on metal is not the medium in which to render 'a few lines' 'sternly clear', especially if pencil or charcoal quality is wanted, and pen line to be eschewed. It is some time since I saw a fine collection of Rembrandt's etchings, but my impression is that, in

[1] Art-critic, essayist, editor, novelist and etcher, Philip Gilbert Hamerton (1834–1894) became Palmer's most acute and outspoken champion. I have omitted parts of three paragraphs that were published in A.H. Palmer's *Life and Letters*; they consist chiefly of quotations from Fuseli, copied out for the benefit of Hamerton's son.

[2] A view of a European city, by the twelve-year-old Richard Hamerton.

[3] A letter by John Ruskin, published in *The Architect* (27 Dec. 1873), containing his views on etching, which were at variance with those of Hamerton and Palmer. Ruskin objected to etched chiaroscuro, and thought that an etcher should restrict his work to 'few lines'. As Hamerton had written to Palmer, 'Ruskin's mistake seems to be that he asks for perfectly *imitative* exactness in the fine arts. Now it seems to me that interpretation *by the mind* is the object of the art, and not imitation by the eye.' (Letter of 23 Jan. 1874; Linnell Trust.)

every instance, they are the better in the ratio of the labour; some of the finest being exquisitely finished, and as etchings, the more essentially precious. What wonder, if the labour be a labour of love? Are not Jacquemart's fine in the ratio of his labour of love? Would Veyrassat's[4] *Crossing the Ford* have been bettered by slightness? Is not tone the prerogative of etching, and chiaroscuro its territory? . . .

You mention mezzotint in connection with etching. It seems to me that, in some degree, the deep shades of mezzotint differ for the worse from those of etching, in much the same way as the shadows of an oil picture painted on a half-tint ground from the shadows of one on a white ground. I mean when a year or two has done its work with the former. The cases too are analogous as to time; mezzotint, beautiful as it is, and low-toned grounds, bad as they are, being more rapid and cashy. One of the finest qualities of etching seems to me to be a certain luminousness even in its dark shades; in all but the very darkest: and, if this be a 'bull', it is the fault of the fact.

Etching, regarded from your point of view, does seem to be the finest of the metal methods; and it can easily be shown to be better than wood-cutting, which lacks variety in its dark shadows, though the sparkle of its light is joyous. Then let its flashes illuminate etching; let all be inclusive and cumulative. What is any art but that which genius has made it by extending its boundaries, while criticism demurred at every venture? Whence this strange gratification in scraping art with a potsherd, and paring the eye-lids of Regulus?

I have been reading again Fuseli's *Lectures* (our best, I think). Your son would enjoy them if he is fond of reading about art. He wrote in vain, it seems, as for the last thirty years we have been walking backwards, not towards nature but naturalism.

The Philosophers, who are by no means too imaginative, can set us right. Lord Bacon says it is the office of poetry to suit the shows of things to the desires of the mind.[5] We seem to aim at

[4] J. Jacquemart (1837-1880) and J.J. Veyrassat (1828-1893), French etchers.

[5] '. . . it doth raise and erect the mind, by submitting the shows of things to the desires of the mind; whereas reason doth buckle and bow the mind into the nature of things' (*The Advancement of Learning*, Book II). Palmer's writings, in contrast to those of Blake, include many complimentary references to Bacon, Reynolds, Newton, and even Locke.

suiting the desires of the mind to the shows of things. Does not the former imply a much more profound and inclusive study of the 'shows of things' — 'nature', as we call it, itself? What was it but his ideal of Helen which obliged the Greek to study all the most beautiful women he could find?

When I was setting out for Italy I expected to see Claude's magical combinations. Miles apart I found the disjointed members, some of them most lovely, which he had suited to the desires of his mind. There were the beauties; but the Beautiful — the ideal Helen, was his own: and the sense of this ideal is so lost and forgotten by a materialistic age that Claude himself is considered rather as an accomplished master of aerial perspective, or what not, than as the genius, equally tender and sublime, who re-opened upon canvas the vistas of Eden.

But is not all this gaseous rhodomontade about the Ideal exploded by the fact that every artist worthy of the name finds it almost impossible to render one tithe of its beauty when he sits down either to copy or to imitate the simplest object? I think not; and it seems to me that, in the present state of our faculties, any system which is without its paradoxes is, by the same token, as suspicious as the exact correspondence of several witnesses in a trial at the Old Bailey.

As a discipline of exactness Mulready recommended the copying sometimes objects which were not beautiful, to cut away the adventitious aid of association. A very inaccurate imitation of a bunch of grapes will be pleasing in virtue of the subject; but when I have gone to school to a potato in black and white chalk, I have found it difficult to make it unmistakably like.

Would other demands upon time permit, it seems to me that, at any stage of a painter's progress, it would be useful frequently to copy some simple object of still life, that exactness which is the common honesty of art might never be on the wane. It would seem to be negation, or a contracted power unable to reach the opposites, that makes cold, unimpassioned art. . . .

This will not be new to you, nor anything I have said above. Then why did I say it? Why indeed? In my last, I performed Morgiana[6] among the oil jars 'by particular desire'; this latter

[6] Ali Baba's clever slave, who kills the forty thieves with boiling oil. Palmer alludes to a long letter he had recently sent Hamerton containing technical information about pigments and painting technique.

looks very like garrulity, so please accept the apologies of

Yours most truly,

S. Palmer

P.S. By way of one last word à propos of the 'shows of things', I will add that I saw the arrangement of your sunset river from a boat near Chelsea, and noticed it as a first-rate landscape theme — the dazzling silver, or rather diamond-flakes of tumbling water under the golden sunset. Now here was the 'show of things'; but inasmuch as the falling water, looking quite pure by reason of its polish, was evidently, from its position, and some deplorable brickwork seen partially between the trees, nothing more nor less than the issue of a sewer, or filthy factory slush, into insulted Father Thames, the 'desires of the mind' were far from being completely satisfied.

The mountain stream fulfils them.

LEONARD ROWE VALPY[1]

February 1, 1875 Furze Hill

My dear Mr. Valpy.

'I have done the deed. Didst thou not hear a noise?'[1] A noise of my groaning when, according to Herbert's advice, I was 'girding up my loins' to attempt the enclosed descriptions[2] or whatever they may be called.

It was no fancied difficulty; for in trying to describe the motive or impulse of a picture, which is or ought to be fervid, it seems to be implied that the painter has realized his idea, else, what is the use of describing it? And whether he has done so is for others to decide. 'Let another man praise thee, and not thine own mouth.'[3]

If the painter says: 'From the skirts of an ancient forest the eye is led to a parapet of granite mountain stretching far away, through a break in which there is a glimpse of a vast champaign, while the golden moon is just emerging from the more distant ocean', it is hard to discern that he is not complimenting his own picture, for

[1] *Macbeth*, II. ii. 15.
[2] Of the watercolours after Milton. The descriptions have not survived.
[3] Proverbs 27:2.

225

an equivalent in *painting* to those few words demands great mastery. As my father-in-law once remarked, it is easier to *say* 'Jack Robinson' than to paint 'Jack Robinson'.

Vastly different were the task, or rather pleasure, of commenting upon another man's picture: the string of one's tongue is loosed; at every inspection, if it be really fine work, we find new beauties; and what we do not find we fancy; so that if the artist were to come to life, he would say with Socrates, 'What does not this young man fable of me?'

I remember a learned D.D. who, when people asked him whether some eloquent preacher did not 'bring a great deal out of a text', was wont to answer, 'Yes; a great deal more than ever was in it!'

But the real charm of art seems to me not to consist in what can be best clothed in words, or made a matter of research or discovery. Its technical means are conversant with several branches of science; and it demands lifelong investigation of phenomena; but I do not think that the *result* is a science, though Constable very truly said that every picture was a scientific experiment.[4] The result I take to be not interpretation, but representation — its first appeal not to the judgement but the imagination.

Lord Stafford's house-maid stood leaning on her broom before that wondrous Claude, not because it excited or gratified her curiosity, but because 'she thought she was in Heaven.'

No man, perhaps, more perfectly rendered his genuine perceptions than the elder Cuyp,[5] in those groups of milch kine beside a brimming river, with maid or swain; all bathed (if a river can be bathed!) in amber light. Now here is ample matter for excogitation — hydrostatics, cattle-breeding, etc.; yet I doubt whether any one who could feel his charm ever *excogitated* at all before the works either of the elder or younger Cuyp. Painters excogitate to find out how it was done. Turner based much of his colouring upon these masters; but this is an after affair; if we are gifted with the seeing eye we feel before we think. . . .

Yours,

S. Palmer

[4] There are statements to such effect on at least four pages of C.R. Leslie's *Memoirs of the Life of John Constable R.A.*

[5] At least three painters of this name flourished in seventeenth-century Holland. Palmer seems to have the works of the landscape painter Aalbert Cuyp (1620-1691) particularly in mind.

LEONARD ROWE VALPY

May 1875 [Red Hill]

My dear Mr. Valpy.

How happy you must have been at Wells under such favourable circumstances! When the love of God makes sunshine within a house, we can bear with wet weather without. I will not say

'Earth hath not anything to show more fair,'[1]

but earth hath not many things to show more fair than the west front of Wells Cathedral. It shows what Christian art might have become in this country, had not abuses brought it down with a crash, and left us, after three centuries, with a national preference of domesticated beasts and their portraits, before all other kinds of art whatsoever.

I must have ill expressed my meaning if it seemed that I would exclude geological drawing from art drawing. It seems to me that art drawing includes it, as figure drawing includes anatomy. Probably the confusion arose from those who seem to me the great rock and earth Masters being supposed by others to be geologically incorrect.

The visible characteristics of the various rocks were as patent to artists before their history (?) was attempted, as since the conflict of opinion began as to their modification by fire, water, ice, and what not; the great 'discovery' that the earth made itself and was never created by the Almighty not being, I should suppose, of any particular service to the painter!

I do not know whether the rocks upon which Nicholas Poussin has seated Polyphemus[2] have ever been gainsaid. They affect the imagination, and if they failed to affect mine, I should feel that I had gained a loss, by any supposed knowledge which has lessened their impression. Had this happened to me after much study of geological diagrams, I should feel that my knowledge was disproportioned, and that I wanted much more of some other kind of knowledge to set me right.

Last year, at Margate, I made several observations and memoranda upon certain reflections of sky in sea, which seemed

[1] Wordsworth, *Composed upon Westminster Bridge*, line 1.
[2] *Landscape with Polyphemus* (Hermitage, Leningrad).

to violate the most obvious optical 'laws'; and I think we shall never see rightly unless we bring science and knowledge of the individual refinements and niceties of nature into contact with an equal amount of art knowledge, and the phenomena which modify individualities.

Nature knowledge and art knowledge ought to be in harmony, but they are two distinct things. Nothing would please me more than to spend a year in resuming my old studies of botanical minutiae. It would replenish the mind with a world of delicate refinement, but it would not give that perception which 'laps me in Elysium'[3] at the sight of a fine (uncleaned) Claude: nor would any amount of geological diagrams bring my soul in unison with Nicholas Poussin's *Polyphemus*: rather, perhaps, it might incline me to pick holes in it.

I think that the great landscape-painters used as much of literal truth as was necessary in order to 'make the ideal probable', and that minute criticism will never be more prone to object than when they showed the chief mastery of art in knowing what to omit. I think the *Callisto* rocks[4] should be studied in order to *see* nature.

I have heard one of the most eminent living painters express his gratitude to art for the specific reason that it taught him to *see* nature. Turner, who of all men was the most pronounced disciple of Claude (painting large pictures of avowed companionship with certain of his great masters'), learned from Claude, Poussin, etc., how to see nature; to see nature in its proper aspect and position relatively to art. I remember some Savoy pictures by Turner in which he was bringing to bear very evidently what he had been learning from the Poussins.

It is thus, I think, that the great original painters and poets are made. They differ from inferior men by having at once more of their own and more of other people's: more of their own and more of their masters'.

I dislike writing about art because the comparative ease of talking twits me with the difficulty of doing: and nothing is more true than the '*de gustibus*'.[5] If a youth of seventeen is not charmed

[3] Adapted from *Comus*, line 257.

[4] In a landscape then attributed to Nicholas Poussin.

[5] *De gustibus non est disputandum*: the Latin proverb, 'There is no disputing about tastes.'

by a fine Claude, no amount of art or nature-culture will avail him: but Turner, in common with the maid who leaned on her broom at Stafford House, had the faculty to which Claude never appeals in vain.

Next time I hope not to talk shop. Excuse hasty first words, and with our united best regards to yourself and Mrs. Valpy (who saw with you the Cheddar rocks, I hope), I remain

Yours most truly,

S. Palmer

PHILIP GILBERT HAMERTON[1]

August 4, 1879 Red Hill

Dear Mr. Hamerton.

Pricked already with etching like a full pincushion, your latter letter burst my side as with a packing-needle! How can I possibly touch copper again for eight months to come, with drawings in hand which ought to have been sent home years ago? Etching, that wheedling hussy, like another Millwood[2] has already made me rob my long-suffering employers of time which really belonged to them. It is true that I have not yet, like my prototype, shot an uncle, neither have I eaten an aged aunt like the Fejee Indians; but there's no knowing.

Some have fancied themselves to be tea-pots; others fragile glass. What am *I* but a broken etching-needle with its wrong end wedged into a paint-pot? . . .

It is *my* misfortune to work slowly, not from any wish to niggle, but because I cannot otherwise get certain shimmerings of light, and mysteries of shadow; so that only a pretty good price would yield journeyman's wages. Happily, I think I could realize

[1] The text printed here *must* be regarded as provisional. I have conflated two published excerpts from what seems very likely to be a single letter, the manuscript of which has been lost: much of it was published by A.H. Palmer (*Life and Letters*, pp. 377-8) and some by John Roget (*A History of the 'Old Water-colour' Society*, London, 1891, pp. 275, 280). In his edition of Palmer's collected letters, Raymond Lister printed only the *Life and Letters* version, which omits some interesting details.

[2] In George Lillo's play *George Barnwell* (1731), Millwood incites a young apprentice to kill his uncle.

something more, in quarters to which I have myself access; this will perhaps soon be in some measure tested, as to what I have already done, because there seems to be a lively demand. . . .

I am very glad that you like my *Bellman*.[3] When I was first introduced to dear Mr. Blake, he expressed a hope that I worked 'with fear and trembling'. Could he see me over an etching, he would behold a fruition of his desire copious as the apple-blossoms of that village,[4] of which this *Bellman* is in some way a 'cropping-up' (geologically speaking). It is a breaking out of village-fever long after contact — a dream of that genuine village where I lost, as some would say, seven years in musing over many strings, designing what nobody would care for, and contracting, among good books, a fastidious and unpopular taste. I had no room in my *Bellman* for that translucent current, rich with trout, a river not unknown to song; nor for the so-called 'idiot' on the bridge with whom I always chatted — like to like perhaps. But there were all the village appurtenances — the wise-woman behind the age, still resorted to; the shoemaker always before it, such virtue is in the smell of leather; the '*Extollager*[5] who went by the stars of the heaven', a strange gentleman whose sketching-stool, unseen before in those parts, was mistaken for a celestial instrument; — the rumbling mill, and haunted mansion in a shadowy paddock, where one of the rooms declined to be boarded; the hospitable vicarage, with its delightful sentiment and learned traditions; the Wordsworth brought to memory every three hours, by

'— the crazy old church clock
And the bewilder'd chimes.'[6]

Byron would have stuffed his ears with cotton had he been forced to live there.[7]

I must again thank you for the pains you took to enlighten me as to publication. I love calculation in the abstract — quite

[3] The etching (Plate VIII) which Palmer had recently completed (he also illustrated the same passage from *Il Penseroso* in watercolour).

[4] Shoreham.

[5] In the 1820s the people in and around Shoreham called Palmer's circle of young artists 'Extollagers' (probably a corruption of 'astrologers').

[6] *The Fountain*, lines 71-2.

[7] Alluding to Byron's displeasure at his future wife's suggestion that nearby church bells were ringing in their honour.

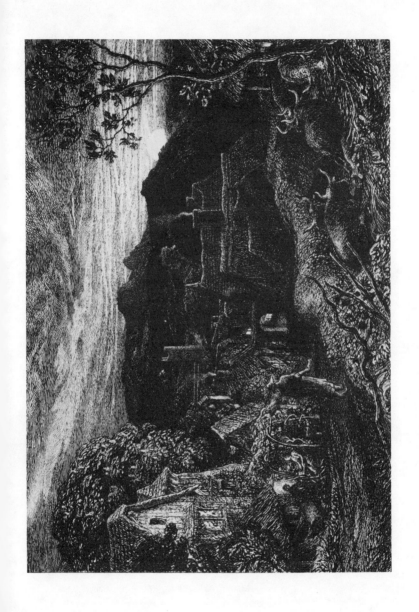

Plate VIII (*overleaf*) *The Bellman*

understand why Johnson put Cocker[8] into his pocket to amuse him in his travels, equations having been, off and on, my daily amusement for some time, but when it comes to the concrete — oh then,

> 'Thy hand great' Dulness 'lets the curtain fall,
> And universal darkness covers all.'[9]

With our united best regards, believe me to be,

Ever faithfully yours
S. Palmer

JOSEPH CUNDALL[1]

Furze Hill, Mead Vale,
Red Hill

July 17, 1880

My dear Sir,

It has vexed me, and I have been *truly sorry* not to have done anything for the 'Etcher', — but you would understand it, could you quite realize my position.

Through over-devotion to that great time-killer, chiaroscuro, my etchings consume much of it;[2] and, not expecting to do much more in that way, I think my family ought to retain possession of whatever plates are done, and of course individual impressions lose their value after publication in a work. Neither have I by me any unpublished plates. Would that I were twenty years younger!

I grieve to hear that you have been suffering so much: I have been free from asthmatic attacks for three or four years; perhaps, through creating an artificial climate with the glass at about 60, *day and night* nor do I do so much as go out into the garden save in

[8] *Arithmetick* by Edward Cocker (1678).
[9] Pope, *The Dunciad*, III, 355-6.

[1] Joseph Cundall (1818–1895), superintendent of publications at the South Kensington Museum (now the Victoria and Albert), and author of many books on art, history, bookbinding and other subjects. In 1846 he had published the first Christmas card. *The Etcher*, a periodical which ran from 1879 to 1883, was edited by his son H.M. Cundall.

This letter is published by courtesy of the Victoria and Albert Museum.

[2] 'of it' replaces the deleted 'time'. By contrast, Blake had called chiaroscuro 'that infernal machine' (*A Descriptive Catalogue*, Number IX).

warm weather, though, with sufficient clothing, the 'respirator' gives much liberty in that respect. A fire skilfully made up the last thing at night with *Cannel-coal* keeps in till morning.

I conclude that you are not living on clay: — the soil here is sand; gravel would probably suit us best.

I am glad to hear that you have so powerful a staff of promised contributors to the work. I was much pleased with the delicate feeling and handling of an old French tower in the Portfolio, (number forgotten,) by Mr. Townsend, a name new to me.[3] Perhaps he has appeared in your work.

Thrice happy those to whom etching is just a pleasant recreation like amateur hay-making. With me it is both a 'labor' and an 'opus': — enjoyable though, in another way, for this very reason.

<div align="right">

Believe me,
with kind regards,
Yours most truly,
Samuel Palmer

</div>

[3] *A Gothic Tower* by T.S. Townsend, published in *The Portfolio* in 1879.

Appendix

The seven newly-discovered letters that seem to be of general value have been included in the main text. Five others, interest in which will perhaps be limited to devotees and scholars, are printed here.

JOHN LINNELL[1]

1852 (?) 6 Douro Place

Dear Sir

I have sent a post office order for 1.0.0 to Mrs. Banister[2] — typhus fever being in her house and being afraid of Annies going there on that account. In the note Mrs. Banister says you mention that balance as being in our hands — but the account stands thus I think.

Recd by Annie at Redstone Paid Mr White[3]
10.0.0 10.18.0
I remain

Dear Sir
Yours truly
S. Palmer

I gave Mr White your note when I paid 10.18.0 and asked him just to put the particulars — but he was in great haste fearing to miss a conveyance out of town — whence I suppose arose the mistake.

[1] Undated. Two other letters from Palmer to Linnell, which refer to Mr. White and which may well be from the same period, were dated March 1852 by Raymond Lister. This letter is printed by courtesy of Mrs. Joan Linnell Burton and the Linnell Trust.

[2] Unidentified.

[3] Probably the art-dealer David Thomas White, with whom Linnell dealt for more than twenty years. The Linnell Trust also possesses a slightly later letter from Hannah Palmer to her father, supporting her husband's position and stating, 'I think Mr. White must have added instead of subtracted the book of Job.'

FREDERICK GOULDING[1]

Sept^r 12 1870 Furze Hill House, Mead Vale, Red Hill

Sir,

After the last meeting of the Etching Club the Hon^y: Secretary informed me that you had been requested to let me know before you began to print my plate.[2]

Before beginning I should be glad if you will send me (by post, without margin, but in a large envelope which will take them without doubling) three impressions, two of them very full with as little wiping as possible.

But in printing any subject in which the sun is introduced — the plate should be held up to the light before it is put into the press to see if there is any accidental smear left in the sun — this should be done with every impression.

Before the margin was cut off my plate used to warp very much, and Mr Haden,[3] who kindly proved it for me, had to put a graduated padding of slips of paper at the back — but you will easily find out whether this is now needful since the plate has been made smaller and steel coated.

No impressions must be taken upon *dark* India — it will ruin the etching. It must be either white or the very lightest straw colour.

No BLUE should be in the ink.

The steel coating gives you the advantage of being able to use a stiffer ink.

Mr. Redgrave[4] tells me that my model proof was forwarded to you — but on receiving the three of your proving I shall perhaps find one of them which I think richer and better than the model. Please take them in the usual way on the lightest India — with the

[1] Frederick Goulding (1842-1909), soon to gain renown as a copper-plate printer. Eventually Palmer came not only to respect his work but to seek his advice about printing. The two letters to Goulding are published by courtesy of the Victoria and Albert Museum.

[2] Presumably the etching which would come to be known as *The Morning of Life*.

[3] Francis Seymour Haden (1818-1910), etcher and medical doctor.

[4] Richard Redgrave (1804-1888), co-author of *A Century of Painters of the British School* (1866), and a fellow member of the Etching Club.

other paper underneath and then cut off any border and send them undoubled by post in a large envelope.

Yours etc
S. Palmer

You need *not* send the model proof, but keep it carefully by you.

FREDERICK GOULDING

Aug 7 '71 Furze Hill House, Mead Vale, Red Hill

Dear Sir

The proofs and that proof marked as the model proof will reach you directly, but you cannot proceed to take a single impression for the work till the false title 'Hercules and Cacus' is obliterated.

The true title is

A leafy Dell.

not Hercules and Cacus.[1]

I do not wish any title to be put, as the numbered list of etchings will contain the subject.

I have written to Mr Day to ask him to prevent the error from appearing in the *list* of Etchings — and shall be glad if *you* will at once have the erasure made of the false title on the plate.

I like much the impression I have marked 'model'. — Being very busy, I will retain the others for the present for careful examination, with a view to some proofs I shall before long want you to take for me of a new subject.

Some days will elapse before I have time to examine them — but at a hasty glance you seem to have attended to my request that there should be no blue whatever mixed with the black.

My late prover told me that it is always as a matter of course mixed with the black unless precaution is taken to the contrary.

Yours truly
Samuel Palmer

[1] Palmer was to change his mind yet again. After having been known as *Hercules and Cacus, Sheep-Washing* and *A leafy Dell*, this etching finally acquired the title *The Morning of Life*.

[2] *The Morning of Life* was published in 1872 in *Etchings for the Art Union of London by the Etching Club*. The result, however, was very disappointing, as the design was etched on old, scraped copper.

HERBERT MINTON CUNDALL[1]

Jan^y 3, '79 Furze Hill House, Mead Vale, Red Hill

Dear Sir,

I made a memorandum of particulars on receiving a schedule some time since, — and should be willing to try the experiment with an etching, were there any hope with various prc-cngage-ments of my finding time to do one for the proposed work; — but 'Wonders never cease' and such a thing may possibly happen.

I understand from the prospectus that the etcher furnishes impressions but that the plate remains his own property.

Hoping that you[2] are in the enjoyment of better health than when we last met in the S. Kensington Museum,

<div style="text-align:right">

I remain,

Very sincerely Yours,

Sam^l Palmer

</div>

[1] Palmer addressed this note to 'Henry Cundall', an error for Herbert Minton Cundall (1848-1940), who edited *The Etcher* from 1879 to 1883 and went on to write several books about art, notably *A History of British Water-Colour Painting* (1908). Presumably he had asked Palmer to contribute to *The Etcher*. Palmer probably confused his name with that of the Victorian painter Henry Cundell. The two letters to H.M. Cundall are published by courtesy of the Victoria and Albert Museum.

[2] In this case Palmer seems to have confused H.M. Cundall with his father, Joseph Cundall, superintendent of publications at the South Kensington Museum.

HERBERT MINTON CUNDALL

Nov^r. 8, 1879. Furze Hill House, Mead Vale, Red Hill

Dear Sir,

In thanking you for the pleasure you have afforded me in the numbers you kindly sent, allow me to correct a misconception of my former note. I could not promise a contribution for the reasons then stated. I can scarcely get time to etch anything even for myself, and when I do, it is at a serious loss, because work so much more profitable is laid aside for it. My etchings take a long time, and it is too late to change my manner, but were I twenty years younger, it would give me much pleasure to help your undertaking by something more substantial than good wishes, though, of such insubstantial commodities, none are more sincere than those of

<div align="right">

Yours very faithfully
Samuel Palmer

</div>

Pray give my best regards to Mr Cundall Sen^r.,[1] who remains, I trust, in the same state of improved health as when I had last the pleasure of hearing from you.

[1] Joseph Cundall (cf. Palmer's letter of 17 July 1880, p. 231).

Index:
recipients of letters

Index of Names